Ca ninal Image

Capturing the Criminal Image

From Mug Shot to Surveillance Society

Jonathan Finn

University of Minnesota Press
Minneapolis
London

The University of Minnesota Press gratefully acknowledges funds contributed to the publication of this book from the Dean of Arts Office and the Office of the Vice-President: Academic, Wilfrid Laurier University.

Chapter 2 was previously published as "Photographing Fingerprints," *Surveillance and Society* 3, no. 1 (2005): 21–44; reprinted with permission of the editors of *Surveillance and Society*. Chapter 5 was previously published as "Potential Threats and Potential Criminals: Data Collection in the National Security Entry–Exit Registration System," in *Global Surveillance and Policing: Borders, Security, Identity,* ed. Elia Zureik and Mark B. Salter, 139–56 (Devon, U.K., and Portland, Ore.: Willan Publishing, 2005); reprinted with permission of Willan Publishing.

Published by the University of Minnesota Press
111 Third Avenue South, Suite 290
Minneapolis, MN 55401-2520
http://www.upress.umn.edu

Library of Congress Cataloging-in-Publication Data

Finn, Jonathan M. (Jonathan Mathew), 1972–
 Capturing the criminal image : from mug shot to surveillance society / Jonathan Finn.
 p. cm.
 Includes bibliographical references and index.
 ISBN 978-0-8166-5069-9 (hc : alk. paper) — ISBN 978-0-8166-5070-5 (pb : alk. paper)
 1. Legal photography. 2. Criminals—Identification. I. Title.
 HV6071.F46 2009
 363.25'8—dc22 2009022445

Printed in the United States of America on acid-free paper

The University of Minnesota is an equal-opportunity educator and employer.

20 19 18 17 16 15 14 13 12 11 10 09 10 9 8 7 6 5 4 3 2 1

Contents

Introduction

Constructing the Criminal
in North America

The images in Figure 1 function as visual substitutes for the human body within practices of criminal identification. The image on the left is of James White, a "hotel and confidence man," arrested, photographed, and included in Thomas Byrnes's text *Professional Criminals of America* (1886). The image in the center represents a fingerprint identified and photographed by the Metropolitan Toronto Police in a fictional crime scene in 1996. The image on the right is an autoradiograph depicting DNA analysis from a rape–murder case that was printed in the National Research Council report *DNA Technology in Forensic Science* (1992).[1]

Through these representations, the criminal subject is recorded, studied, followed, and ultimately identified. In addition to their roles as evidentiary statements, these images also participate in important debates on privacy, surveillance, and power. Far from being mere static representations, these photographs are engaged in what Michel Foucault termed a "micro-physics of power": they function across juridical, medical, legal, and other discourses in the construction of identity and its attendant rights and limitations.[2] Because these representations are sites of tremendous social importance, to produce and interpret them is to participate in cultural constructions of normalcy, deviance, gender,

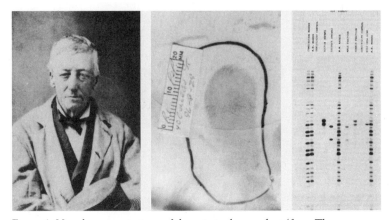

Figure 1. Visual representations of the criminal: mug shot (from Thomas Byrnes, *Professional Criminals of America* [New York: Cassell, 1886], between 162 and 163); fingerprint (property of the author); and autoradiograph (from National Academy of Sciences, Committee on DNA Technology in Forensic Science, National Research Council, *DNA Technology in Forensic Science* [Washington, D.C.: National Academies Press, 1992], 39; reprinted with permission).

and race and in moralistic debates of right and wrong. As such, the need to examine this type of representation critically is paramount. *Capturing the Criminal Image: From Mug Shot to Surveillance Society* attempts to address this need.

Continued scientific and technological innovations have greatly altered the ways in which the criminal body has been represented visually within law enforcement and criminal identification practices. Over the past three decades, technological tools have become steadily more available, enabling new ways of representing the criminal body. Infrared and ultraviolet lasers, chemical baths, DNA analysis, computer databases, and digital imagery have yielded several new visual substitutes for the criminal. Despite the specific nature of such changes, visual representation has remained an important means through which the criminal subject is understood and defined. The act of representing, or *making the criminal visible*, is central to modern and contemporary law enforcement and criminal identification practices and is the focus of this book. The criminal is most obviously represented through the traditional police photograph, or mug shot. However, the criminal is also represented in more disparate and subtle ways, as in the fingerprint, the autoradiograph,

and other forms of visual and textual evidence. Reading these images as objective documents or records presupposes the existence of the criminal body. In contrast to this, by taking the criminal as a social construct, I aim to locate and examine the changing role and importance of photographic representation as it functions in the process of construction.

By the close of the nineteenth century, the photographic representation of the criminal body was enmeshed in a socially defined binary of normal versus deviant and in questions of power, surveillance, and privacy. Now, at the beginning of the twenty-first century, we are caught in an interesting paradox. Technological developments have advanced the abilities of individuals and groups, both public and private, to record and study the human body down to its minutiae, often without the person's consent or acknowledgment. New media technologies now enable police to collect, store, and exchange visual representations and other identification data for entire populations, contributing to what sociologists and cultural historians have called a society or culture of surveillance.[3] However, and partly in response to this development, these activities are taking place within and by a society that is increasingly concerned with such intrusive practices and that prides itself on its democracy. This tension is nowhere more clear than in the post–September 11, 2001, initiatives of the United States to document persons entering or leaving the country. The National Security Entry–Exit Registration System (NSEERS), announced in June 2002, captured digital representations of the fingerprints and faces of select nonimmigrant aliens crossing any U.S. border. Similarly, the U.S. Visitor and Immigrant Status Indicator Technology (US-VISIT) program, implemented in January 2004, captures similar visual materials from each of the approximately thirty-five million annual visitors to the country.[4] The use of visual representation in these programs attests to its continued prominence in law enforcement practices and reminds us of its highly problematic nature.

What must be addressed is the changing nature of visual representation in law enforcement and criminal identification from the nineteenth century to the present day. To what extent are contemporary methods of visual representation merely new manifestations of nineteenth-century practices? What new issues have arisen, and what old ones have disappeared? And, perhaps most importantly, what is at stake in these new methods of representation as they assist in the construction of identity, with its attendant freedoms and limitations?

Looking at Photographs: Objectivity, Representation, and Inscription

Visual representations of the criminal body emerge from continual negotiations among humans, technology, and the social networks through which they interact. The naming, regulating, classification, and identification of the criminal body have roots in the intersections of scientific and visual practices. Adding to the complexity is the unique status of photography and the extensive debates about the medium's subjectivity and objectivity.

To address this complexity, I draw on a range of sources and perspectives from the humanities and social sciences, chiefly from the fields of visual culture and science and technology studies. In its treatment of the visual, the book reflects an emphasis on the dynamic nature of images and image-making practices. Rather than approaching the topic from a single disciplinary or theoretical perspective or with a predetermined methodology or series of questions, I have worked outward from the objects of study, from the images themselves. In this way, the approaches taken in the book acknowledge, reflect, and are directly drawn from the complexity of the specific subjects of study. My treatment of photography and photographic representation is purposefully and necessarily broad. I address the concrete production and use of photographic technologies in law enforcement, while also using the image as a point of departure to investigate more-abstract and theoretical issues associated with law enforcement and criminal identification such as the construction of identity and issues of power, surveillance, and social control.

From its inception, photographic representation was seized on by social institutions, including law enforcement agencies, for the documentation and administration of the body. The relative ease and low cost of photography combined with its rapid means of reproduction served the interests of scientific, social scientific, institutional, and other practices that sought to document or record their specific subjects or objects of study. From the 1840s onward, plants, animals, humans, landscapes, buildings, and events were routinely subject to the camera's gaze. This documentary effort is perhaps nowhere more clear than in Eadweard Muybridge's 1887 text *Animal Locomotion*. Muybridge produced an estimated thirty thousand negatives for the text, which provided precise visual documentation of human and animal movement.

In addition to the advantageous material conditions of photography, the medium's claim to objectivity was of central importance to those using the camera. Unlike other forms of visual representation, the photographic image was considered to be a direct, unmediated copy or index of its subject in the natural world.[5] The tension between photography as a subjective medium and as an objective one has been the subject of continued debate by photographic theorists, historians, and practitioners.[6] The supposed uniqueness of photographic representation is often attributed to its mechanical and chemical basis, its "nature." Whereas a painting or drawing is obviously produced through the mediation of an author, the photograph is taken to be the product of a purely mechanical process. This view is aptly summarized in the words of film critic and theorist André Bazin, who noted that with photography, "for the first time, between the originating object and its reproduction there intervenes only the instrumentality of a nonliving agent. For the first time an image of the world is formed automatically, without the creative intervention of man."[7]

Bazin's remark is indicative of an understanding of photography that has dominated much of the medium's use since the nineteenth century. Because it is the product of a chemical and mechanical process, the photograph is taken to be more objective than less-mechanistic forms of visual representation. This understanding of photography carries an important corollary, particularly as the image is used in law enforcement and criminal identification practices. If the camera can be used to accurately record events in the live world, it follows that events and objects depicted in a photographic image actually exist(ed) and occurred at some specific point in time, what Roland Barthes refers to as the "having-been-there" or the "this-has-been" of the photographic image.[8] In other words, photographs are unique among forms of visual representation in that they are believed to guarantee the presence of their subjects at some specific point in time.

The photomechanically produced image is indeed unique among forms of visual representation; however, its uniqueness is as much cultural as it is material. The introduction of photomechanical reproduction in the nineteenth century did not suddenly bring order and objectivity to representational practices that were otherwise disorderly and subjective.[9] Similarly, photographs were not (and are not) universally accepted

as objective, unmediated copies of the natural world. For example, in her analysis of the introduction of photographic evidence into American courts of the nineteenth century, Jennifer Mnookin shows that photographs were often treated with great suspicion and were often viewed not as evidence in themselves but as supplements to eyewitness accounts, which were believed to be more truthful.[10] Mnookin shows that in the official doctrine of the court, photographs were not accepted as uniquely objective statements; rather, under the general heading "visual evidence," they were analogized with subjective forms of representation such as maps, drawings, and charts. Discussing scientific atlases, Lorraine Daston and Peter Galison convincingly demonstrate that the particular type of objectivity attributed to the photomechanical image was the product not of the sudden emergence of the camera but of a centuries-long practice of nonintervention in scientific image making.[11] In their account, photographic objectivity is tied to the ability of the camera to produce verisimilar images. That is, the specific conception of objectivity that developed in the nineteenth century privileged the visual accuracy of the mechanistic image over its human-authored counterpart.[12]

All photographs employ subjective conventions such as framing and focus and therefore can never be direct, unmediated copies of their subjects. And as the work of Mnookin and Daston and Galison shows, photography's objective status cannot simply be attributed to its "nature" as a chemical and mechanical process. Rather, photography's unique claim to objectivity is as much cultural as it is natural. As it has been used since the nineteenth century—with the possible exception of its use in artistic production—the photograph has largely been understood as being more objective than other forms of representation. This is particularly true in certain practices, law enforcement and criminal identification among them, that depend on the veracity of the photographic image. Indeed, studies of photography's use in criminal justice, fine art, advertising, journalism, medicine, and other fields would show diverse and changing claims to objectivity and subjectivity. Throughout its history of use in law enforcement and criminal identification practices, the subjectivity of the photograph has been rendered largely invisible against the tremendous literal power of the image to record objects in the live world.

This book understands photography as unique among forms of visual representation for both material and cultural reasons. Photography's "nature" as a chemical and mechanical process allows for the limitless, quick, and economical reproduction of verisimilar images. Photography's culture of use has privileged the medium with claims to objectivity beyond other forms of representation. Taken as a whole, photography's material features and its culture of use make it a premier mode of representation for scientific and institutional practices that require verisimilar images.

Within the still-limited body of academic work that directly addresses the photographic representation of the criminal, those of John Tagg and Allan Sekula remain unparalleled. Tagg's *The Burden of Representation* and Sekula's "The Body and the Archive" are still the most important texts on the topic.[13] Working from the ideas set forth in Foucault's *Discipline and Punish,* Tagg addresses the ubiquity of photographic representation within Foucault's conception of the carceral network. To this end, he investigates the medium as it functioned throughout a series of nineteenth- and early-twentieth-century practices. His analysis includes discussions of the rise of photographic portraiture, the establishment of the photograph as a legal document, the use of photography in medical and police practices, and the federally sanctioned documentary work of the Farm Security Administration. In all cases, Tagg refutes the possibility of the universality of the photograph, stressing the historical specificity of its value and meaning. He writes: "The photograph is not a magical 'emanation' but a material product of a material apparatus set to work in specific contexts, by specific forces, for more or less defined purposes." This leads Tagg to refute any single history of photography, referring to it instead as "a flickering across institutional spaces."[14]

Whereas Tagg focuses on photography as it was employed by state institutions, Sekula de-emphasizes the specificity of the medium, positioning it within a larger "bureaucratic-clerical-statistical system," or, in his now famous term, in an "archive."[15] Sekula describes the archive as a particularly visual space where the good, the heroic, and the celebrated of society coexist with and are defined alongside the criminal, the deviant, and the poor. Within the developing archival mode of the nineteenth century, practices of physiognomy, phrenology, eugenics, and social statistics grew in conjunction with the new field of criminology

and provided a scientifically legitimized discourse of the criminal body. Culminating in the work of the Italian criminologist Cesare Lombroso, this discourse held that criminality could be read directly from the body and, by extension, captured in the body's visual representation.

Importantly, and as Sekula shows, photographic representation was also used to capture the "normal" body. During the historical development of the medium, photography served both honorific and repressive functions. Sekula uses the development of photographic portraiture in the nineteenth century to explain, noting:

> Every portrait implicitly took its place within a social and moral hierarchy. The private moment of sentimental individuation, the look at the frozen gaze-of-the-loved-one, was shadowed by two other more public looks: a look up, at one's "betters," and a look down, at one's "inferiors."[16]

In this way, the photograph served a classificatory function. It provided a static, visual means to identify oneself among others in society and, in turn, to be distinguished from others.[17] By emphasizing this double role of the image, Sekula is able to show that in the nineteenth-century construction of a deviant or criminal body, a more generalized social body was also being produced. Within the visual space of the archive, deviance and normalcy helped define one another.

Work in the history and theory of photography that addresses its use in law enforcement and criminal identification is essential to understanding the historical development and deployment of photography as a documentary and evidentiary medium. This body of work highlights the broad, discursive networks within which photography functions, and it stresses the historical specificity of photographic meaning. This work also effectively shows the role of photography in a larger, more abstract field of visual representation within which bodily identity is often negotiated. Nonetheless, work in the history of photography leaves space for continuing critical investigation. The myriad of new visual and information technologies at work in criminal identification calls for a rethinking of this material, which refers almost exclusively to nineteenth-century practices. In addition, and more importantly, in its treatment of the photograph as a representation of a criminal body, this work fails to acknowledge the concrete production and use of images as they function in scientific practices and in the production of identity.

To address these questions and to complement work in visual culture, my work draws from the field of science and technology studies, where it focuses on the social construction of scientific facts.[18] A metaphor often used in social studies of science and technology is that of the black box. In *Science in Action*, Bruno Latour uses the metaphor to trace the construction of "scientific fact and technical artefacts" through scientific practice.[19] For Latour, a central feature of scientific practice is the ability to "black-box," or to treat as givens, certain concepts, practices, and presuppositions. In this way, the complex negotiations that take place in the construction of scientific facts are enclosed by the black box and rendered invisible in the final product. Once closed, the black box can serve as a site to be used in future scientific practice (so that any black box can contain within it a series of other black boxes). Because of this process, and key to the metaphor, Latour emphasizes that analyses of scientific practice should not take the final product as their object of study. Instead, social studies of science should begin at the planning stages in an attempt to "be there *before* the box closes and becomes black."[20] In its ultimate manifestation, Latour's method positions the researcher alongside the scientists, documenting every move in the creation of scientific facts.

I want to suggest that, in addressing the use of photographic representation in law enforcement and criminal identification practices, work in the social study of science allows us to avoid the traps of this metaphor. That is, instead of beginning with the final product (the photograph of the criminal), we should start with the complex series of negotiations in the process of production.[21] To this end, this book investigates photographic representations used in law enforcement and criminal identification as *inscriptions*: as material representations used in the production of scientific knowledge and evidence.

My use of the term "inscription" draws primarily from the work of Bruno Latour and Steve Woolgar. In *Laboratory Life*, the authors trace the construction of scientific facts by examining the daily activities within a specific endocrinology laboratory.[22] Their text begins with the description of a fictitious character through whom their text will take form. "The observer" is conceived of as a newcomer to the laboratory. He has no specific knowledge about the activities taking place in the lab; he is an anthropologist, trying to understand its practices. Latour and Woolgar use

this fictional character to set out the central question of their book. The observer asks, "How is it that the costly apparatus, animals, chemicals, and activities of the bench space combine to produce a written document, and why are these documents so highly valued by participants?"[23]

Throughout their text, Latour and Woolgar demonstrate the central importance of documents, or inscriptions, in the production of scientific facts. As diagrams, curves, pictures, lists, tables, or textual statements, inscriptions are the basic currency of scientific practice. They are produced in the lab by inscription devices, defined as "any item of apparatus or particular configuration of such items which can transform a material substance into a figure or diagram which is directly usable by one of the members of the office space."[24] Crucially, the labor and procedures involved in the production of inscriptions are lost in the final representation. Latour and Woolgar point to two consequences of this loss. First, "inscriptions are seen as direct indicators of the substance under study." Second, the process of producing inscriptions gives way to a "tendency to think of the inscription in terms of confirmation, or evidence for or against, particular ideas, concepts, or theories."[25]

The notion of inscription is developed throughout Latour's work after *Laboratory Life*.[26] In particular, he distinguishes between inscription in a general sense, which refers to any material representation produced and used in a given practice, and a more refined and specialized type of inscription, referred to as an immutable mobile. Five features define these objects. They are immutable, mobile, presentable, readable, and combinable with one another. Whereas inscriptions can function within individual laboratories or isolated groups of practitioners, the idiosyncrasies of their production prevent their acceptance and use in a larger scientific community. To function in an aggregate field of scientific practice, inscriptions must be made highly standardized and nearly universal to ensure proper communication. Latour shows that inscriptions must become immutable mobiles if they are to be effective in scientific practice that is dependent on continued dialogue between individuals and groups of practitioners; among laboratories, companies, and institutions; and through professional channels such as conferences and journals.

Latour's concept of the immutable mobile, with its five features, provides a model through which to investigate the daily activities of a given scientific practice. For the purposes of this book, it is sufficient to address inscriptions in a more general sense, emphasizing their im-

mutability and mobility. Rather than detailing the production, exchange, and consumption of inscriptions through the various professional channels and organizations of a specialized practice, this book employs the notion of inscription to highlight and investigate a primary feature of modern and contemporary law enforcement and criminal identification practices: data collection. This book argues that modern and contemporary police practices are based in the collection, exchange, and use of aggregates of identification data and that inscription—more specifically, photographic inscription—is fundamental to this effort.

The notion of inscription is particularly effective in studying modern and contemporary criminal identification practices. The reason for this is twofold. First, the modern conception of the criminal body, developed in the nineteenth century, was tied to contemporaneous developments in the social sciences that sought ways of classifying, systematizing, storing, and sharing information. One result of this confluence of activity was an increased need for visual representation within social, institutional, and scientific contexts. Second, a defining feature of the modern criminal, developed in the latter half of the nineteenth century, was his mobility.[27] Law enforcement practices of the time reflected a need to communicate identification information between specific locales. In order for this communication to be effective, information identifying the criminal's body had to be mobile and immutable. Inscriptions of the criminal's body had to move seamlessly between contexts and locations without the loss or alteration of the necessary information. Inscriptions were helpful in reducing the complex three-dimensional body into a two-dimensional representation; however, to be effective within law enforcement practices that were increasingly reliant on communication, the inscription of the criminal body had to be immutable and mobile.

The camera developed in conjunction with this network of scientific and social scientific activity of the nineteenth century. Photography's cost-effectiveness, ease of use, rapid means of production, and unique claim to objectivity assured the photograph a central position among other forms of visual representation across social, institutional, and scientific practices. The mechanical nature of the camera and the chemical nature of photographic development were taken to guarantee the accuracy and immutability of information within the image's frame. Law enforcement agencies quickly seized these benefits of the camera to transform the body, with all its complex idiosyncrasies, into two-dimensional

documents, which were considerably easier to manage. Just as in the endocrinology laboratory, the resultant representations function as "direct indicators" of the subject of study. However, rather than indicating molecules, the inscriptions produced and used by law enforcement agencies indicate the body. Within law enforcement and criminal identification practices, images of faces, fingerprints, and DNA are routinely collected and compiled into networks of similar representations, to be reproduced, read, and exchanged as necessary.

In addressing photographs as inscriptions, I want to highlight an essential functional difference between types of photographic representations, one that reflects a primary theme of this book. This distinction can be understood by returning to Figure 1. As the camera was used to photograph James White, it functioned as a tool of representation. The camera recorded his identity as a known criminal, and the image was used primarily as a reference document, one that attested to White's *having-been-there*, to use Barthes's phrase. As part of the visual vocabulary of police in the nineteenth century, the mug shot fulfilled two primary purposes: one, it could be used to keep an individual under surveillance while not in police custody; two, the archived photograph could be used as evidence of an individual's criminal identity if he or she were arrested at a later date and gave a false name to avoid increased penalties associated with recidivism. In each case, the mug shot's function is the same: to document criminal identity.

The images of the fingerprint and autoradiograph are also representations, but only of data. The difference is functional rather than ontological. As with the mug shot of James White, these images benefit from the evidentiary power of the photomechanically produced image. However, the fingerprint and autoradiograph are not representations of preexisting criminal bodies, as the mug shot is, but are inscriptions that function in the production of visual evidence and bodily identity. These images are the end products of distinct scientific practices: fingerprint identification and DNA analysis. The images contain data that is interpreted by relevant "experts" and is coded as a representation of a criminal or noncriminal body through the disciplinary and organizational frameworks guiding the investigation.[28]

The distinction between photographs as representations of preidentified bodies and as inscriptions used in the production of bodily

identity underlies the central argument of this book. As inscriptions—as data—fingerprints, DNA, and other identification data used in law enforcement and criminal identification practices can be deployed according to mutable conceptions of criminality or deviance. The interpretation, meaning, value, and ultimate import of a fingerprint or an autoradiograph will necessarily change depending on the specific deployment of the data. Fingerprints, autoradiographs, and other forms of identification data function across a disparate array of fields and practices, including paternity testing, employment and insurance background checks, issuance of travel documents, and law enforcement, in personal security, biotechnology, and immigration. I may be denied access to a colleague's laptop through a fingerprint scanner that identifies my fingerprint as "other than the owner," or I may be identified as a participant in a criminal act or group through a search of the FBI's fingerprint database. In each case the data is the same—the ridge characteristics of my fingerprint—however, my identity, together with the rights and limitations it affords, changes depending on the deployment of the data and its specific transformation into evidence.

Photography and photographic technologies are only a part of the diversity of scientific, technological, social, economic, and cultural practices that inform law enforcement and criminal identification. This book is not a historical overview of photography as it relates to that whole. Nor is it an attempt to read the history of law enforcement and criminal identification as a history of the development of inscriptions. Rather, by highlighting the distinction between the deployment of photographs as representations of criminal bodies and their deployment as inscriptions used in the production of bodily identity, the book seeks to bring new questions and analyses to bear on contemporary and future law enforcement practices and on their social impact.

The book is chiefly concerned with three specific facets of modern and contemporary criminal identification: fingerprinting, DNA analysis, and surveillance systems and databases. Each is fundamental to current identification practices, and each makes heavy use of photographic representation. In addition, and to fully understand the nature of photography within these specific practices, I begin with a discussion of the contemporaneous development of photographic representation and the modern criminal body in the nineteenth century.

Chapter 1 provides the necessary historical and contextual framework for the book, outlining the developing relationship between photography and criminal identification in the nineteenth century. By the close of the nineteenth century, the body had been defined as a text throughout a series of scientific and social scientific practices. As exemplified in Cesare Lombroso's 1876 text *L'uomo delinquente*, the new field of criminal anthropology promoted the ability to read normalcy and deviance directly from the body via the visual signs it was believed to offer.

The chapter argues that the camera was an essential component in the construction of the modern criminal subject. Photographic technology developed in conjunction with the newly emerging social institutions of the nineteenth century and served as a fundamental tool in recording the identity of both normal and deviant bodies. I stress that, as the camera developed for use within law enforcement and criminal identification practices, it originally served as a tool of representation. However, by the close of the nineteenth century, the photograph was also being employed as an inscription in the study of the criminal, as exemplified in the work of Lombroso and of Francis Galton, and in emerging identification practices, as in the work of Alphonse Bertillon.

Chapter 2 examines fingerprinting as a method of criminal identification. I argue that the specific collaboration of fingerprint identification and photography announced a new mode of law enforcement, reflected by a new role for the camera. Fingerprinting gave rise to practices of latent identification within which the camera functioned as a tool of data collection. During the latter half of the nineteenth century and prior to fingerprinting's introduction to law enforcement, the camera was used to represent and record the captured criminal's body, a body often already identified as normal or deviant. In contrast, the ability to photograph fingerprints independently of the presence or knowledge of the physical body gave rise to the collection of latent identification data. Latent data represents an unknown physical body, its identity to be determined within the confines of the police laboratory. I argue that the specific intersection of photography and fingerprint identification greatly extended the capabilities and reach of law enforcement and announced— at first theoretically—a new, pervasive form of state surveillance.

The chapter draws on research conducted during an apprenticeship position with the Metropolitan Toronto Police's Forensic Identification Services. I use a fictional crime scene produced during this research to

show the centrality of photography within fingerprint identification. I argue that a new archive emerged within early-twentieth-century law enforcement agencies, one that included the collection and storage of latent identification data.

Whereas chapter 2 focuses on the concrete production and interpretation of inscriptions within criminal identification, chapter 3 addresses their institutional control. The chapter examines the contentious development of DNA analysis in law enforcement from the 1980s to its formalization in the DNA Identification Act of 1993. I trace the development of federal control over DNA analysis in law enforcement via the development of control over the inscription of DNA, the autoradiograph.

The 1993 DNA Identification Act, enacted in 1994, brought a premature end to the productive, critical debate surrounding DNA analysis and was a necessary precondition for the development of federal control over the technique. The DNA Identification Act facilitated federal control over DNA analysis in three primary ways: it gave the FBI the authority to determine the procedures for analysis; it constructed a workable boundary for the FBI within the larger, competitive field of DNA analysis; and it provided the funding necessary to enlist the participation of local and state laboratories. I argue that federal control over DNA analysis in law enforcement is cause for particular concern, as it yields control over the production and use of genetic identification data.

Chapter 4 returns to the notion of the archive and investigates contemporary information databases in law enforcement. I argue that, in contrast to Sekula's nineteenth-century archive, which was limited by its physicality, the twenty-first-century digital archive exists largely free of these material constraints. The theoretical possibilities associated with the collection of latent identification data, announced by the intersection of fingerprinting and photography as addressed in chapter 2, have become a reality in the twenty-first century. Law enforcement agencies now collect and store vast amounts of identification data for its potential use. Not only is this data often collected without any clear reason, but these practices also contribute to new conceptions of crime, criminality, and the body.

The chapter addresses two specific digital archives in contemporary law enforcement: the National Crime Information Center 2000 and the Combined DNA Index System. In each case, I question the rationale governing the collection and storage of identification data, and I raise

concerns regarding its potential misuse. Specifically, and drawing from the discussions of chapters 2 and 3, I argue that the inscriptions contained in these archives can be redeployed according to the changing needs of law enforcement and to mutable conceptions of crime and criminality. I argue that the body in the digital archive is reconceptualized as a site of potential criminality.

Chapter 5 expands on the argument of the previous chapter and brings the book to conclusion with an analysis of two registration and border-security programs in the United States. NSEERS and US-VISIT were developed in response to the events of September 11, 2001. Both programs collect and archive identification data, including digital images of the faces and fingerprints of persons entering or leaving the country. The chapter positions NSEERS and US-VISIT as contemporary surveillance systems and analyzes the collection of personal identification data in these programs.

Registration in US-VISIT is required of nearly every visitor to the United States; however, registration in NSEERS was selectively applied nearly exclusively to Arab and Muslim men. I contrast the inclusive focus of US-VISIT with the exclusive program of NSEERS to suggest that data collection in NSEERS functioned less to enhance border security than to code, categorize, and display certain bodies as potentially threatening and as potentially criminal. I situate NSEERS within the larger visual program of the so-called war on terror to suggest that the registration program gave a visual face to a threat described as largely invisible and omnipresent. This not only enabled the public to participate in the surveillance of targeted populations but also served as a display of heightened state power.

This book contributes to the limited body of work that addresses the intersections of photography, law enforcement, and criminal identification. More broadly, it contributes to the increasing body of literature in visual culture and related fields that addresses images and image making in scientific practices and in programs of surveillance and social control. My aim is to highlight the centrality and diversity of photographic representations and inscriptions in law enforcement and criminal identification practices. By focusing on select uses and key changes in the function of visual representation in police practices, I hope to bring critical analysis to a topic that, despite its tremendous import, is still largely undeveloped.

1

Picturing the Criminal: Photography and Criminality in the Nineteenth Century

The police mug shot has become an icon in contemporary visual culture. The pose, framing, and formal conventions of the image are easily recognized throughout the general public. It is an image that is taken to indicate criminality. Mug shots permeate our daily lives in newspapers, on television, and in film. They have been the subject of an art exhibition at the San Francisco Museum of Modern Art[1] and have been the seat of controversy, as with the picture of O. J. Simpson used by *Time* and *Newsweek* for their covers of June 27, 1994. The magazines used the same mug shot of Simpson; however, *Time* altered the image by darkening his skin, further promulgating a racist stereotype that links criminal behavior with skin color.

More recently, as outlined by former U.S. attorney general John Ashcroft and by the then newly formed Department of Homeland Security, the mug shot has been adopted for use in the war on terror. NSEERS and US-VISIT are post–September 11, 2001, initiatives that collect identification data, including mug shots, from persons entering or leaving the United States. These initiatives highlight the tremendous authority attributed to the image, as well as its continued prevalence within law enforcement practices, and thus call attention to the need to critically address this mode of representation.

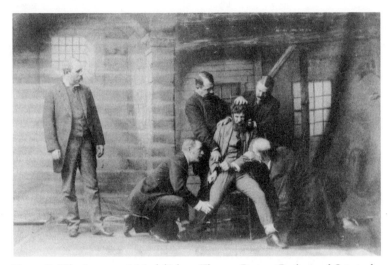

Figure 2. "The Inspector's Model" from Thomas Byrnes, *Professional Criminals of America* (New York: Cassell, 1886), between 52 and 53.

The mug shot has its roots in photographic portraiture of the mid-to-late nineteenth century. Here the formal conventions of the image were defined: frontal, clear, showing head and shoulders, and, where possible, with no facial expression. The goal was the same for both types of portrait: to capture an accurate representation of the sitter's face. The mug shot was understood to be so accurate and objective that it would foil any later attempt by its subject to avoid identification by providing a false name or other fictitious information upon arrests. Thus, criminals subjected to the camera would often twist and turn and change their facial expressions to avoid being captured by the camera. Figure 2, from 1886, shows such a scene: a man is wrestled into position by four attendants while Thomas Byrnes, chief detective of the New York Police, watches over. The right hand of one attendant pulls back on the arrestee's hair, to force the sitter's face within the frame of the image.[2]

The new field of criminology developed contemporaneously with the rise of photographic portraiture and the police mug shot. This work posited direct links between the physical body and criminal propensity and was championed in the work of Cesare Lombroso.[3] Lombroso pioneered the field of criminal anthropology, and his work is central to the development of modern, Western disciplinary practices. He was the first to apply positivist methods to the study of crime, describing the "born

criminal" and linking criminal behavior to atavism. According to Lombroso, criminality could be read directly from the body and, by extension, captured in its visual representation.[4]

Our current understanding of the criminal subject is based in social and scientific discourses established in conjunction with a new conception of the criminal body in the nineteenth century, particularly, its accessibility to being represented visually. Because developments in photomechanical reproduction during the nineteenth century allowed for the relatively quick and easy documentation of bodies, photography became a premier mode of representation and was central to the construction of the modern criminal body. The camera originally served as a tool of representation as it developed for use within law enforcement and criminal identification practices. The photograph was deployed to document the identity of criminals brought into police custody. However, by the close of the nineteenth century, the photograph was also being employed in the study of the criminal body. In this latter sense, the image functioned as an inscription to be used in the production of knowledge of crime and criminality. This transition, from representation to inscription, foreshadowed the growth of law enforcement and criminal identification practices that were increasingly abstracted from the live body of the offender, a feature fundamental to contemporary police practices.

Among works addressing modern penal and judicial systems, Michel Foucault's *Discipline and Punish* remains paramount. In this work, Foucault examines the growth of a new disciplinary society in the late eighteenth and nineteenth centuries. The new system was based in a normalizing discourse that sought to reform, and not harm, the physical body and, by extension, the soul. This system operated through the cyclical relationship of power and knowledge: the exercise of power yielded new forms of knowledge, which in turn facilitated the exercise of power.

An essential feature of the new disciplinary society was the way in which power, in the form of discipline and punishment, was exercised. Its application had to go unnoticed and unchallenged to be effective. Prior to the development of the modern disciplinary regime, power—understood as the sovereign power of the king—was exercised in highly public displays. Foucault opens *Discipline and Punish* with an example of such display, detailing the public execution of Robert Damiens. Damiens had been accused of regicide for an attack on Louis XV in 1757, and as

punishment he was brutally tortured, tied by his arms and legs to horses, and then torn to pieces in the public square. Foucault uses this example to document the transition from the public exercise and display of power to the more subtle and diffuse exercise of power characteristic of the modern state and of a new disciplinary regime. Through the subtle workings of what he called the "carceral network"—the body of institutions including prisons, schools, hospitals, and reformatories—a new modality of power arose, a "micro-physics" of power. The body, previously the site of physical punishment, became the site of knowledge as it was recorded, tracked, and trained at the everyday level. In a circular manner, the knowledge gained from the subtle administration of the body was applied back to the carceral network, ultimately producing a more docile, normalized, and productive body, which was more easily managed by the state.

Foucault uses Jeremy Bentham's design for the Panopticon to illustrate a central feature of the new disciplinary regime: visibility. Bentham's design includes a central observation tower surrounded by a ring of individual cells, each of which faces the tower and has openings at the front and back. Individuals within the cells are made permanently visible to those in the central tower through backlighting. By contrast, those in the central tower cannot be seen by the occupants of the cells because the windows of the tower are shielded by blinds and the corridors of the tower are configured so as to prevent any indications of light or sound that would suggest the presence of an observer. For Foucault, the primary effect of the Panopticon was "to induce in the inmate a state of conscious and permanent visibility that assures the automatic functioning of power."[5] That is, inmates took to disciplining themselves because of the constant, unverifiable threat of being observed.

The architectural structure of the Panopticon serves well to illustrate the emphasis on visibility in the new disciplinary society. Bentham's design continually surfaces in discussions of surveillance, power, and social control and commonly serves as a metaphor for the modern disciplinary regime described by Foucault.[6] However, the Panopticon as metaphor can also be misleading in at least two ways. First, the architectural arrangement of cells surrounding a tower suggests a conception of power as centralized, localized, and monolithic. The observer exercises power over his subjects, who are themselves powerless. Second, the

model of the Panopticon suggests that the exercise of power and discipline is directed toward a limited section of the population. The centralized power of the observer is exercised only on the prisoners, patients, or other "inmates" of the Panopticon.[7]

I want to avoid positioning power, discipline, and social control as being tied to the architectural structure of the Panopticon. Thus, it is important to distinguish—as Foucault does—between the Panopticon and panopticism. The former is an architectural model, and the latter refers to the diffuse and subtle micro-physics of power characteristic of modern, disciplinary societies. In the Panopticon, power appears as an all-encompassing entity of the state; by contrast, in panopticism, power is continually negotiated through broad discursive networks—through "multiple movements," "heterogeneous forces," and "spatial relations."[8] By extension, whereas the architectural structure of the Panopticon suggests that subjectivity is also the domain of the state, panopticism suggests that, as with power, subjectivity is a site of struggle and contestation. Finally, instead of targeting the individual bodies enclosed in the architectural structure of the Panopticon, the micro-physics of power in panopticism affects the entire social body.[9]

In its focus on an emerging industrial society, Foucault's project necessarily emphasized the power of the state in producing docile, normalized bodies that served the interests of a capitalist economy. However, power, discipline, and social control in contemporary society are not so easily localizable as the product of a central agency (the state) toward a specific goal (the production of disciplined workers). Hence the failure of the Panopticon, with its clean, enclosed, and totalizing space, to serve as a model for discipline and social control in the twentieth and twenty-first centuries. While I am not attempting to extend a Foucauldian or Panoptic model to address contemporary policing, my analyses of law enforcement and criminal identification practices are influenced by Foucault's work in two primary ways. First, I understand power not as exclusively the domain of an all-seeing state apparatus but as a micro-physics, as something that is diffuse, subtle, and contested and that functions in the construction of identity. Further, I borrow Foucault's positioning of visibility as a key locus of power. Being made visible is to be made a social subject, a body among other bodies to be identified, analyzed, and classified.

Given its material features and its cultural value as an objective form of representation, the camera provided the perfect tool for the documentation, classification, and regulation of the body within the carceral network. The camera's deployment within this context is well documented by John Tagg, Allan Sekula, Suren Lalvani, David Green, and Sander Gilman.[10] Their work helps illustrate the camera's diverse roles both as a panoptic technology used in the surveillance of targeted populations and as a tool in a more abstract project of regulating and training an aggregate social body. Rather than recounting their work here, it is sufficient to highlight the salient features of photography in this effort: it enabled the surveillance of aggregate populations, and its application was subtle, inexpensive, and pervasive. Here, I want to expand on this existing work, emphasizing the camera's role as an inscription device. The full significance of photography's import to modern, disciplinary societies is found in the image's double role as representation and as inscription.

From its inception, the photograph's potential for documenting criminals was acknowledged by law enforcement agencies. As early as 1841, the French police began producing daguerreotypes of prisoners.[11] In the United States, the San Francisco Police Department began daguerreotyping prisoners in 1854, followed by police departments in New York in 1858, Cleveland in the late 1860s, and Chicago in 1870.[12] And in Canada, the Toronto police collected photographs of criminals beginning in 1874.[13] Early professional references to the topic appeared in the 1872 and 1875 editions of the *British Journal Photographic Almanac* by the noted photographers Oscar G. Rejlander and W. B. Woodbury, respectively.[14] By the last decades of the nineteenth century, police departments in major metropolitan areas around the world were collecting photographs of criminals.

The images collected by police were combined with textual accounts of criminals' histories and their biographical information and were compiled in leather-bound books. The resultant albums, called "rogues' galleries," were collected by police departments worldwide. The albums enabled police in growing urban spaces to record criminal activity within their districts and helped identify repeat offenders. What I want to stress here is that the primary purpose of these photographs was to document, or represent, known criminals.

A well-known rogues' gallery, and one that illustrates the representational role of the photograph, is Thomas Byrnes's 1886 *Professional Criminals of America*. Byrnes, then chief detective of the New York Police Department, created an album with 204 frontal portraits, or mug shots, of criminals, six per page. Figures 3 and 4 show typical pages of Byrnes's book. As with other galleries, the images are combined with text that describes each offender, including his or her name, alias, biographical and physical description, and criminal history. The entry for James White, number 94 in Figure 3, reads as follows:

James White, alias Pop White, alias Allen, alias Doctor Long.
Hotel Thief and Confidence Man

Description:
Seventy years old in 1886. Born in Delaware. Painter by trade. Very slim. Single. Height, 5 feet 8½ inches. Weight, about 135 pounds. Gray hair, dark-blue eyes, sallow complexion, very wrinkled face. Looks like a well-to-do farmer.

Record:
OLD POP WHITE, or "DOC" LONG, is the oldest criminal in his line in America. Over one-third of his life has been in State prisons and penitentiaries. He has turned his hand to almost everything, from stealing a pair of shoes to fifty thousand dollars. He was well known when younger as a clever bank sneak, hotel man and confidence worker. He is an old man now, and most of his early companions are dead. He worked along the river fronts of New York and Boston for years, with George, alias "Kid" Affleck (56), and old "Hod" Bacon, and was arrested time and time again. One of their victims, whom they robbed in the Pennsylvania Railroad depot at Philadelphia in 1883 of $7,000, died of grief shortly after.
Old White was discharged from Trenton, N.J., State prison on December 19, 1885, after serving a term for grand larceny. He was arrested again in New York City the day after for stealing a pair of shoes from a store. He pleaded guilty, and was sentenced to five months in the penitentiary on Blackwell's Island, in the Court of Special Sessions, on December 22, 1885.
Pop White's picture is a good one, taken in July, 1875.

The entry for James White in Byrnes's gallery is indicative of law enforcement's adoption of photography in the latter half of the nineteenth century. The text carries the biographical data collected by police and provides a short narrative of his life as a criminal. The photograph of White offers no additional information; it is strictly a representation of

91 92 93

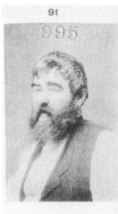
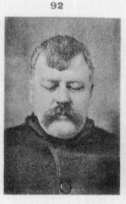
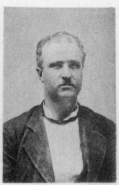

JAMES CASEY, CHARLES MASON, PETER LAKE,
ALIAS BIG JIM CASEY, ALIAS BOSTON CHARLEY. ALIAS GRAND CENTRAL PETE,
BANCO AND PICKPOCKET. PICKPOCKET AND BANCO. BANCO.

94 95 96

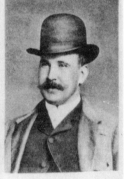

JAMES ALLEN, JOSEPH LEWIS, WILLIAM JOHNSON,
ALIAS POP WHITE and DR. LONG, ALIAS HUNGRY JOE, PICKPOCKET.
HOTEL AND CONFIDENCE MAN. BANCO.

Figure 3. A page of male criminals from Thomas Byrnes, *Professional Criminals of America* (New York: Cassell, 1886), between 162 and 163.

his identity as a criminal and supplements the textual data compiled on the offender. Similarly, the mug shots in Figures 3 and 4 function only as representations of known offenders: they document Charles Mason, the "pickpocket and banco"; Annie Reilly, the "dishonest servant"; and Annie Mack, the "sneak and shop lifter." In all cases, identity as a crimi-

127 128 129

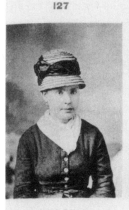 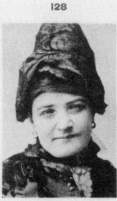 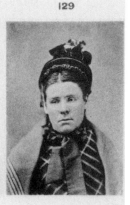

ANNIE REILLY,
ALIAS LITTLE ANNIE,
DISHONEST SERVANT.

SOPHIE LYONS,
ALIAS LEVY,
PICKPOCKET AND BLACKMAILER.

KATE RYAN,
PICKPOCKET.

130 131 132

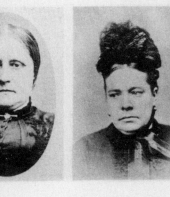

ANNIE MACK,
ALIAS BONO,
SNEAK AND SHOP LIFTER

LOUISA JOURDAN,
ALIAS LITTLE LOUISE,
PICKPOCKET AND SHOP LIFTER.

CATHARINE ARMSTRONG,
ALIAS MARY ANN DOWD — DILLON,
PICKPOCKET.

Figure 4. A page of female criminals from Thomas Byrnes, *Professional Criminals of America* (New York: Cassell, 1886), between 202 and 203.

nal precedes the use of the camera. Stripped of their textual counterpart and their placement within a rogues' gallery, these images display the formal features of any standard portrait. Indeed, the poses and smiling faces of William Johnson and Sophie Lyons would fit equally well in any nineteenth-century family album.

Photomechanical reproduction developed rapidly from the experiments in the 1820s by Joseph Nicéphore Niépce and Jacques Louis Mandé Daguerre with the camera obscura to the release in 1888 of the first Kodak camera, giving rise to what Tagg has called "the era of throwaway images."[15] The development of the halftone process in the 1880s gave rise to the mass production and dissemination of images in various print media, including newspapers and magazines. By the closing years of the nineteenth century, nearly anyone could, and many did, produce photographs.

Within the law enforcement community, continued advancements in photographic equipment and developing processes led to increased accumulation of mug shots. The ease and speed with which police could photograph criminals ensured that police records grew in parallel with the rising crime rates of an increasingly industrialized and urban world. By the closing decades of the nineteenth century, rogues' galleries had grown in size from the hundreds (recall that Byrnes's text housed 204 records) to the thousands, leather-bound books had given way to filing cabinets, and the resultant archives required the assistance of full-time attendants.[16] An example of the problem is Berlin's collection, which grew to such an extent that by 1877 it had been subdivided into ten crime-based groups and required three attendants. In 1880 the Berlin gallery housed 2,135 images, and within three years this had increased to 3,459.[17]

The deployment of photography to document the criminal therefore posed a central problem: as the numbers of records increased, the utility of the collection decreased. Managing and effectively utilizing the 204 records of Byrnes's gallery, let alone the 3,459 in the Berlin gallery, presented a significant challenge for police. Byrnes himself attempted to address this concern by producing his album for public distribution. Rather than limiting the album to the police, Byrnes enlisted the public in the practice of policing. He outlines his mission in the preface to his text, noting:

> While the photographs of burglars, forgers, sneak thieves, and robbers of lesser degree are kept in police albums, many offenders are still able to operate successfully. But with their likenesses within reach of all, their vocation would soon become risky and unprofitable.[18]

Here too we see the emphasis on the evidentiary status of the photograph. Members of the public are asked to familiarize themselves with

these criminals by studying their "likenesses." The image is presented as an evidentiary document: as a representation of a known criminal.

The photographs amassed in various rogues' galleries and in police archives were given new use through the emerging field of criminal anthropology. The photograph as representation gave way to the image as inscription, with the result that images became a central feature in the study and understanding of crime and criminality.

Signs of Criminality: The Visibly Deviant Body

The transition in disciplinary practices of the late eighteenth and nineteenth centuries is based in an essential difference in the treatment and understanding of the body. The body as object, as a site of physical punishment, gave way to the body as subject, as a site worthy of study. This transition had significant impacts across scientific and social scientific practices. Of central importance here is the emergence of the new field of criminal anthropology and its emphasis on the physical pathologies of the body. Championed in the work of Cesare Lombroso, this body of work developed a new conception of criminality and with it a new understanding of the criminal body.

The modern, visibly deviant body has its roots in the second half of the eighteenth century and the belief of the time that the inner character and faculties of the body could be gleaned through an investigation of its outward signs. German physiologist Franz Joseph Gall's theory of cranioscopy or phrenology proposed that an individual's inner character could be derived from reading the shape of the skull. The underlying presupposition was that brain function developed in localized sites and that the skull formed around the brain; therefore, an investigation of the localized sites of the brain could take place through manipulation of the skull. Similarly, the Swiss pastor Johan Caspar Lavater expanded on existing theories of physiognomy, suggesting that inner character could be derived by reading the surface of the body, particularly the face.[19]

Whereas phrenology and physiognomy took the individual body as their subject of study, the emerging field of social statistics analyzed entire populations. The work of the Belgian astronomer Adolphe Quetelet is crucial to this discussion, as he was the first to study crime and criminality through the use of statistical models.[20] Quetelet's work on crime began in response to studies produced by the French government during

the 1820s.[21] These studies documented criminal activity and showed that it varied little from year to year. This was taken to mean that, among other things, if the causes of crime could be illuminated, it could be reduced. In pursuit of this goal, Quetelet began to apply statistical methods to the study of crime.

Quetelet's work was based in mathematical error theory; he believed in a natural order to the universe in which humans, through conscious actions, created deviations. Importantly, Quetelet treated deviation as both positive and negative. Deviation, or change, caused by conscious human decisions could be productive if it was of benefit to society, if it contributed to what Quetelet conceived of as mankind's natural, evolutionary progression.[22] In this way, Quetelet's work was not limited to the activities of criminals but instead spoke to the entire population. The statistician's work fit perfectly within an emerging evolutionary discourse—Darwin's *On the Origin of Species* was published in 1859 and his *Descent of Man* in 1871—that privileged certain bodies over others.

Quetelet's crowning achievement was his conception of *l'homme moyen*, or "the average man," developed in his 1835 text *Sur l'homme et le development de ses faculties, ou Essai de physique sociale* (A Treatise on Man and the Development of His Faculties).[23] Using data collected on both the physical and moral characteristics of humans, he plotted a statistical distribution in the form of a bell curve.[24] Deviations that hinder mankind's evolution and those that benefit it form the poles of the distribution. In the middle rests the majority of actions (and the citizens who produce them), neither harming nor helping progress. Through the creation of *l'homme moyen*, Quetelet provided a statistical basis for understanding criminal activity. He accomplished this by substituting analysis of the individual for that of the group. As Theodore Porter notes:

> Quetelet maintained that this abstract being [the average person], defined in terms of all human attributes in a given country, could be treated as the "type" of the nation, the representative of a society in social science comparable to the center of gravity in physics.[25]

By replacing the individual with the group and by reducing human behavior to a sequence of numbers, Quetelet attempted to demonstrate in an inscription, in the form of a single, static, two-dimensional bell

curve, the aggregate behavior and characteristics of complete societies. Lombroso would combine this work with the theoretical claims of physiognomy and phrenology in the development of criminal anthropology. The result was individual and social bodies that were interchangeable and that were readily understandable through the interpretation of their external, bodily signs.

Lombroso and the Criminal's Body

In his introduction to *Crime: Its Causes and Remedies*, the English translation of Lombroso's *Le Crime, causes et remèdes*, Maurice Parmelee claims that Lombroso "led in the great movement towards the application of the positive, inductive methods of modern science to the problem of crime" and that he "stimulated, more than any other man, the development of the new science of criminology."[26] Prior to Lombroso, and under the direction of the Italian criminologist Cesare Beccaria, the classical school of criminology reacted against the then overarching discretionary power of the judge in cases of criminal justice. Beccaria's 1764 text *Dei delitti e delle pene* (On Crimes and Punishments) outlined the classical school's beliefs, calling for the equal treatment of all under the law and arguing that punishments should be matched to the crime committed.

Whereas the classical school emphasized the universal application of the law, Lombroso, with his contemporaries Enrico Ferri and Raffaele Garofalo, detailed a system in which punishment was based more on the individual character of the offender than on the specific crime committed. Lombroso called it a shift in focus from the study of crime to the study of the criminal body.[27] Under the leadership of Lombroso, these three formed the Italian school of criminology, also called the modern, positivist, or anthropological school, and sought to identify a distinct anthropological criminal type.[28] Crucially, through outlining different types of criminal behavior, this group also argued that it was possible to reform certain types of offenders. Under the classical school, criminals were incarcerated for a definite and predetermined period of time. Under the modern school, criminals were often given an indefinite sentence, based on their specific anthropological type and their potential for treatment or reform (which was based on body type).

The central text to emerge from the Italian school was Lombroso's *L'uomo delinquente* (*Criminal Man*), first published in 1876. Here Lombroso outlined his theory of criminality, defining his notion of the "born criminal" and arguing that criminal behavior was essentially atavistic. Crime was something that certain bodies were predisposed to; social influence was almost exclusively denied. Leonard Savitz summarizes Lombroso's born criminal, noting that "physically, emotionally and behaviourally, he was very similar to primitive races and to children, all of whom were hedonistic, non-intellectual, curious, cruel and cowardly."[29]

This idea met with considerable criticism, particularly from the competing French school of criminal anthropology lead by Gabriel Tarde and Alexandre Lacassagne, which placed significant emphasis on the social causes of crime. Over the next several years, Lombroso altered his theory to allow for greater social influence in criminal behavior.[30] By the time *Crime: Its Causes and Remedies* was published (originally published in Paris in 1899 and translated into English by 1911), Lombroso had constructed an elaborate theory taking account of various "types" of criminality. In addition to the born criminal, he defined the passionate, political, accidental, and occasional criminals, often with several subcategories to each. Remaining true to the original positivist goal, he linked punishment, or treatment, to the type of criminal rather than to the crime committed.

What emerged from Lombroso's work was a conceptual distribution of criminality remarkably similar to Quetelet's *l'homme moyen*. To the left was the born criminal, a habitual offender who was biologically predisposed to crime. In opposition to this, the accidental or occasional criminal was an otherwise "normal" citizen who, in a random and isolated moment, committed a criminal act. The born criminal was beyond reform. He existed in a repressed state, parallel to that of children, savages, and animals. The potential for reform increased as one moved further away from this pole. Nicole Hahn Rafter describes the hierarchical order with its inherent discrimination against certain types of bodies:

> At the bottom of the scale is the born criminal, rough in appearance and manners, a foreigner or Negro . . . , uneducated, of poor background, a drinker. At the top stands . . . [the] gentlemanly normal offender, anomaly free, a product of not heredity but environment, intelligent and skilled, conscience stricken and reformable.[31]

Rafter's reference in the above passage to the "anomaly free" offender is important. In reacting to the classical school of criminology, Lombroso did not only establish a new pseudoscientific method in the study of criminal behavior; he also established a new kind of criminal. With Lombroso's positivist, inductive method, criminal behavior could be traced to, and read from, the body. In Lombroso's theory, the number of "signs" of criminality (tattoos, cranial and bodily anomalies, and other distinguishing physical marks) was directly related to the severity of the case. In other words, those criminals who displayed several and obvious signs of criminality were likely to be biologically predisposed to crime (the born criminal), were likely to be habitual offenders, and were less amenable to reform. Conversely, those subjects who displayed few or no signs were increasingly less likely to exhibit criminal behavior and had the highest potential for reform. Criminal behavior was reduced to a simple, positivist correlation between physical, bodily "signs" and the propensity to commit crime. Within this scheme, the scarred and tattooed body of Anton Otto Krauser, depicted in Figure 5, represented a body more prone to recidivism and less likely to be reformed than that of the alcoholic, depicted in the same figure, whose body displayed comparatively few physical anomalies.

Like phrenologists and physiognomists, criminal anthropologists derived their data directly from individual bodies. Physical, bodily anomalies were taken as proof of criminal disposition. Commenting on Lombroso's work, Rafter notes that "nature had made the investigator's task relatively simple: To detect born criminals, one needed only the appropriate apparatus."[32] Developing and employing the "appropriate apparatus" became a central part of Lombroso's work. He borrowed, altered, and used an array of instruments in measuring the "signs" of criminality. To measure the level of affection in subjects (whether or not they had feelings toward others), he tested their blood pressure, using the plethysmograph and the hydrosphygmograph invented by Francis Frank. The phonograph would measure speech patterns, and Thomas Edison's electric pen could be used for handwriting analysis. Anfonsi's tachyanthropometer and craniograph could measure the subject's height and arm length and the form and capacity of the skull. Tactile sensibility was measured with Weber's esthesiometer. Du Bois-Reymond's algometer measured general sensibility and sensitivity to pain, and Nothnagel's thermo-esthesiometer measured sensibility to temperature. Vision

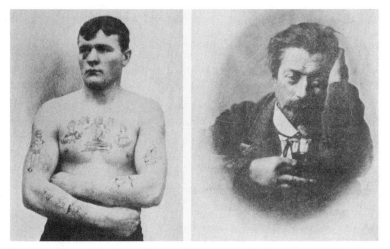

Figure 5. The visibly deviant body as illustrated in Lombroso's work: "Anton Otto Krauser, Apache" *(left)* and "Italian Criminal, a Case of Alcoholism." From Gina Lombroso-Ferrero, *Criminal Man: According to the Classification of Cesare Lombroso* (New York: G. P. Putnam's Sons, 1911), 236, 82.

was tested by using Landolt's apparatus. Sense of smell was measured with Ottolenghi's osmometer, and strength, with the dynamometer.[33] Using these tools and others, Lombroso filled his texts with tables, charts, statistics, photographs, and drawings, all attesting to the criminal nature of the body (Figure 6).

David Horn suggests that Lombroso used images not only to substantiate his theories and research but also to make visible a more abstract social risk: dangerousness.[34] What I want to stress is Lombroso's deployment of the image as inscription. Unlike the image of James White from Byrnes's rogues' gallery, which serves only to document White's identity as a criminal, the image of Anton Otto Krauser is a material object to be studied and interpreted. The identity of this particular body as Anton Otto Krauser is of secondary importance in comparison to the "signs" of deviance it displays. This is not to suggest that Lombroso only used photographs in the study of the body; the images in Figure 6 serve to represent certain procedures and tools. Nonetheless, many of the images used in Lombroso's texts are presented as texts in themselves rather than as supplemental documentation.

That Lombroso's "science" was problematic is clear. Like Quetelet's, Lombroso's work on the criminal was tied directly to evolutionary and,

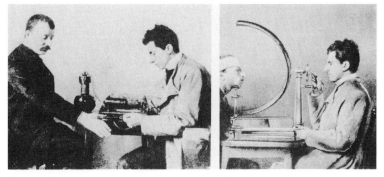

Figure 6. Two instruments used to measure the "signs" of criminality as illustrated in Lombroso's work: the algometer for measuring sensibility and sensitivity to pain and the campimeter for measuring field of vision. From Gina Lombroso-Ferrero, *Criminal Man: According to the Classification of Cesare Lombroso* (New York: G. P. Putnam's Sons, 1911), 248.

later, eugenicist practices that privileged certain types of bodies. The born criminal had parallels to "savages" and "lower races" and was clearly bound to racial hierarchies.[35] The female was continually defined as a threat or benefit to society in terms of procreation.[36] Her existence as prostitute was so heinous as to draw comparison to the male born criminal.[37] Throughout his work, Lombroso continually defined the deviant body in opposition to its white, European male counterpart.

A chief result of the work of Lombroso and contemporary criminologists was to provide a scientific basis for existing theories on society and social structure. Using the statistical methods of Quetelet and the theories of physiognomy and phrenology, Lombroso wrote criminality onto the body. Commenting on Lombroso's methodology, Rafter notes that his criteria at first seem "putatively derived from biology" but that they "are in fact derived from social class and then attributed back to biology."[38] This is nowhere more clear than in Lombroso's treatment of the female criminal.

As its title suggests, Lombroso's *L'uomo delinquente* was concerned exclusively with the study of male criminality. Lombroso also produced work extensively on the female criminal, culminating in his 1895 *La donna delinquentz (The Female Offender)*, coauthored with William Ferrero.[39] In this text, Lombroso again turns to detailed written accounts of physical bodies and to photographs, such as those in Figure 7, as the material sources for his theoretical endeavors. The basis for this text

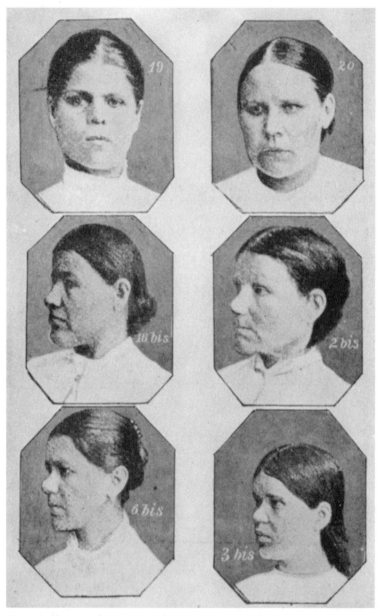

Figure 7. Photographs depicting the physiognomy of Russian criminals used by Lombroso in his study of female criminality. From Cesare Lombroso and William Ferrero, *The Female Offender*, ed. W. Douglas Morrison, The Criminology Series (New York: D. Appleton, 1895), plate 1.

was a study of twenty-six skulls and five skeletons from prostitutes and case studies of seventy-seven criminals who died at prisons in Turin and in Rome. The text relies heavily on inscription. It is filled with charts, diagrams, statistics, and photographs, amalgamated into case studies detailing the physical anomalies of female criminal subjects.

Lombroso's reliance on the physical anomalies of the body proved problematic in his work on female criminality. His analyses of female skulls, skeletons, and bodies showed significantly less variance than was present in the bodies of male criminals. In response to this, Lombroso reformulated his theories on criminality, claiming that diversity among species was an asset (even in the form of physical anomalies), thus reinforcing the primacy of the male body. Horn explains, "The relative rarity of signs of degeneration on the female body, which had seemed potentially a sign of women's superiority, could now be linked to a lesser degree of variability, itself a sign of inferiority and weakness."[40]

In both *The Female Offender* and *Crime: Its Causes and Remedies*, the female criminal is continually described in a way that positions her as inferior to her male counterpart. Females neither match the savagery or animalistic nature of the male born criminal (with the exceptional case of the prostitute), nor are they capable of the more intellectual and strategic crimes of the male accidental criminal. In other words, female criminality falls at the median of the classificatory and reformative curve. By using the same statistical and pseudoscientific method of *L'uomo delinquente*, Lombroso defined the female criminal, and with it the female body, as ineffectual.

Whether studying the male or the female body, Lombroso relied on the body itself for his data. As the quotation from Rafter above suggests, these visual "signs" were often read, or discovered, in support of existing social hierarchies. The result was a new conception of the criminal subject. As nonwhite, non-Western, sexually deviant, and animalistic, his or her criminality was readily apparent on the skin. This new, visibly criminal body, and Lombroso's reverse, biologizing method, is summarized in what Lombroso describes as a pivotal case in his work. After being called to perform an autopsy on the Italian criminal Vilella, Lombroso opens the skull and finds

> the problem of the nature of the criminal—an atavistic being who reproduces in his person the ferocious instincts of primitive humanity and the inferior animals. Thus were explained anatomically the

enormous jaws, high cheek-bones, prominent superciliary arches, soli-
tary lines in the palms, extreme size of the orbits, handle-shaped or
sessile ears found in criminals, savages, and apes, insensibility to pain,
extremely acute sight, tattooing, excessive idleness, love of orgies, and
the irresistible craving for evil for its own sake, the desire not only to
extinguish life in the victim, but to mutilate the corpse, tear its flesh,
and drink its blood.[41]

In his examination of Vilella, Lombroso literally "finds" a clear link be-
tween physical attributes and deviant behavior. Thus, "high cheek-
bones," "solitary lines in the palms," and "tattooing" are taken as direct
indicators of a body that has a love of orgies and a craving for evil that
manifests itself in the mutilation and consumption of bodies.

The intersection of Lombroso's conception of the visibly deviant
body and the use of the camera to document and study that body finds
its most extreme application in the work of Francis Galton. Galton
continually worked on and tested various theories of evolution but is
most famous for his work on eugenics. He defined and introduced this
topic in his 1883 *Inquiries into Human Faculty and Its Development*.[42] In
the introduction to the text, he summarizes his project:

> My general object has been to take note of the varied hereditary facul-
> ties of different men, and of the great differences in different families
> and races, to learn how far history may have shown the practicability of
> supplanting inefficient human stock by better strains, and to consider
> whether it might not be our duty to do so by such efforts as may be
> reasonable.[43]

Like Lombroso, Galton treated the body as a series of signs to be exam-
ined and interpreted. To this end, he traced heredity through the visible
signs of the body. By producing composite images of faces and bodies, he
made general pronouncements on race, gender, sexuality, and criminal-
ity, ultimately suggesting that society could rid itself of its lowest forms
through the eugenic practice of controlled breeding.

The composite images (such as those illustrated in Figure 8) are made
of multiple exposures on a single frame of film. Galton's first composites
were made from photographs he received from Pentonville and Mill-
bank prisons. Sir Edmund Du Cane, then H.M. inspector of prisons,
asked Galton to examine the photos and see whether he could identify
features specific to certain types of criminality.[44] Galton divided the
photos into three classes: those of people convicted of murder and

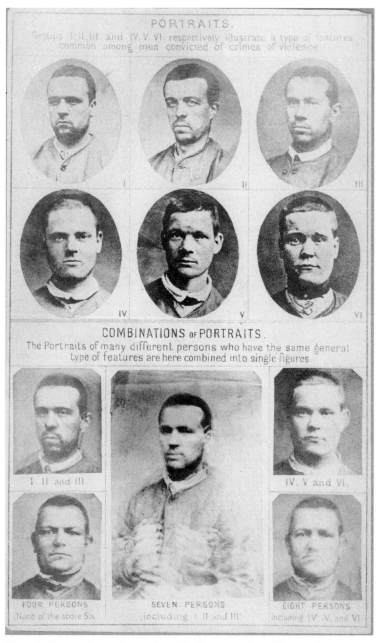

Figure 8. Composite images produced by Francis Galton. The combination of images of individual violent criminals was taken to illustrate the types of features common to all violent criminals. Courtesy of the Galton Papers, University College London Library Services, Special Collections.

manslaughter, those of people convicted of felonies, and those of people convicted of sexual offenses.[45] Galton then took composite photos of the individual classes by dividing the total exposure length by the number of cases. If an exposure was to last ten seconds and ten criminals were to be photographed, then each criminal would receive one-tenth of the total exposure, or one second. As Galton defined it, the rationale behind the process was

> to bring into evidence all the traits in which there is agreement, and to leave but a ghost of a trace of individual peculiarities. There are so many traits in common in all faces that the composite picture when made from many components is far from being a blur; it has altogether the look of an ideal composition.[46]

Thus, according to Galton's theory, composite images like those shown in Figure 8 reveal the common physiological features of criminals. The idiosyncratic features of each sitter's face are lost in the exposure, and only the features common to all violent criminals remain.

The spatial arrangement and combination of images presented in Figure 8 show Galton's interest in studying heredity and suggest the influence of Mendelian genetics, which developed in the years prior to Galton's work. As the images were part of studies of heredity, Galton produced composites of both "good" and "bad" stock. He created composites of Alexander the Great (using coins depicting him), sisters, brothers, families (across sexes), horses (to show the heredity of successful racehorses), criminals (divided according to crime), persons suffering from consumptive disorders, Westminster schoolboys, lunatics, members of the Royal Engineers, members of the Jewish race, and others. Under Galton's theory of eugenics, with its link to inheritance, any and all bodies were subject to composite portraits. In the case of Alexander the Great, the composite was created to show the apex of humankind; this was then contrasted with other composites to show those groups that might be avoided through controlled breeding.

Galton's composite images stand at the extreme of nineteenth-century scientific and social scientific activity that sought to identify and understand the body through its visual representation. His composites were used by Lombroso for illustration in the 1895 French and 1896–1897 Italian editions of *Criminal Man*.[47] They were also used for the cover of the 1890 text *The Criminal*, written by a follower of Lombroso's, Have-

lock Ellis.[48] Galton's composites can be seen as a photographic manifestation of Quetelet's statistical distribution and Lombroso's theory on crime. Large numbers of bodies were quickly reduced to aggregate "types" that represented entire populations. Crime and criminality, with all its idiosyncracies, could be discerned through the careful production and interpretation of inscriptions.

Anthropometry Mobilizes the Photograph

While Galton's work with photography did not find significant practical application, the work of Alphonse Bertillon, a contemporary of Galton, was adopted by the law enforcement community. As noted earlier in this chapter, the tremendous economy of photomechanical reproduction gave rise to extensive photographic archives within law enforcement agencies. Thomas Byrnes's attempt to enlist the public in practices of identification points to the limitations of these vast compilations of images. A solution to the problem of rogues' galleries was developed in the work of Alphonse Bertillon.[49] Bertillon mobilized the mug shot into a system of classification, which enabled police to more effectively store and exchange criminal records.

After taking a job with the Paris Prefecture of Police in 1879, Bertillon recognized that the central problem plaguing the department's identification practices was the vast number of photographs in its collection. More specifically, the department had accumulated a tremendous number of images but lacked any real way to utilize them. To alleviate this problem, Bertillon developed his "signaletic" system of identification.[50] Bertillon's system involved recording specific identification data onto a standardized form. Law enforcement officers would first record eleven detailed anthropometric measurements: height, head length, head breadth, arm span, sitting height, left middle finger length, left little finger length, left foot length, left forearm length, right ear length, and cheek width. Figure 9 from the Paris Prefecture of Police, circa 1900, demonstrates the procedure for taking the anthropometric measurement of the ear. The image draws immediate parallels to the numerous bodily measurements illustrated in Lombroso's texts.

The eleven anthropometric measurements were supplemented with a physical description of the body, particularly the features of the face

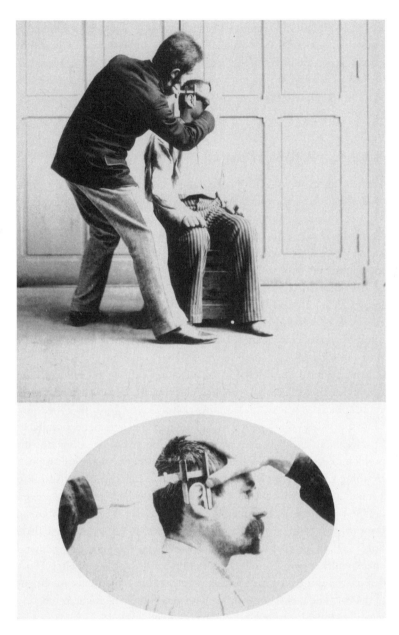

Figure 9. Images depicting the procedure for taking the anthropometric measurement of the ear. Courtesy of Prefecture of Police, Paris; all rights reserved.

Figure 10. A complete Bertillon identification card for Lucy Schramm, showing the combination of full-face and profile photographs on one side of the card with anthropometric measurements and physical description on the reverse. Courtesy of New York City Municipal Archives.

and head. For this task, Bertillon devised a shorthand language describing the body in tremendous detail. The final aspect of Bertillon's signaletic system was the recording of one full-face and one profile photograph. The resultant identification card, or *portrait parlé*, was a comprehensive data sheet detailing the criminal subject. Figure 10 shows a typical

Bertillon identification card. Full-face and profile photographs of Lucy Schramm, arrested by the New York City Police Department in 1908, are combined with anthropometric measurements and physical description to form a complete identification record.

Like his predecessors, Bertillon employed the photograph as both representation and inscription. The full-face and profile photographs on the identification card functioned as visual evidence of the body identified through the detailed anthropometric measurements and information contained on the card. However, Bertillon also used the camera to isolate, make visible, and study the various "signs" of the body. Like Lombroso, Bertillon believed in the ability to read identification information directly from the physical body. To this end, he isolated and studied the various features of the face and head, ultimately producing a synoptic table of "typical" facial features, shown in Figure 11. This table was to be used as a reference chart for practitioners of Bertillon's method. The shorthand code for a particular facial feature was derived by comparison with the images in Bertillon's table.

Through the systematic application of anthropometric measurements and detailed physical descriptions (using the shorthand language and synoptic table devised by Bertillon), the body could be translated into a series of words and numbers and could be classified according to its visible signs. Bertillon identification cards were classified by subdividing them according to the eleven anthropometric measurements. Each of these was further subdivided into "small," "medium," and "large." The resulting categories of cards were divided by eye color and were finally filed according to ear length.[51] Searches of the filing system followed the same procedure, eliminating categories of cards until a matching identification card was found.

Bertillon's work mobilized the vast photographic images in police archives into a larger communications network. Using Bertillon's classificatory system, one could reduce any body to a series of standardized measurements and codes. This was advantageous for police, who were facing increasing crime rates and increasingly mobile criminals. Combined with the textual data on the identification card, the image could be indexed, sorted, accessed, and exchanged within and between law enforcement agencies. Lombroso applauded Bertillon's system, drawing attention to anthropometry's scientific status. In *Crime: Its Causes and Remedies*, he writes:

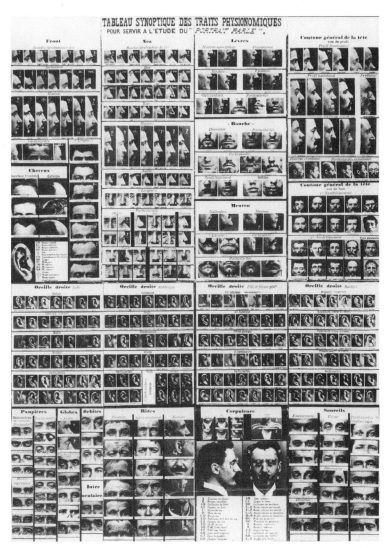

Figure 11. Bertillon's "Synoptic Table of Facial Features." The images served as data for the production and interpretation of identification cards. Courtesy of Prefecture of Police, Paris;

If a good police commissary in Italy wants to put his hand upon the
unknown author of some crime, he has recourse to his memory, to
photographs, and also to the clumsy criminal register instituted a few
years ago. But in a kingdom as large as Italy, with such rapid means of
communication, thousands of individuals escape observation. The best
memory would be not much help. Delinquents easily succeed in eluding
the police by changing their names, or, if arrested, give them a false idea
of their antecedents by taking the name of some respectable person. From
this one sees how necessary it is to have means of identifying accused
persons with scientific accuracy; and of all the systems proposed for this
purpose that of Bertillon is undoubtedly the best.[52]

Once officially accepted for use by the Paris police in 1883, Bertillon's
signaletic system was quickly adopted across Europe, Canada, and the
United States. Despite its initial promise, and as will be discussed in
chapter 2, Bertillon's system was not entirely successful, and finger-
printing would eventually replace it as the dominant mode of criminal
identification. Nonetheless, Bertillon's work had an important practical
impact on law enforcement and criminal identification practices. By stan-
dardizing the identification process, Bertillon extended the capabilities
of police to effectively store and use criminal identification information.

Conclusion

Throughout law enforcement and criminal identification practices of
the nineteenth century, the individual, physical body of the criminal
was increasingly replaced by its representation and inscription in the
form of text, curves, charts, and photographs. Police seized on the benefits
of photomechanical reproduction to transform the body, with all its com-
plex idiosyncrasies, into two-dimensional documents, which were con-
siderably easier to manage. However, as the resultant rogues' galleries
grew, the utility of these representations decreased. Bertillon's classifi-
catory system mobilized the photographic representation of the crimi-
nal into a comprehensive records-keeping and communications system
that enabled the sharing of identifying material within and between
police forces.

The ability to be represented, visually and graphically, is a defining
feature of the modern criminal subject. Photographs function both as
representation and as inscription. In the former, as a tool of representa-
tion, photography was fundamental to law enforcement practices of

the nineteenth century. It reduced live bodies to a standardized, two-dimensional document, a material representation to be combined, analyzed, and exchanged in a network of similar representations. In the latter, the photograph as inscription gave rise to new forms of knowledge regarding crime and criminality. Galton, Lombroso, and Bertillon all found criminality on the body. The use of the photograph as inscription in their work, which was meant to document what were believed to be the signs of criminality, in fact helped produce the very subject of study. This process is exemplified in the Bertillon identification card. Bertillon used the photograph as a document, as a supplemental record to the anthropometric measurements that were taken to guarantee identity. However, these same bodily measurements, and the theory of anthropometry from which they were derived and which they served, were dependent on the use of the camera as an inscription device. The shorthand textual codes of the identification card were the result of detailed studies of the body, for which the camera was an essential tool. The immediate function of the Bertillon identification card was to represent an individual criminal body. However, seen with the benefit of historical distance, the card also represents the confluence of scientific and social scientific activity—including phrenology, physiognomy, social statistics, and criminal anthropology—which participated in the development of a new criminal subject.

A central effect of photography's use in law enforcement and criminal identification practices of the nineteenth century was to bring more bodies under police and state surveillance through their representation and inclusion in the police file or, in Sekula's term, the archive. To be photographed was to be recorded as a subject of the state. This function of the image is effectively captured in the title of Tagg's text *The Burden of Representation*. But photography's influence on law enforcement and criminal identification practices was not simply quantitative; it was also qualitative. The full significance of photography's impact on police practices and its role in a Foucauldian micro-physics of power is found in its complementary functions as representation and inscription. As a representational device, the camera effectively extended the disciplinary mechanism manifest in Bentham's Panopticon: it isolated and made visible bodies as they moved through the social and institutional spaces of the carceral network. As an inscription device, the camera facilitated the production of new forms of disciplinary knowledge, which, in turn,

helped describe the types of subjects that were to be made visible. True to Foucault's description, the exercise of power through law enforcement practices enabled the production of new forms of knowledge by providing subjects for Quetelet, Lombroso, Galton, Bertillon, and others. The knowledge accrued through the detailed studies of the body facilitated the further exercise of power through law enforcement practices.

The accumulation and use of identification data in law enforcement practices reflect socially constructed categories of what constitutes criminality. By the end of the nineteenth century, criminality was bound to the physical body and, as the work of Galton and Lombroso clearly illustrates, certain types of bodies were believed to be more prone to deviance. The criminal body was defined in terms that reflected racial and gender biases and that supported existing social theories and hierarchies. This knowledge in turn influenced further law enforcement and criminal identification practices. In this way, the production and exercise of power and knowledge through law enforcement and criminal identification practices reinforced the normalcy of the white male body, simultaneously stigmatizing the bodies of multiple "others" as anomalous and, therefore, deviant.

It is difficult to overstate the importance of photography to police in the development of advanced communications and records-keeping systems. Bertillon is rightly famous for his efforts in this regard. Nonetheless, and despite the tremendous capabilities afforded by photography, law enforcement and criminal identification practices remained largely confined by the physicality of the body. The taking of anthropometric measurements required the presence of the criminal's body. As will be shown in chapter 2, the unique intersections of photography and fingerprint identification announced distinctly new capabilities for police. The ability to photograph fingerprints enabled the collection of aggregates of identification data from known and unknown bodies alike.

2

Photographing Fingerprints:
Data, Evidence, and Latent Identification

Speaking at the 1926 International Association of Chiefs of Police convention, J. Edgar Hoover, then the newly appointed director of the Federal Bureau of Investigation (FBI), announced that the Identification Division had passed the million mark in its collection of fingerprint records.[1] During fiscal year 2001, the bureau received 15.4 million fingerprint submissions.[2] By the close of the twentieth century, the FBI was receiving approximately fifty thousand fingerprint records a day. Half of those related to criminal investigation and half to civilian use, such as background checks for employment purposes.[3] The collection of personal information on such a vast scale raises distinct concerns regarding the control and use of this information and regarding the role of law enforcement in public life.

These issues have taken on tremendous importance following the events of September 11, 2001. Now, within the United States and under the guise of a war on terror, previously disparate law enforcement databases and information networks are being combined into a centralized resource of identification information. Mobilized by discourses centered on notions of fear and national threat, these heightened communication and identification capabilities are being employed in overtly discriminatory practices, including racial profiling and the mandatory fingerprinting

and photographing of visitors to the country from nations deemed a national threat. The collection, interpretation, and control of personal information are fundamental to this effort and to its construction of individual and national identities. These practices originated in the development of fingerprinting during the turn of the nineteenth and twentieth centuries.

"Bertillonage"—the system of criminal identification developed by Alphonse Bertillon at the close of the nineteenth century—was a necessary response to increasing populations in urban areas and to increasing crime rates. The goal of Bertillon's work in Paris was to make a vast photographic archive useful to police for identification. The resultant reduction of bodies and their histories into identification cards enabled police to keep track of growing numbers of crimes and criminals. This is a central point of Allan Sekula's analysis of the nineteenth-century visual archive: that the defining feature of criminal identification at the close of that century was the filing cabinet, and not the photograph.[4]

Bertillonage remained in use well into the 1920s; however, by the close of the nineteenth century, it was continually being called into question.[5] As the use of Bertillonage increased, two central problems emerged. First, Bertillonage was time-intensive: significant time was needed to produce and search identification cards, and the system could not keep pace with the increasing needs of law enforcement. Second, Bertillonage was prone to discrepancies between individual practitioners. The system depended on exact measurements obtained through the universal application of procedures, apparatuses, and Bertillon's specialized language. As more agencies and individuals practiced Bertillonage, greater discrepancies arose.

Dr. Henry Faulds and Sir William Herschel introduced fingerprinting as a method of identification during the 1870s and 1880s. From its outset, fingerprinting appeared to avert the problems of Bertillonage. It was faster in both the collection and the retrieval of information, and it removed much of the human element responsible for discrepancies in application. Highlighting the advantages of fingerprinting over Bertillonage, most histories dealing with criminal identification describe it as a natural extension or expansion of the ideas behind Bertillonage, describing the technique as a more accurate and efficient means of classifying and identifying criminals.[6] By contrast, in this chapter I want to stress

the significant changes fingerprinting introduced into identification practices. Fingerprinting, I argue, announced new concerns regarding the role and level of law enforcement in public life and in pervasive state surveillance. More specifically, fingerprinting raised questions about the ethics and ramifications of law enforcement practices based on the collection, control, and use of personal information, issues at the forefront of law enforcement and criminal identification practices in the twenty-first century.

The photograph is central in fingerprint identification. The camera is present from the crime scene to the courtroom. It is a central means through which prints are collected, examined, identified, and shared. The individual, physical print holds little value in comparison to its photographic representation, which can traverse physical barriers and can be at work in any number of locations and contexts simultaneously. The collaboration between the theory of fingerprint identification and photographic technology produced coherent, unified, and highly effective inscriptions that were both immutable and mobile. This unique collaboration marked an essential transformation in law enforcement and criminal identification practices.

Fingerprints as Inscriptions

As a method of identification, fingerprinting is usually attributed to the work of Dr. Henry Faulds and Sir William Herschel.[7] In the late 1870s, Faulds, then a physician at Tsukiji Hospital in Japan, was asked to examine finger impressions left in ancient Japanese pottery. This project inspired him to collect and study the prints of humans from various nationalities in the hopes of finding racial or familial similarities. Faulds outlined his work in an 1880 article in *Nature:* "On the Skin-Furrows of the Hand."[8] He noted that his attempts to trace heredity through the examination of fingerprints were inconclusive but that fingerprinting presented several other potential uses. Chief among these was the ability to identify criminals. In the article, Faulds writes: "When bloody finger-marks or impressions on clay, glass, &c., exist, they may lead to the scientific identification of criminals." He then refers to two cases in which he was able to use fingerprinting successfully to aid in criminal investigations and concludes, "There can be no doubt as to

the advantage of having, besides their photographs, a nature-copy of the for-ever-unchangeable finger-forms of important criminals."[9]

William Herschel, an employee for the British East India Company, made a subsequent contribution to *Nature:* "Skin Furrows of the Hand."[10] Herschel's work on fingerprints began in the 1850s when he was working in Bengal and used fingerprints in place of written signatures on contracts. Like Faulds, Herschel tried to trace heredity through fingerprints but was also unsuccessful:

> My inspection of several thousands has not led me to think that it will ever be practically safe to say of any single person's signature [fingerprint] that it is a woman's or a Hindoo's, or not a male European's. . . . In single families I find myself the widest varieties.[11]

Like Faulds, Herschel saw the potential uses of fingerprints in criminal justice practices, proposing that prisoners entering jail be fingerprinted for identification. Despite their differences, Faulds, Herschel, and other early investigators approached fingerprints similarly in that they investigated them as unique identifiers.[12] The central concern of this work was to prove that no two fingerprints could ever be the same.

As described by Faulds and Herschel, fingerprinting was prone to the problems facing other modes of identification. As an inscription, as a piece of data, the fingerprint's value lay in its potential to participate in a larger system of criminal identification. Fingerprints had to be classified, and those classifications had to be organized. Contemporaries of Faulds and Herschel sought ways to mobilize the fingerprint and transform it into the basis for a complete system of identification. The work of Francis Galton and Dr. Juan Vucetich was of significant importance in this regard. Galton took up Faulds's work through the prompting of his cousin, Charles Darwin, ultimately seeking evidence of heredity through the examination of fingerprints. A necessary corollary to his scientific investigations was the construction of a system for ordering and classifying his data. Although unsuccessful in his quest to prove heredity through fingerprints, Galton did produce essays and a detailed text on the topic, in which he described a system to classify prints.[13] A year prior to the publication of Galton's 1892 text *Finger Prints,* Dr. Juan Vucetich established the Identification Bureau in Argentina and developed a system for classifying fingerprints into a large, workable file. Vucetich's system was employed throughout Latin America. Simon Cole calls

Vucetich's "the first classification system which rendered finger prints a practical means of indexing a large criminal identification file."[14]

The work of Sir Edward Henry and his assistant Azizul Haque marked a key transformation in fingerprint identification. Like Herschel, Henry worked under colonialist governments in India. Henry devoted specific attention to creating a detailed system for collecting, sorting, and searching fingerprints. He divided fingerprints into four basic types: arches, loops, whorls, and composites. These types were further sub-divided according to distinction in the ridge characteristics of the print.[15] Using these categories, Henry devised a complete classificatory scheme. His 1900 text, *Classification and Uses of Finger Prints*, quickly became the central text on the topic.[16] The resultant "Henry system" remains at the foundation of current fingerprinting practices.

Henry's system provided a means for identifying, classifying, filing, and searching fingerprints. This enabled law enforcement agencies to collect fingerprint files against which they could potentially identify individuals brought into police custody. Under Henry's system, finger-prints were analyzed according to four classificatory divisions.[17] The first division, the primary classification, was based on the impressions of the ten fingers of the suspect or criminal. The prints were assigned num-bers based on the presence of specific features, such as loops, whorls, and arches. The specific sequence of numbers representing the ten prints of the fingers was expressed as a fraction and served as the file number for that particular fingerprint record. The second division, the subclassifica-tion, distinguished prints with the same primary classification through an analysis of the patterns of the index fingers. The third division, the second subclassification, divided prints having the same primary and subclassification according to the ridges of the index and middle fingers. The fourth division, the final classification, used the ridges of the little finger to separate prints having the same primary, subclassification, and second subclassification. Once reduced through these four stages, prints were filed in cabinets or in a pigeonhole system organized according to the classificatory scheme.

To check a suspect against the fingerprint file, his or her prints would be subjected to the same classification process. Once the suspect's prints were categorized through the four divisions, they would be compared against the records in the corresponding pigeonhole. In a 1920 fingerprint manual, James Holt compares the process to searching an encyclopedia:

The finger print file has been likened to an encyclopedia. In fact it is an encyclopedia of prints, the primary classification or first division is the index; the sub-classification or second division the page; the second sub-classification or third division the paragraph, the final classification or fourth division the line in the paragraph.[18]

Three years prior to the publication of Henry's *Classification and Uses of Finger Prints*, the British Home Office officially accepted finger-printing over Bertillonage in cases of identification.[19] Although finger-printing was taken up in various locations and contexts throughout the closing decades of the nineteenth century, it was not officially introduced to North America until the 1904 World's Fair in St. Louis, Missouri. Representing Scotland Yard at the fair, John K. Ferrier provided demonstrations of the technique to prominent law enforcement officials from Canada and the United States. After the close of the fair, Ferrier remained in St. Louis to teach the technique to interested persons.

During the closing years of the nineteenth century and the first decade of the twentieth, fingerprinting and anthropometry coexisted as methods of identification throughout western Europe and in North America. Law enforcement organizations experimented with both systems, often combining them. Bertillon eventually provided space on his identification cards for fingerprints. Faced with increasing crime rates and increasingly mobile criminals, law enforcement practices of the time were preoccupied with the need for large-scale information exchange. The situation was compounded in North America by the fragmentation of its police practices. As Donald Dilworth notes, policing in the United States developed sporadically and at the local level and was marked by competition among locales.[20] The same issue existed in Canada, although to a lesser degree, as the country had a significant federal-level police force.[21] These North American models were in contrast to the European one, which was centralized and more easily facilitated communication and cooperation.

Initially, identification cards were seen as a productive step toward developing communication among local police departments. Information was shared by departments through the mail in the form of "wanted" circulars. These circulars included offenders' photographs, Bertillon measurements, and histories. The effort was aided, in the early 1890s, by the *Detective*, a journal that published information on criminals in a manner reminiscent of the rogues' galleries.[22]

The need for communication among law enforcement organizations culminated in the formation of the International Chiefs of Police Union in 1893. Comprising law enforcement officers from across Canada and the United States, the union was renamed the International Association of Chiefs of Police (IACP) in 1902.[23] A primary goal of the association was to establish a centralized resource for housing and sharing information on criminals. This took form in the National Bureau of Criminal Identification, which opened in Chicago in 1897 and moved to Washington, D.C., in 1902. A staffed, centralized resource promised more effective distribution of identification information among police departments.

At its outset, the National Bureau promoted the use of Bertillonage for identification. It was hoped that through the use of a common language, Bertillonage, departments across Canada and the United States could share information on criminals. However, by the opening years of the twentieth century, police and law enforcement personnel were openly criticizing the Bertillon system's inefficiency and uneven application. At the 1903 International Association of Chiefs of Police convention, George M. Porteus, superintendent of the National Bureau of Criminal Identification, commented:

> The unreliability of photographs as well as the inability of most people to identify by this means is generally conceded. The time occupied in attempting an identification in this way makes it decidedly unsatisfactory, if not entirely impracticable.[24]

Proceedings of the International Association of Chiefs of Police conventions from the years surrounding the turn of the century attest to the general frustration with the Bertillon system.[25] Even if the National Bureau could facilitate better communication among departments, it could not guarantee the reliability of identification information, which still varied between practitioners. Through the association's conventions, law enforcement officers continually expressed interest in standardizing identification practices. A separate meeting of Bertillonage and fingerprint specialists took place at the 1914 convention and gave rise to the International Association for Criminal Identification in 1915, renamed the International Association for Identification in 1918.[26] The primary task of this group was to universalize identification procedures.

Allied with photography, fingerprinting produced identification information that was concise, compact, and readily transferable. The resultant

documents served the communications and records-keeping needs of law enforcement. This effort was aided by the development of fax technology, first demonstrated in 1902, and the ability to transmit photographs over radio, described in 1920.[27] The potential use of these communication technologies for criminal identification was immediately acknowledged. A 1922 *Scientific American* article, "Finger-Prints via Radio," described this benefit of the new technology:

> The latest obstacle thus placed in the path of the wrong-doer is the long arm of the radio, which not only serves to ensure rapid inter-communication of news and notes between the various police forces of the world, but also transmits photographs and finger-prints of the wrong-doer for the purposes of instantaneous and positive long-distance identification.[28]

Interestingly, it was not just law enforcement officials but also communications industry representatives who lauded the benefits of the new technique. At the 1925 International Association of Chiefs of Police convention, J. J. Carty, vice president of the American Telephone and Telegraph Company (AT&T), spoke on the benefits of the tele-photograph and the ability to transmit fingerprints over telephone lines.[29] The ability to send fingerprints over radio and telephone positioned fingerprinting within a large communications system, which not only increased the mobility of the fingerprint but also extended the reach of law enforcement through an increasingly international communications network.

The relative ease with which the fingerprint could be produced and shared assured the technique's prominent position within law enforcement. Centralized resources housing fingerprint files took form in the establishment of the Canadian Criminal Identification Bureau in 1911 and the Identification Division of the Federal Bureau of Investigation in 1924. In both cases, fingerprint records and other identification information were amalgamated into national archives. During this same period, the technique's weight as a legal and evidentiary document was being established in founding court cases.[30] By the 1930s, fingerprinting served as the basis for a complete system of identification within the Western world, national bureaus were established that housed and shared fingerprint records, the technique had gained full acceptance within scientific and legal communities,[31] and developments in communication

technologies transformed criminal identification into an increasingly international practice.[32]

Simon Cole, Donald Dilworth, and others have addressed the transition from Bertillonage to fingerprinting in detail. Here, I stress that the success of fingerprinting is bound to its ability to function as an immutable and mobile inscription. Fingerprinting provided the information necessary for identification in a more condensed physical space than did Bertillonage. Further, in contrast to the complexity of Bertillon's photographic, textual, and numerical descriptors, fingerprints offered a single, visual statement. Most importantly, although fingerprints and Bertillonage measurements were both derived directly from the criminal body, fingerprints afforded a more direct representation of the biological body than did photographic portraits or anthropometric measurements. More than a representation, they were a literal, physical trace or index of the criminal.

The semiotician Charles Sanders Peirce uses the term "index" for a sign that has a "real connection" to the object it represents.[33] This is in contrast to "iconic" signs, which are likenesses of the objects they represent, and "symbolic" signs, which refer to abstract concepts and have no natural connection to the objects they represent. While Peirce's three types of signs are not mutually exclusive, indexical signs are unique in their real connection with the objects they represent. Peirce positioned the photograph as an indexical sign. In Peirce's taxonomy, the photomechanical process guarantees both that the image is accurate and that the image and its subject coexisted in space and time, thus fostering a real connection between sign and referent. The fingerprint is also an indexical sign; however, unlike the photograph, which is mediated through the process of photomechanical reproduction, the fingerprint serves as an unmediated, literal trace of the body. As such, the fingerprint has an evidentiary weight and power beyond other forms of representation such as the mug shot or Bertillon measurements. The fingerprint is unique in its literal and unmediated connection to the body. In an early history of fingerprint identification, George W. Wilton highlights the unique authority of the fingerprint, noting: "While photographic prints or slides and recorded voices are artificial, the evidence of finger-impressions is the natural inference of presence at some particular spot of the maker."[34]

While this "natural inference of presence" guaranteed the weight of fingerprint evidence as the direct manifestation of a criminal's body, the mechanically objective photograph transferred that presence between locales. As Lorraine Daston and Peter Galison have shown, physical, medical, and biological sciences of the nineteenth and early twentieth centuries relied on the mechanically objective camera to represent what was accepted as the inherent truth of the natural world.[35] This combination of mechanical objectivity and the "natural inference of presence" of a body constructed the fingerprint as a particularly effective inscription. The compact visual space of the fingerprint could be reproduced and transferred between locations and contexts indefinitely, each time reasserting the supposed natural presence of the criminal's body. I now turn to this chapter's main argument: that the unique collaboration of fingerprint identification and photography signaled a distinct transformation in law enforcement and criminal identification practices.

Photographing Fingerprints

Fingerprint identification emerged within the confluence of activity discussed in chapter 1. Like other scientific and social scientific practices of the time, fingerprinting benefited from the rapid developments in photomechanical reproduction. As an individual, physical object, the fingerprint is of little value. Its weight as an evidentiary statement depends on its ability to stand as a reference to an individual body from the crime scene to the courtroom. This is achieved through its mobilization in the photograph.

Crucially, in accounts of fingerprinting, both historical and critical, the fingerprint and its photograph are rarely differentiated in any substantive way. As a result, what is routinely referred to as "the fingerprint" is, more accurately, its photograph. This is nowhere more clear than in the fingerprint's use in court. Within the courtroom, "the fingerprint" is actually a fingerprint chart: a material representation that includes photographic enlargements of fingerprints and is produced specifically for display in court.

Differentiating between the fingerprint and its photographic representation is not to suggest that the latter is an inaccurate representation of the former. Rather, it is to stress the extent to which the latter func-

tions as an unacknowledged representation of the former. Fingerprint identification benefited from the communications capabilities associated with photomechanical reproduction. The photograph made the finger-print mobile. Importantly, the camera also rendered what was perceived as the "inherent value" of the fingerprint, its "natural inference of presence," immutable by positioning it within a discourse of mechanical objectivity.

Not only did the collaboration of the theory of fingerprinting and photography give rise to an accurate and economical means of identification, but it also signaled a distinct transformation in police practices. Like physiognomy, phrenology, and anthropometry before it, finger-printing yielded data that was derived directly from the physical body. However, unlike those earlier forms of identification, fingerprinting enabled the collection and use of a new type of data: that derived indirectly from the body, lifted from the live environment. Prints could be collected, analyzed, and identified independently of the physical presence and knowledge of the body, giving rise to practices of latent identification.

The camera's role in this new system of identification was paramount. Prints could be collected from the live environment by being photographed. The procedure and promise of this new method of identification were described by Superintendent Arthur Hare at the 1904 International Association of Chiefs of Police convention:

> In cases of murder, the marks left by the blood stained fingers have been photographed and compared with the finger prints of the habitual criminal on file in the bureau, and by reason of the simple classification, is sometimes identified and the crime brought home to an individual who would never have been suspected but for the clue which nature has provided.[36]

Superintendent Hare's comment references the mobilization of the camera to link the direct and indirect presence of the criminal. The criminal's presence at the crime scene, via the "blood stained fingers," is tied to his presence in the bureau's file by the deployment of the photograph. The criminal exists in both locations independently and is only known through the use of the camera.

I am not suggesting that all fingerprints were or are collected and examined through the use of photography. Fingerprints are also collected

directly from the bodies of persons in police custody and also from surfaces through the process of dusting and lifting (a copy is taken by applying adhesive tape or a similar material to the dusted print and "lifting" it off the surface). Nonetheless, the specific importance of photography in fingerprint identification must not be underestimated. The ability to photograph fingerprints gave rise to criminal identification practices that were distinct from earlier practices in three ways: first, the camera enabled the collection of identification information in a subtle and nonphysical way; second, the resultant images could be examined and reexamined infinitely and independently of the physical body; third, this entire process could be performed without the suspect's knowledge.

The unique capabilities afforded to law enforcement through photography were not limited to fingerprinting. For example, during the opening years of the twentieth century, F. H. DePue of the San Francisco Police Department proposed the use of the camera in a more subtle and covert application of Bertillonage. DePue's system worked by comparing photographic projections of suspected and wanted persons. The enlarged, projected images were dissected into a grid, and anthropometric measurements were taken and compared. DePue's system was unique in the way he promoted the use of the camera:

> By the DePue system you can take a flash photo anywhere of your suspected party, do your own measuring at your own sweet pleasure in the secrecy of your office, without your subject having the slightest knowledge of what is going on.[37]

While his efforts were ultimately rejected, DePue's work provides a clear illustration of the new features that photography afforded law enforcement and that were ultimately manifest in photographing fingerprints.

With physiognomy, phrenology, and anthropometry, measurements were taken from a body that was physically present and often already known as normal or deviant. In contrast, fingerprinting gave rise to the production and accumulation of data on unknown bodies. Fingerprints were devoid of the "obvious" bodily connotations of race, gender, and class and of the various "signs" of criminality or deviance that served as the data for prior methods of identification. Faulds, Herschel, and Galton had all concluded that fingerprints did not reveal themselves as belonging to any specific type of body. In this way, fingerprints collected from

crime scenes were collected only with the potential of identification, not because they displayed any signs of criminality.

The results of this shift in identification practices were significant. The camera transported data from the complexity of the ever-changing live environment to the controlled setting of the police laboratory. This, in turn, increased the importance of the act of interpreting, or reading, images and, ultimately, led to the construction of a distinct, professional group of fingerprint examiners.[38] Identification was no longer the purview of entire departments (or the general public, as had been Thomas Byrnes's hope) but was now the domain of a specialized group of trained and certified fingerprint examiners, whose task was to transform data into evidence. The search for criminality shifted from application (as in the application of instruments to the criminal's body) to interpretation (as in the interpretation of the fingerprint).

The development of the halftone process and celluloid roll film gave rise not only to an expansive and fragmented photographic industry but also to the separation of practices within the criminal identification process. Equipped with cameras, officers in the field took on a new task as data collectors.[39] Within the laboratory, the trained eye of another expert separated the evidence from the data and identified the body as criminal or otherwise. Prints were collected from crime scenes because they held the promise of identification, not because they displayed obvious associations with criminality, as had been the case with earlier identification systems. In this sense, fingerprints are sites of latent or potential identification.

Photography from the Crime Scene to the Courtroom

Superintendent Hare's example at the 1904 International Association of Chiefs of Police convention highlights the central role of photography in fingerprint identification. Importantly, cases like that described by Hare would have been relatively uncommon during that period, because fingerprinting operated according to the ten-print Henry system. Identifying a single or an isolated few latent fingerprints found at a crime scene by searching a fingerprint file based on the ten-print system was not impossible, but it was time-consuming. Thus, individual police departments collected files of single fingerprints, organizing the prints according to their specific idiosyncratic features.[40] Numerous single-print identification

systems developed through the late 1910s and the 1920s in Europe and North America and were commonplace by the end of the 1930s.[41]

The theory and practice of fingerprint identification remained surprisingly unchanged during the middle decades of the twentieth century. Law enforcement agencies continued to collect fingerprint records, filing them according to their own specific variant of the systems developed by Henry and Vucetich. As these fingerprint archives grew in size, their usefulness declined. Filing systems based on Henry's or Vucetich's classifications became inadequate in the face of the vast accumulation of fingerprint records. The development of computer technology in the 1960s and 1970s offered a solution to this problem. Converting the live fingerprint to an electronic code enabled law enforcement agencies to collect, store, and search fingerprints in ways far beyond the limits of the earlier manual systems.

Experiments to record fingerprints electronically began in the late 1960s and early 1970s under the direction of companies including McDonnell Douglas Corporation, KMS Technology Center, Sperry Rand, Rockwell International, and NEC.[42] Despite taking different approaches, each company developed computer programs for reading and searching fingerprints based on the same principles governing Henry's classification system. Law enforcement agencies adopted the technology quickly. Among the first to employ automatic fingerprint identification equipment were the New York State Identification and Intelligence System (in 1968), the Atlanta Police Department (in the early 1970s), the Kansas City Police Department (in 1974), and the Nassau County Police Department (in 1975).[43] At the federal level, the FBI installed its first fingerprint scanner and began digitizing its extensive fingerprint collection in 1972.[44] A year later, the Royal Canadian Mounted Police installed its automated system.[45] By the late 1970s and early 1980s, Rockwell International and NEC had developed complete electronic fingerprinting units for commercial sale.[46] These units, referred to as automated fingerprint identification systems (AFISs), were capable of scanning, classifying, filing, storing, and searching fingerprints electronically and are now a mainstay of law enforcement agencies.

The original AFIS units developed by Rockwell International and NEC scanned preexisting inked impressions, transforming them into digital code. Law enforcement agencies could scan existing, inked fingerprint records or could fingerprint a person brought to the police station

and then scan the record into the system. By the late 1980s and early 1990s, paperless and inkless "live scan" systems had been developed. Today numerous companies produce and sell a variety of AFIS hardware, software, and peripheral and accessory products, and law enforcement agencies are moving toward a paperless environment.[47]

AFIS units have two primary features: the ability to scan a fingerprint and record its minutiae, and the ability to search existing fingerprints according to the recorded information. An AFIS creates a binary code for a fingerprint based on the spatial relationship of the print's minutiae. The binary code and a digitized image of the print are stored in the program's database. AFIS searches will yield a number of potential matches, predefined by the operating personnel, based on similar binary codes found in the database. Searches will return the images of the prints with similar codes for side-by-side comparisons against the print in question. Importantly, the fingerprint examiner must ultimately decide on identification; the AFIS replaces the manual tasks of filing and searching the fingerprint archive.

AFIS units archive two distinct types of prints: complete ten-print fingerprint records collected directly from physical bodies and single, partial, or multiple latent prints found at crime scenes. Searches function across three levels. First, a complete ten-print record can be searched against a database of known offenders. This is primarily beneficial for establishing identity when a person being printed gives a false name. Second, a latent print can be searched against a database of known offenders. This search would identify individuals whose presence at a crime scene would otherwise be unknown to police. Third, a new ten-print record can be searched against the latent database. This final search could link the individual who is being printed to past and unsolved crimes.

The development and growth of computer technology from the 1960s to the present has revolutionized the fingerprinting capabilities of law enforcement. The majority of law enforcement agencies in the United States and Canada currently use a combination of the traditional, ink-based system and the new, paperless and inkless live scan systems. However, I stress that the basic classificatory and searching mechanisms remain remarkably similar to those developed at the turn of the nineteenth and twentieth centuries.

Despite the continued advances in systems for classifying and searching fingerprints, the camera's role has remained relatively constant.

Fingerprinting manuals from the early 1900s to the present describe a similar process. The camera is used initially to document the crime scene prior to investigation. Officers enter the scene, search for finger-prints and dust, illuminate, or otherwise prepare prints to be photo-graphed. Photographic enlargements are made from the collected prints away from the crime scene. Prints are classified according to an existing system, from the ten-print Henry system of the early 1900s to more current automated digital systems, and a fingerprint file is searched for a match. Once a match is made, photographic enlargements of the found and known prints are produced. The identifying features of the prints are marked on their photographs and are described in an accompanying text.

To better understand the role of photography in fingerprint identifi-cation, I turn to a fictional crime scene produced during an apprentice-ship with the Forensics Identification Services Division of the Metro-politan Toronto Police.[48] The case used real techniques and procedures, but its goal was not to produce courtroom evidence for identification of a real person. Rather, its purpose was to trace the use of photographic representation in fingerprint identification from the collection of crime scene materials through investigation and into use in the courtroom.

The fictional scene proceeds as follows: scenes of crime and identifi-cation officers examine and photograph a crime scene, its contents, and its setting.[49] Within the scene, sites that might reveal fingerprints (window sills, doors, glasses, and the like) are dusted, illuminated through ultraviolet or infrared light, or manipulated in some other way to make the prints visible.[50] These prints are then either photographed, lifted, or both, depending on the nature of the print. In this specific case, a dinner plate located at the crime scene is examined and dusted and fingerprints are found. All prints from the scene that can be lifted or photographed are taken to the police department, where they are scanned into the AFIS. Using a computer mouse, an officer marks the idiosyn-cratic features of each print, its "ridge characteristics," and searches the database for similar markings. The AFIS presents a series of possible matches, each of which is compared against the found prints. If a match is not made, the print under examination remains in the database as a potential source for future investigations. If a match is made, the finger-print and any accompanying information will be collected by the exam-ining officer. In our case, a print from the dinner plate draws a match to a print in the database, and both are prepared for further examination.

Identification by fingerprint takes place by matching the idiosyncratic features of found (from the crime scene) and known (on file with the police) prints. The first step is to determine which hand, left or right, and which finger a print originated from. This can be determined from a visual inspection of the print's specific orientation. Next, the print's general pattern is noted (whether it swirls or moves in a given direction). The most significant part of the process is the identification of the ridge characteristics, sometimes still referred to as the "Henry details" or the "Galton details." The various combinations of these features, as dots, lakes, bifurcations, and ridge endings, are unique to each print (Figure 12). Using the ridge characteristics as signposts, the examining officer constructs a narrative that links the known and found print.

Although simplified, the scene described is representative of the general investigative procedure. The fictional scene demonstrates the central role of photography throughout the investigation. A first photograph is taken that positions the dinner plate within the context of the crime scene (Figure 13). The second photograph locates the fingerprint on the plate (Figure 14). The third is a close-up of the print (Figure 15). Once this general continuity is established, the print is lifted onto acetate, enabling it to be scanned into the AFIS and to be used for further investigation (Figure 16). In our fictional scene, the AFIS produced a match to a latent print on file. The matching criminal record is obtained (Figure 17), and an examination takes place.

For the examination, the identification officer uses the third photograph from the series, the close-up of the print. Both the close-up and the latent print (from the fingerprint file) are rephotographed and enlarged to 8½ x 11 inches (Figures 18 and 19). These two photographs are then read by the examining officer and prepared for use in court. The resultant fingerprint chart is accompanied by a narrative account of how the evidence is to be read (Figure 20). This material is combined with a detailed list of the examining officer's credentials and is presented as final evidence.

The fictional crime scene shows well the three unique features and capabilities of fingerprint identification and its collaboration with photography cited earlier in this chapter. First, the camera enables the collection of identification data in a subtle and nonphysical way. Photographing fingerprints captures the body through the representation of its trace via the tactile markings of the fingers. Second, the resultant images can

be examined and reexamined independently of the presence of the physical body. The bulk of work during the identification process takes place through the production and interpretation of photographs at the police station. And finally, the entire process takes place without the suspect's knowledge. The fingerprint, its photographing, and its eventual identification all take place independently of the presence or knowledge of the individual in question.

The fictional scene also exemplifies the efficacy of fingerprinting as a method of identification for modern and contemporary police practices. Photographs of fingerprints function as particularly effective inscriptions. They are both immutable and highly mobile. Throughout the fictional scene, the photographs establish a continuity of presence, a photographic paper trail linking the individual body to the crime scene. The body's presence, manifest in the ridge characteristics of its fingerprint, drives the investigation. The mechanically objective camera captures, reproduces, represents, and guarantees the "natural inference of presence" of the body from the crime scene to the courtroom. The individual's presence on the dinner plate is tied to his presence in the department's file, and his body is identified as criminal through the production and interpretation of inscriptions.

The fictional scene focused on the collection and examination of a single fingerprint. This was necessary to trace the production of evidence and the use of photography throughout that process. It is important to note that the final print is one among a much larger number collected from the crime scene. Each of the fingerprints collected is archived into the AFIS database. The prints not used in the investigation of the case at hand can be linked to past crimes or can wait for identification in future cases—that is, an individual present at a crime scene, although not ultimately identified or arrested in relation to that case, could be linked to that scene if arrested and printed at a later date. The prints remain archived as sites of latent identification: as data to be transformed into evidence (see Figures 12–20).

Conclusion

The point of differentiating between the fingerprint and its photographic representation is not to call for the more accurate use of language in law enforcement and legal and penal practices. Rather, it is to acknowl-

edge the fingerprint's status as an inscription that is used in the production of identity. In this way, a "fingerprint" is more accurately understood as a material representation produced through a complex series of practices and events. As an inscription, the fingerprint was assured success over competing methods of identification because of the relative ease, efficiency, and accuracy of its use. Law enforcement practices required identification information in a compact, concise format that could be produced and transferred between locales quickly and without misinterpretation or loss of information. Photography and the fingerprint combined to produce the inscriptions necessary to fulfill these needs. In this sense, fingerprinting merely extended existing law enforcement practices. However, I stress that fingerprinting enabled distinctly new capabilities for the collection, control, and use of personal identification data. This in turn facilitated heightened state power through the surveillance of greater numbers of bodies.

In his work on the history of fingerprinting, Simon Cole documents the ways in which the technique developed both in colonial India and in Western police forces as part of a project to record and control populations. In the former, fingerprinting was viewed as a way to differentiate among faces that were perceived as visually homogeneous. In the latter, the technique aided in the control of "marginalized individuals."[51] Because fingerprinting was an inexpensive and efficient method of identification, Cole argues, the technique "offered a way to bring the poor, the ill, the addicted into the custody of the state under the guise of petty crimes, such as prostitution, vagrancy, or intoxication."[52] Thus, in Cole's account, fingerprinting yielded increased state power through the arrest of greater numbers of bodies. By casting a wider net, more criminals were caught, and more were subject to the identification process. I agree that fingerprinting greatly assisted in this effort; however, I want to stress that the technique yielded a greater, more abstract power at the level of the state, as it announced practices of latent identification.

Lombroso described the shift in criminological and penal practices of the nineteenth century as a shift from the study of crime to the study of the criminal body. Similarly, fingerprinting foreshadowed a transformation in law enforcement and identification practices from a focus on the individual, physical body to a focus on an abstract, inclusive social body. Within this new system, identification data is collected independently of the physical presence and knowledge of the body. Fingerprinting

enabled the collection of aggregates of data on unknown and unidentified bodies. Photography and fingerprint identification mobilized law enforcement agencies, extending their capabilities and reach and creating a new, more pervasive form of state surveillance. The latency of fingerprints and the mobility of the camera meant, at least theoretically, that all public and private space could be subject to police surveillance. Fingerprinting therefore enabled the state to bring all bodies, not just those of marginalized individuals or known offenders, under surveillance.

I do not want to suggest that, from its inception, fingerprints were being collected randomly in the hopes of finding criminals or that law enforcement agencies quickly seized on the unique capabilities of fingerprinting and amassed records on entire populations. Early uses of the technique mirrored prior identification practices: it was used to record and track the bodies of known and suspected criminals. However, as it was allied with the camera, fingerprinting announced—at first theoretically—law enforcement practices that were increasingly abstract from the spatial and temporal constraints guiding earlier identification practices.

The theoretical capabilities announced by the development of fingerprint identification in the nineteenth and twentieth centuries are only now becoming a practical reality as law enforcement agencies move toward a paperless environment. Nonetheless, the unique capabilities associated with photographing fingerprints foreshadowed the abstract, inclusive gaze of contemporary law enforcement programs and such tools as closed-circuit television systems, identification archives, and border-security programs. Contemporary law enforcement initiatives based in the mass collection of data have proven to be valuable in tracking and arresting repeat offenders. However, such practices are also indicative of heightened state power and pose numerous challenges to individual rights, freedoms, and capabilities, for identification data can be interpreted and reinterpreted according to changing conceptions of criminality, deviance, or threat, a topic that is addressed at length in chapters 4 and 5.

A fingerprint, whether live or photographed, is immutable in the sense that it attests to an individual's presence at a specific time and location. In contrast, criminality is a highly mutable social construct. Throughout the development of the modern criminal subject, outlined in chapter 1, criminality was bound to conceptions of race, class, and

gender. These notions continue to influence contemporary conceptions of crime and criminality. I do not want to suggest that fingerprint data is collected for deliberate and malicious use; however, as it is collected for potential use, it threatens to discriminate against individuals, groups, and nations according to mutable conceptions of criminality. The aggregates of identification information stored in fingerprint files exist as sites of potential or latent identification. The data is collected, mobilized, and identified through processes of investigation and interpretation that reflect historically specific conceptions of criminality. Within this process, variables including race, class, gender, and sexuality as well as moralistic values of right and wrong predetermine the use and interpretation of the data. At stake are the construction of individual, group, and national identities and their attendant rights and limitations.

Figure 12. The ridge characteristics of the fingerprint. Property of the author.

Figure 13. The first photograph in the production of identification: the image locates the dinner plate within the context of the crime scene. Property of the author.

Figure 14. The second photograph in the production of identification: the image locates the fingerprint on the dinner plate. Property of the author.

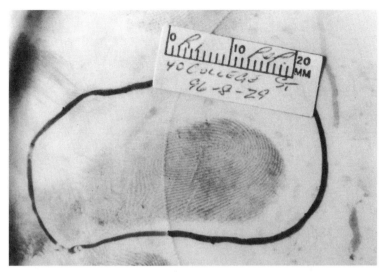

Figure 15. The third photograph in the production of identification: the image isolates the fingerprint. Property of the author.

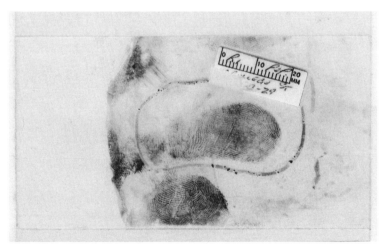

Figure 16. The found fingerprint isolated in the previous image is lifted onto a sheet of acetate, enabling it to be transferred from the crime scene to the police station. Property of the author.

Figure 17. An AFIS search of the found print produces a match to a latent print on file, and the corresponding criminal record is obtained. Property of the author.

Figure 18. The isolated image of the found print is rephotographed and enlarged so that the found and known prints can be compared. Property of the author.

Figure 19. The matching latent print on file is rephotographed and enlarged so that the prints can be compared. Property of the author.

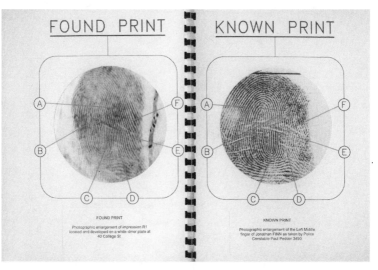

FOUND PRINT KNOWN PRINT

FOUND PRINT
Photographic enlargement of impression R1
located and developed on a white diner plate at
40 College St

KNOWN PRINT
Photographic enlargement of the Left Middle
finger of Jonathan FINN as taken by Police
Constable Paul Pedder 3490

Explanation of Illustrated Characteristics
A. Ridge ending downward. Move left one ridge to:
B. Bifurcation opening downward. Move left into the furrow (space between the ridges) and follow that down to:
C. Ridge ending upward. Left into the furrow and follow that down to:
D. Ridge ending upward. Move up and to the right seven ridges to:
E. Bifurcation opening downward. Move left one ridge and follow that up to:
F. Bifurcation opening downward.

Figure 20. The final image in the production of identification: a fingerprint chart and its accompanying narrative identify the matching ridge characteristics of the found and known fingerprints. Property of the author.

3

The Control of Inscriptions: Standardizing DNA Analysis

In "Galton's Regret: Of Types and Individuals," Paul Rabinow points to a central distinction between fingerprinting and DNA analysis.[1] Whereas the former is a phenotypic process, the latter is genotypic. Fingerprinting is based on the external, physical signs of the body, and DNA identification works at the cellular level. Proponents of DNA analysis describe it as the most powerful and effective method of criminal identification precisely because it operates at this primary biological level. As described in a 1996 National Research Council report on DNA evidence, "these newer molecular techniques permit the study of human variability at the most basic level, that of the genetic material itself, DNA."[2] DNA analysis suggests the "natural inference of presence"[3] of the criminal at a level beyond that of fingerprinting. Instead of being the tactile trace of a body, DNA is understood to represent the biological constitution of that body.

Despite having only started its third decade of use in law enforcement practices, DNA analysis has become an essential and powerful tool in criminal identification. It is particularly useful in cases involving rape and murder, where biological material is often left and where other forms of evidence are often absent. DNA analysis has enabled the capture of large numbers of repeat violent and sexual offenders and

has been used to exonerate the falsely convicted. In addition, DNA technology has several applications beyond law enforcement. It is used by biotechnology corporations in paternity testing and in genetic research; by the military for the future identification of soldiers killed in battle or missing in action; by employment, insurance, and health organizations in determining clients' contracts and policies; and by research laboratories for studies in disease, health, and heredity. The potential use and misuse of genetic information within these contexts has been a source of continued discussion since the technique's inception.

By 1994, only seven years after its initial use for criminal identification in the United States, DNA analysis in law enforcement was standardized under the direction of the FBI. The DNA Identification Act, written in 1993 and enacted in 1994, ceded authority over the technique's procedures and protocols to the FBI and concretized federal-level control in the field of DNA analysis.

Because of its unique dependence on inscriptions, DNA analysis provides an excellent arena through which to address the importance of visual representation in scientific practice. In particular, the development and implementation of DNA analysis in law enforcement highlights the tremendous power associated with the control of inscriptions. Whereas chapter 2 focused on the concrete production of inscriptions, this chapter examines the more abstract field of their institutional control. What is at stake is not simply federally controlled procedures of analysis, but also control over aggregates of identification data.

In contrast to fingerprinting, DNA analysis has received significant critical attention throughout specialized and popular presses. This chapter draws significantly from this work, using a variety of sources from scientific, legal, academic, and professional fields. In addition, because identification by DNA takes place through the continual mediation of visual representation, I position DNA analysis as a largely visual process. Existing work on the technique does not often address its visual nature. K. Amann and K. Knorr Cetina have examined the literal acts of "talk" that take place between laboratory practitioners as they engage in the visual process of interpreting autoradiographs. Sheila Jasanoff uses the DNA evidence of the O. J. Simpson trial to investigate the role of trial judges in framing the interpretation of visual evidence by controlling what will and will not be seen by the jury.[4] My particular treatment of DNA analysis as a visual practice is unique. Whereas Amann and Knorr

Cetina examine the act of interpreting autoradiographs in the research laboratory and Jasanoff examines the authority associated with controlling the deployment of autoradiographs as visual evidence in criminal trials, I examine the institutional control of inscriptions in the construction of authority, or dominance, over the technique.

Visualizing DNA: From Sample to Profile

Criminal identification by DNA involves the comparison of sample DNA (from the crime scene) with DNA drawn from the suspect. Analysis begins with the collection of DNA from cells, usually from found samples of blood, semen, bone marrow, and hair. Once extracted, the DNA is cut into smaller pieces using restriction enzymes. The separate pieces are of different lengths and represent specific groupings of the building blocks of DNA: adenine, cytosine, thymine, and guanine. From here, the pieces are subjected to an electrical charge through the process of gel electrophoresis. This charge separates the pieces according to size and the speed with which they move through the gel. After being transferred from the gel to a sheet of nylon through a process called blotting, a radioactive probe is added. Because the building blocks of DNA only pair with their specific complements (adenine with thymine and cytosine with guanine), the probe binds to its matching fragment and makes the structure of the DNA known. The segments of DNA with their bound probes are rendered visible by placing the sheet of nylon against a sheet of photographic paper, where the probes register as dark bands. The final product is called an autoradiograph or, alternatively, an autoradiogram or autorad (Figure 21).[5] The parallel lanes of an autoradiograph represent the sample DNA, the suspect's DNA, and control markers.[6]

It is important to note the distinction between DNA samples and DNA profiles. The blood, hair, semen, or other source from which the DNA is derived is referred to as "the sample." The autoradiograph produced from the sample represents the DNA profile. DNA profiles are distinguished from DNA samples by the type of information they contain. DNA profiles contain information useful in differentiating between individuals and establishing identity. They use noncoding fragments of DNA, that is, fragments that do not carry information regarding an individual's phenotypic, behavioral, or pathological traits. By contrast, DNA samples contain the entire genetic sequence of the individual from

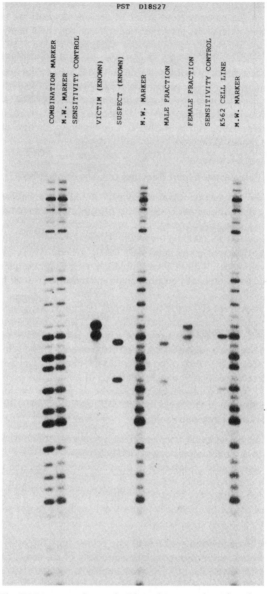

Figure 21. The DNA autoradiograph. Identification takes place by matching parallel lanes of DNA as drawn from the crime scene and from the suspect. From National Academy of Sciences, Committee on DNA Technology in Forensic Science, National Research Council, *DNA Technology in Forensic Science* (Washington, D.C.: National Academies Press, 1992), 39; reprinted with permission.

whom they are drawn. DNA samples contain an individual's complete genetic code. Concerns regarding the collection of DNA generally refer to the collection of samples because of the wealth of personal information they contain, information irrelevant for criminal identification. This distinction will be taken up more fully in chapter 4; here it is sufficient to note that the autoradiograph is a DNA profile.

Once made visible, the DNA profiles from suspect and sample are compared. Using a computer, the analyst measures the specific displacement of bands in the suspect and sample profiles, comparing the measurements against one another. This interpretation produces one of two results. If the displacement of bands in the sample DNA and the suspect's DNA are dissimilar, the suspect can be removed from suspicion, or exonerated if already convicted. If the two DNA profiles match, a second procedure takes place. A probability is calculated to show the likelihood that the matching DNA could have come from someone other than the suspect (but with similar genetic makeup). Because only a fraction of the world's population have had their DNA analyzed, to calculate probability it is necessary to work with population samples and statistics. Sample populations are broken down according to race-based categories such as Caucasian, African American, Asian, and Hispanic. From here, a numerical value is produced, such as "one in one million," estimating the likelihood that the sample DNA could have come from someone of the same sample population other than the suspect. Together, the autoradiograph and the numerical probability constitute the evidence used in DNA identification.[7]

As described above, the production and interpretation of visual representation is a fundamental component of identification by DNA. In this way, DNA analysis has many parallels with its predecessor, fingerprinting. Most immediately, both techniques ultimately require the trained eye of an expert to read and interpret the image (of the fingerprint or autoradiograph) and to produce identification. Further, to function as an effective method of identification, both DNA analysis and fingerprinting depend on the mobility and immutability of inscriptions. Both techniques benefit from an indexical relationship with their referent and employ the cultural legacy of photomechanical objectivity to capture that relationship. That is, photographs of DNA and photographs of fingerprints are taken to be indexes of the body and are considered guarantees of the "natural inference of presence" of their maker.

Despite these similarities, the complexity of DNA analysis immediately distinguishes it from fingerprinting in two primary ways. First, because it operates from the molecular level, DNA analysis is dependent on inscription in a way fingerprinting is not. A fingerprint, with its identifying ridge characteristics, is visible to the naked eye. By contrast, DNA can only be seen and identified through its material representation. Indeed, as noted in work in the social study of science, particularly that of Bruno Latour, Steve Woolgar, and Michael Lynch, DNA can only exist as an object of scientific knowledge through recourse to material representation.[8] Second, as a highly specialized scientific practice, DNA identification is produced within a network of individuals and agencies that extends well beyond the law enforcement community. That is, whereas fingerprinting and Bertillonage were practiced in the enclosed space of the police station, DNA identification involves the collaboration of a diverse group including police, molecular biologists, population geneticists, and biotechnology corporations.[9] Given its unique dependence on inscriptions and its complexity as a method of identification, the ability to control the production, exchange, and interpretation of autoradiographs is of premier importance in the field of DNA analysis.

Criticisms and concerns are raised about both parts of the DNA analysis process. Challenges to the first part, the procedures with which it is performed, include charges of faulty collection of evidence, its mishandling or misuse, and personal or laboratory error. With reference to the second part, criticisms are leveled at the notion of population samples. Because the world does not exist in strict race-based groups, critics argue, sample populations based on such groups will necessarily be flawed. In addition to these procedural issues, DNA analysis continually raises concerns regarding the collection of genetic information. The storage and use of DNA information in databanks poses threats of discrimination against individuals based on their genetic makeup. These concerns have been addressed at length by scholars throughout the humanities, sciences, and social sciences and in the law.[10]

During the "DNA wars" of the late 1980s and early 1990s, proponents and opponents of DNA analysis debated these issues and others related to the efficacy and accuracy of the technique as it applies to personal identification. The debate took place in newspapers, popular and specialized journals, government reports, and courtrooms. The

DNA Identification Act was designed to alleviate these concerns by standardizing and "black-boxing" the technique. As with earlier methods of identification, it was thought that standardized procedures would guarantee the immutability of the evidence. Toward this goal, the DNA Identification Act called for the establishment of a DNA advisory board under the direction of the FBI to develop and monitor standards for DNA analysis in law enforcement.

DNA from the Laboratory to the Courtroom

The first use of the technique then called "DNA fingerprinting" was by a British geneticist, Alec Jeffreys, in March 1985. Jeffreys's method was patented by Cellmark Diagnostics and was used primarily for paternity testing in relation to immigration in the United Kingdom.[11] In the United States, during the mid-to-late 1980s, the technique was performed by a series of private companies, including Cellmark Diagnostics of Maryland (the U.S. subsidiary of the British company that held the patent), Lifecodes Corporation of New York, Genelex of Washington State, and Forensic Science Associates of Richland, California. In 1988, the Federal Bureau of Investigation became the first public laboratory to use the technique.

The transition of DNA analysis from the research laboratory to the courtroom was surprisingly quick. Commenting on this move, Jeffreys expressed his surprise in a *Parade Magazine* interview, stating, "It has astonished me how rapidly the scientific community has used the technology, how rapidly it has been viewed positively by many young lawyers. . . . I thought the practical uses were years in the future."[12] Jay David Aronson's Ph.D. thesis investigates this transition in detail; here it is sufficient to note the technique's quick acceptance into criminal trials.[13] The first conviction in the United States based on DNA evidence was in the 1987 case *State v. Andrews*.[14] The accused, Tommy Lee Andrews, was convicted of rape after DNA drawn from his blood matched that found in a vaginal swab taken from the victim.

During the first few years of its use in cases of criminal identification, DNA analysis held a reputation similar to that of fingerprinting. The technique was deemed infallible and was likened to a "magic bullet" in criminal investigation by both specialized and popular audiences. The use of the term "DNA fingerprinting" throughout this early period

attests to the technique's positive reputation but also to a general mis-understanding of its basis. As described earlier in this chapter, DNA analysis identifies a person through the use of probability statistics. The technique does not provide a unique identification, as does fingerprint-ing; instead, it offers only a probability of identification. The misleading term "DNA fingerprinting" was gradually replaced with "DNA profiling," "DNA typing," or "DNA analysis."[15] Throughout this book, I use the term "DNA analysis," as it emphasizes the concrete processes of pro-duction and interpretation.

During the mid-to-late 1980s, DNA analysis had the reputation of being as infallible a method of identification as fingerprinting, and so its incorporation into criminal investigations regularly prevented cases from reaching trial.[16] Combined with a general lack of familiarity with the technique, this reputation prevented DNA analysis from being ques-tioned. But when it did enter into trials, DNA evidence confounded defense attorneys. In a *New York Times* article, Peter Neufeld, a promi-nent defense lawyer and an early critic of DNA evidence, commented on the technique's effect on the adversarial legal system:

> In the first two dozen cases where DNA evidence was introduced, the opposing attorney did not even challenge the evidence. . . . they felt scientifically illiterate and unable to even perceive of questions. No adverse experts were even retained by the counsel. Everyone just sort of lay down and died.[17]

Whereas the *Andrews* case set a precedent as the first conviction in-volving DNA analysis, the 1989 trial of Joseph Castro was the first to seriously question the technique.[18] Castro was accused of murdering a neighbor and her daughter in February 1987. Lifecodes Corporation was called in to perform DNA analysis for the case. During a pretrial hearing, lawyers Barry Scheck and Peter Neufeld and population geneti-cist Eric Lander were among a team of lawyers and scientists that ques-tioned the way Lifecodes performed the technique.[19] As a result, the presiding judge allowed some, but not all, of the DNA evidence to be used, citing procedural error as key point of concern.

The next case involving DNA analysis that would prove to have lasting significance was a 1990 murder trial in Ohio, *United States v. Yee*.[20] In this case, defendants Steven Wayne Yee, Mark S. Verdi, and John Ray Bonds were accused of murdering David Hartlaub. The case

would prove highly influential because of the way the DNA evidence was handled. The judge in the case, James E. Carr, gathered thirteen experts on DNA for a six-week hearing. The experts covered a variety of elements of DNA testing, from procedural details to the use of population samples in the analysis.[21] Carr's ruling after the six-week hearing was highly debated. The thirteen experts returned with views that were, in many cases, diametrically opposed. Despite this, Carr ruled that no unanimity or consensus was needed for the evidence to be used in court.

Carr's ruling in the Ohio case was provocative, as it seemed to contradict the only existing precedent for scientific evidence in the courtroom. That vague precedent came from the 1923 trial of James Frye.[22] The resultant Frye principle stated that to be accepted in court, any new scientific technique "must be sufficiently established to have gained general acceptance in the particular field in which it belongs."[23] Carr's ruling directly refuted the Frye principle, since he did not require consensus among his thirteen experts.

The immediate acceptance of DNA analysis as evidence in court is in large part due to the construction of the autoradiograph as a coherent and unified evidentiary statement. Recall that DNA analysis originally developed within research laboratories and for use in paternity testing. The development of the technique within this relatively idealized environment is important in two ways. First, within research laboratories, DNA analysis is largely free from the problems that plague its use in criminal identification. In nonforensic uses, samples are abundant and contamination-free, and tests do not rely on the use of population samples. Paternity tests generally involve determining a match or exclusion based on readily available samples of all parties involved. Second, unlike earlier methods of identification, DNA analysis developed in a competitive, profit-driven arena. Corporations such as Cellmark and Lifecodes competed aggressively for control over DNA analysis within the highly lucrative identification market. Aronson details this competition in the United States, stressing the extent to which corporations knew that the success of their technique was dependent on its acceptance in court and thus advertised directly to lawyers, judges, and others through professional channels such as conferences and journals. The corporations promised reliable, quick, and infallible results in an effort to capture significant market share.

When DNA analysis made the transition from the laboratory to the courtroom, it did so as a coherent visual statement. The autoradiograph was said to provide conclusive proof of identification. Before the method was being used in criminal trials, its language was being created and revised within the controlled setting of corporate laboratories. By the time the product of this new method of identification, the autoradiograph, reached criminal trials, it was constructed as a newer, more scientific, more technological manifestation of the fingerprint. The autoradiograph entered the practice of criminal identification as a genetic "fingerprint": it was a coherent, unified evidentiary statement that was understood to guarantee identification. Once its cycle of use began, it had a head start on oppositional views, which first had to decode the language and then had to reformulate it to express the opposing view. Thus, as Peter Neufeld put it, defense attorneys in the early court cases "just sort of lay down and died."

When DNA evidence was eventually questioned, as in the *Castro* and *Yee* trials, its status as a coherent, evidentiary statement was disrupted. The autoradiograph was deconstructed, revealing the fragmented and specialized processes behind its construction. The image was shown to be the product of complex and diverse scientific practices, and its interpretation was shown to be bound to the equally complex subject of population genetics. Once its unity was disrupted, lawyers and scientists were able to question the autoradiograph based on the elements of its construction. This is apparent in the pretrial hearings in *Castro* and *Yee*, where experts challenged the procedures used in performing DNA analysis and the use of population samples in the calculation of probability.

Developing Standards: The FBI in the DNA Identification Act

The immediate and unquestioned acceptance of DNA analysis in criminal identification and its eventual challenge in the *Castro* and *Yee* trials highlights the contentious nature of the technique. A primary reason for its problematic introduction to criminal identification was that, unlike Bertillonage and fingerprinting, which were performed within the specific confines of criminal justice institutions, DNA analysis was performed by numerous and different companies and laboratories, each with its own specific procedures of analysis. With independent labs such as Cellmark and Lifecodes producing the tests, there was no way to assure

consistency in the method. In a 1988 *New York Times* article, Congressman Don Edwards (D-Calif.) warned of "certain cautionary reservations about private firms galloping in and testifying all over the place, because the procedures, the protocols, the standards have not been established yet." Eric Lander, a central early critic of the technique (and also a critic of the analysis carried out by Lifecodes during the *Castro* trial), noted the very serious consequences of procedural inequalities, pointing out that "clinical laboratories have to meet higher requirements to be allowed to diagnose a case of strep throat than a forensic laboratory has to meet to put a defendant on death row."[24]

Several professional groups and committees formed in response to the contentious nature of DNA analysis. The rapidity of the introduction of DNA evidence to the legal system forced the issue of standardization into the foreground. The American Society of Crime Laboratory Directors (ASCLD), founded in 1974, established a Laboratory Accreditation Board (ASCLD-LAB) in 1985.[25] This board was initiated by the FBI to bring together local and FBI forensic laboratories and provided a voluntary accreditation program to crime laboratories, including those performing DNA analysis. Whereas the ASCLD offered laboratory-level accreditation, the American Board of Criminalistics, formed in 1989, provided certification to individual practitioners.[26] Toward the end of the 1980s, and again under the direction of the FBI, a group of thirty scientists from forensic laboratories in the United States and Canada formed the Technical Working Group on DNA Analysis and Methods (TWGDAM).[27] This group did not provide accreditation or certification; instead, it was an arena in which forensic scientists met to discuss, monitor, and examine various aspects of the technique, including standards for analysis. Finally, in direct response to the growing concern about DNA as evidence, the National Academy of Sciences established the Committee on DNA Technology in Forensic Science in 1990. Despite differences in their individual approaches, each of these groups sought to alleviate the contentious nature of DNA analysis through the creation and regulation of standards. Two of these initiatives, both developed by the FBI, the ASCLD-LAB, and the TWGDAM, remain prominent forces in shaping and monitoring DNA analysis.

The search for standards was also carried out through detailed governmental reports. The first of these was the 1990 Office of Technology

Assessment's *Genetic Witness: Forensic Uses of DNA Tests*. The report was a response to the quick movement of DNA into the courtroom and to the contentious ruling in the *Castro* trial. It provided a general review of DNA technology, including discussions of how DNA is tested and how test results are used in court and of the potential use and misuse of genetic information by external parties. Early in the report, a portion of highlighted text calls attention to standardization: "Setting standards for forensic applications of DNA testing is the most controversial and unsettled issue. Standards are necessary if high-quality DNA forensic analysis is to be ensured, and the situation demands immediate attention."[28] The 1990 report does not offer any specific conclusions on DNA analysis. Instead, it suggests, as in the passage above, that with the accelerated use of DNA as evidence, setting standards was the pressing issue.

The second major report came in 1992 with the National Research Council's *DNA Technology in Forensic Science*.[29] Unlike its 1990 predecessor, this report set out to establish specific goals and recommendations. The adviser to the Committee on DNA Technology in Forensic Science, Victor A. McKusick, noted that the report issued out of the increasing concern about the use of DNA evidence in court. Concluding his preface to the report, McKusick writes:

> DNA typing for personal identification is a powerful tool for criminal investigation and justice. At the same time, the technical aspects of DNA typing are vulnerable to error, and the interpretation of results requires appreciation of the skills of population genetics. These considerations and concerns arising out of the felon DNA databanks and the privacy of DNA information made it imperative to develop guidelines and safeguards for the most effective and socially beneficial use of this powerful tool.[30]

Again, as in the 1990 report, the National Research Council's analysis attempted to take into consideration the wide array of issues at work in DNA analysis. The report includes chapters on technical considerations, the calculation of probability statistics, the development of standards, DNA databases, and the social implications of these practices. Each chapter also includes a brief summary of the committee's recommendations. But, once again, the development of standards for DNA analysis took precedence.

The committee suggested that because of the powerful nature of the technique (referring to its scientific potential and public benefit), "some

degree of standardization of laboratory procedures is necessary to assure the courts of high-quality results."[31] The committee then detailed ways in which such standards could best be achieved. Among the recommendations was a call for quality assurance and quality control programs within individual laboratories. The report also suggested that laboratories and individual practitioners should be required to seek professional accreditation. To ensure that these recommendations were met appropriately, the report also called for the development of a professional organization to monitor these activities. And finally, the report recommended that the federal government enact a committee to oversee these processes and to ensure that the highest standards would be met in each case.[32]

The search for standards in DNA analysis through the reports, committees, and groups detailed above is similar to law enforcement's search a century earlier for standards in Bertillonage and fingerprinting. Both sought the same result: standardized procedures for the creation of evidence that would transform its visual representation into an inscription that could function in communications-dependant law enforcement practices. The image's certification as having been produced according to accepted standards would guarantee its authority and render the image's unique and fragmented context of production invisible. The standardized autoradiograph could move seamlessly and immutably between contexts and locations. Without standards, any autoradiograph could be challenged on its production and interpretation.

The development of a uniform set of procedures for the production of DNA evidence was a central concern behind the drafting of the DNA Identification Act in 1993.[33] Congressman Don Edwards sponsored the act to provide legislation covering the use of DNA technology in criminal justice practices. Recall that Edwards had earlier warned of the dangers in having several independent companies performing DNA tests. Edwards's concern was that these private companies would each perform the technique in its own way and that this would result in a lack of consistency. As sponsor of the 1993 act, Edwards promoted the establishment of a regulated set of standards to be used in future cases involving DNA analysis.

The DNA Identification Act covers five areas: funding to improve availability of DNA analysis for criminal investigation; quality assurance and proficiency testing; development of an index for the exchange of genetic information; external testing for the FBI laboratory; and

authorization of funds. The act includes a statement of summary and purpose that is particularly clear:

> The purpose of the DNA Identification Act of 1993 is to promote the use of DNA identification technology for law enforcement purposes, in accordance with appropriate quality control and privacy standards. The Act authorizes federal funding for State and local governments to establish or improve DNA forensic capabilities; requires grant recipients and the FBI laboratory to adhere to minimum quality control, proficiency testing and privacy standards; requires the FBI to establish a forensic DNA advisory policy board to provide the FBI with advice from a range of DNA experts, including scientists from outside the forensic field; and authorizes the FBI to establish a national index of DNA profiles of convicted offenders, pursuant to minimum quality control, proficiency testing and privacy standards. The bill does not set standards for the admission of DNA evidence in court; that question is left to the law of evidence and must be adjudicated on a case-by-case basis.[34]

From this statement, it is clear that the DNA Identification Act was drafted as a conscious appeal to the concerns and recommendations set out in the 1992 National Research Council report. The act also acknowledges recommendations suggested by the Office of Technology Assessment in its 1990 report. Moreover, in deferring to the courts, the document even refers back to the Frye principle. The 1993 act reads as a point-by-point response to the various criticisms leveled at the technique.

The act did not go uncontested. A chief concern of critics was the control of standards. Subsection three of the act states: "Not later than 180 days after the date of the enactment of this Act, the Director of the Federal Bureau of Investigation shall appoint an advisory board on DNA quality assurance methods," and it continues on to say:

> The Director of the Federal Bureau of Investigation, after taking into consideration such recommended standards, shall issue (and revise from time to time) standards for quality assurance, including standards for testing the proficiency of forensic laboratories, and forensic analysts, in conducting analyses of DNA.[35]

Under these provisions, the development, implementation, and control of standards for performing DNA analysis in law enforcement practices would remain under the direction of the FBI, with significant discretionary power given to the bureau's director.

Responding to the FBI's authoritative role, Barry Scheck and Peter

Neufeld (from the *Castro* trial and later part of the O. J. Simpson defense team) argued that the bureau depends on a certain success rate and that therefore allowing this agency to establish DNA standards would be problematic. In their view, the FBI would be able to define privacy and proficiency criteria and could manipulate these criteria to serve its own needs.[36] John Hicks, then assistant director of the FBI, responded by calling Scheck and Neufeld's suggestion ludicrous. "Where you have the technological competence and mission," Hicks defended, "that's where you want to place your confidence." Don Edwards, the sponsor of the act, took a similar stand. While Edwards acknowledged that there were still problems with identification by DNA analysis, he ultimately insisted: "We've got to get it started, and the FBI is all set up to move ahead quickly."[37]

Despite continued debate, the DNA Identification Act of 1993 was adopted as the DNA Identification Act of 1994 into the Violent Crime Control and Law Enforcement Act on September 13, 1994.[38] The Violent Crime Control and Law Enforcement Act was the country's most expansive crime bill and served as an amendment to the Omnibus Crime Control and Safe Streets Act of 1968. The specific DNA Identification Act appears under Title XXI ("State and Local Law Enforcement"), Subtitle C ("DNA Identification"). Following on the heels of the enactment, Eric Lander and Bruce Budowle proclaimed that "the DNA fingerprinting wars are over."[39] This triumphant remark appeared in a 1994 issue of *Nature*. The combination of previously opposing forces—Lander was an early critic of the technique and Budowle was director of the FBI's DNA typing laboratory—gave particular and peculiar weight to their statement.[40] In this article, Lander and Budowle suggested that the National Research Council's recommendation for a national committee on DNA analysis had been met with the enactment of the 1993 act. According to the authors, this meant that the debate surrounding DNA analysis had been solved. Their concluding remarks place central importance on standardization:

> Most of all, the public needs to understand that the DNA fingerprinting controversy has been resolved. There is no scientific reason to doubt the accuracy of forensic DNA typing results, provided that the testing laboratory and the specific tests are on par with currently practiced standards in the field. The scientific debates served a salutary purpose: standards were professionalized and research stimulated.[41]

The DNA wars of the late 1980s and early 1990s were essential in developing, questioning, and testing DNA analysis for criminal identification. Lander and Budowle's remark that the activity of the DNA wars had served its "salutary purpose" belittles the importance of critical debate and discussion in practices as far-reaching as DNA analysis. The various government reports, scientific and popular articles, and legal battles of this period were essential in providing much-needed critical investigation of a technique that posed serious questions regarding individual rights and freedoms and that problematized the intersections of science, law enforcement, and criminal justice. The development of committees and pretrial hearings to debate the accuracy, efficacy, and social ramifications of genetic identification emphasizes the problematic nature of the technique. Attempts to alleviate the controversy surrounding DNA analysis within this context took place almost exclusively through the search for standards of analysis.

The formalization of standards for DNA analysis under the DNA Identification Act did much to allay the concerns, highlighted by Congressman Edwards, regarding inconsistent analyses. However, standardized procedures did not wholly resolve the controversy surrounding the technique. In response to Lander and Budowle's claim in the journal *Nature* that "the DNA fingerprinting wars are over," two volumes of the journal included articles suggesting the wars were very much still on. In the December 1 issue, Richard C. Lewontin, of Harvard University, accused the authors of "completely distort[ing] the current situation" in discussions of DNA analysis. For Lewontin, serious questions remained concerning laboratory reliability, the calculation of probabilities, and the ability of jurors to make logical decisions based on probabilities. The second of these concerns, the calculation of probabilities, was the subject of another response to Lander and Budowle appearing in the same issue, authored by Daniel L. Hartl, a colleague of Lewontin's at Harvard.[42] The debate did not end there. Five more responses appeared in the January 12 edition of the journal. The concerns associated with the calculation of probabilities and with the use of population samples were extensive enough to warrant a second National Research Council report in 1996.[43] Elsewhere, Sheila Jasanoff suggested that, rather than solving issues associated with inconsistent analyses, standardization allowed DNA evidence to be challenged in a new way. By providing a step-by-step account of how the collection and analysis of

DNA evidence *should* be performed, she argued, established standards allowed defense attorneys to map the *actual* performance of the technique against its ideal model.[44]

Although standardization did not wholly resolve the conflict surrounding DNA analysis, it did have two significant and far-reaching effects. First, the enactment of the DNA Identification Act in 1994 and the standardization of federally controlled procedures had the effect of streamlining DNA analysis in law enforcement, bringing a premature end to much of the critical investigation of the technique. The comments of John Hicks and Don Edwards cited earlier illustrate the extent to which DNA analysis was sped into application. The rationale used to justify the FBI's authoritative role was that the bureau possessed the available technology and could implement standards quickly.

The second significant effect of standardization was that it served as a necessary precondition for the development of control over DNA analysis in law enforcement. Importantly, while standardization was an essential component in this process, it was not in itself sufficient for this task. As part of a larger process of construction, standardization worked in concert with existing federal initiatives toward this goal. Specifically, in addition to developing standards for DNA analysis, the DNA Identification Act effectively delineated a workable boundary for the FBI within the larger field of DNA analysis and provided the agency with funding necessary to function in what is a highly competitive market.

Disseminating Standards and Developing Control over Inscriptions

The DNA Identification Act defines its purpose as promoting "DNA technology for law enforcement purposes." The explicit reference to "law enforcement" was necessary in establishing a workable boundary within the larger, competitive, and profit-driven field of DNA analysis. In his examination of DNA-typing companies, Arthur Daemmrich notes that biotechnology companies derive substantial profits from paternity testing and are attracted to criminal cases because of the visibility and credibility they provide.[45] In 2009, the typical cost of testing (screening and analysis) with Orchid Cellmark ranges from five hundred to a thousand dollars. In rare cases where the sample has been severely degraded, the cost can exceed three thousand dollars. Orchid Cellmark provides expert-witness testimony at a rate of two thousand dollars per

day, although discounted rates are available for contract customers.[46] Given the substantial remuneration for DNA analysis, individual and corporate reputations and careers can be shaped through participation in civil and criminal cases. Private laboratories, therefore, have a vested interest in both the production and the interpretation of their product. Toward this end, Daemmrich notes that these corporations control all aspects of the creation and sale of their product. He describes the reasoning for this practice:

> All DNA-typing companies face formidable challenges in presenting a credible product to courts. Only by tightly coupling the company organization and testing procedures to the expert witness do they gain the competitive edge needed to enter the courtrooms around the country and, in each, to persuade a different cast of judges, lawyers, and jury.[47]

DNA-typing companies create a monopoly over their specific product. This allows them to monitor and guarantee every aspect of its production and interpretation. This is essential in the for-profit business of DNA analysis because the product, the autoradiograph, represents not only the results of the analysis but the credibility of the corporation performing the test and of its employees.

During the mid-1980s, DNA analysis was the domain of private biotechnology companies such as Cellmark. These companies competed for control over the technique: the company that produced the best inscriptions, in this case the best autoradiographs, procured higher profits and greater visibility through participation in high-profile cases. Therefore, when the FBI opened its laboratory in 1988, it was entering an already competitive, profit-driven market. The bureau's identification laboratories had to compete against well-funded biotechnology corporations that were already establishing themselves within civil and criminal cases and that had developed highly specialized and controlled procedures for producing their product, the autoradiograph. The DNA Identification Act was essential in delimiting a specific field of DNA analysis within which the FBI laboratories could effectively compete and which the FBI could, ultimately, control.

Importantly, although the DNA Identification Act established FBI-regulated standards for DNA analysis in law enforcement, it did not prevent private biotechnology companies from performing the technique. These companies are able to perform analysis in forensic cases provided

they adhere to the FBI's standards. Preventing private companies from performing forensic work, amid the significant public debate of the DNA wars, would have appeared to be an overt attempt to control the technique and would have caused widespread concern among scientific, academic, and professional communities. Further, the exclusion of biotechnology companies would have eliminated a valuable resource for the bureau. DNA analysis is a time-consuming and expensive process. The technique is still in its infancy and is constantly undergoing development. The collection of DNA samples within law enforcement proceeds at a rate considerably faster than that of its analysis, producing large backlogs of samples. Law enforcement agencies often rely on biotechnology corporations, which have the most up-to-date equipment and large staffs, to analyze these backlogs of DNA samples. Orchid Cellmark lists law enforcement agencies in South Dakota, Oregon, Wyoming, New York, and Nevada as former "clients" and notes that it is "currently under contract to perform the STR [short tandem repeat] analysis of thousands of backlogged sexual assault kits from the New York City Police Department, the Illinois State Police, and the Phoenix Police Department."[48] Similarly, Genelex advertises that it has "completed DNA profiles under contract on more than 25,000 individuals that are currently in law enforcement databanks, including the FBI's National DNA Index System."[49]

Using these biotechnology companies not only assists law enforcement agencies in clearing backlogs of DNA samples but also provides access to amassing records of genetic identification data. The participation of biotechnology companies also serves to further mobilize the federally controlled standards of analysis by disseminating them throughout the private sector. At the very least, this dissemination of standards strengthens the bureau's authoritative position within DNA analysis in law enforcement. However, it also threatens to influence and interact with other applications, such as paternity testing and medical and genetic research. This issue and others associated with the data-banking of genetic information will be addressed at length in chapter 4.

The dissemination of federally controlled standards for performing DNA analysis was equally important within law enforcement agencies. As was the case with fingerprinting at the turn of the nineteenth and twentieth centuries, the potential of DNA analysis as a method of criminal identification was quickly seized upon and implemented by law

enforcement agencies throughout the country.[50] As with Bertillonage and fingerprinting, each law enforcement agency collected and analyzed DNA and produced autoradiographs in its own way, often contracting out to private companies. By legalizing and funding the establishment of a federal-level DNA database, called the National DNA Index, the DNA Identification Act disseminated FBI-regulated standards of analysis throughout local and state law enforcement agencies. This did not simply standardize procedures; it also strengthened federal control over the technique.

The National DNA Index has its roots in the establishment of the Combined DNA Index System (CODIS). This was a program initiated by the FBI in 1990 to collect, store, and exchange genetic identification data among law enforcement agencies. The potential data-banking of genetic information was a primary concern of critics from the inception of DNA identification. Concerns were raised that this information could be accessed and shared among law enforcement, health, insurance, and other agencies and used to discriminate against individuals. Critics also expressed concern that a large genetic index developed for use in criminal identification would eventually expand to other uses, posing threats to personal privacy. I have omitted the discussion here to focus on the attempts to universalize procedures and because the issue is addressed in chapter 4. Nonetheless, to fully understand the construction of control over DNA analysis and the ramifications of that position, it is necessary to touch briefly on the development of the National DNA Index.

In order for a program such as the Combined DNA Index System to be effective, its data, DNA profiles, must be standardized. The notion of different organizations using different methods of analysis and producing different results is antithetical to the proper function of communication programs such as CODIS. Federal-level initiatives to standardize procedures through both ASCLD and TWGDAM were essential preconditions for CODIS. The enactment of the DNA Identification Act further mobilized CODIS by universalizing its data and establishing the National DNA Index.

The DNA Identification Act also provided the FBI with forty million dollars over five years to implement the National DNA Index and CODIS. A significant portion of the money was to be used for establishing DNA analysis facilities and databases at the local and state levels.

This substantial financial allotment provided the leverage necessary to strengthen federal control over DNA analysis. Unlike the private laboratories that charge high fees, the FBI will perform DNA analysis free of charge.[51] Crucially, in order to access the FBI's services, law enforcement agencies must accept and adhere to FBI standards for DNA analysis. Local and state agencies that agree to this requirement receive CODIS software, training for the program, and continued support from the FBI at no cost. The benefits include access to the national database and the backing and credibility of the FBI laboratory in cases of identification.

The implementation of a program such as CODIS and its national index reinforces the bureau's authoritative position in DNA analysis by further disseminating its procedures for performing the technique. This process was expedited through the reallocation of funds outlined in the DNA Identification Act. In the original 1994 act, the $40 million allotted to the FBI was to be distributed from 1996 to 2000 in five annual installments, of $1 million, $3 million, $5 million, $13.5 million, and $17.5 million. An amendment to the act, the DNA Identification Grants Improvement Act of 1995, redistributed the funds into increments of $1 million, $15 million, $14 million, $6 million, and $4 million.[52] The amendment explains that the FBI and the ASCLD "recommended that this modification be made because of the significant start-up costs to States in creating DNA testing programs and databases." I argue that the redistribution of funds also functioned to expedite control over DNA analysis, by amassing the support and participation of state and local laboratories. The redistribution of funds in 1995 brought large numbers of state and local laboratories under the control of the FBI through their participation in CODIS. In 1990, the pilot year of the program, 14 laboratories were active participants. As of March 2009, there were over 170 participating laboratories. Moneys granted through the DNA Identification Act were essential to the rapid growth in their number.[53]

I am not suggesting that the development of standards for DNA analysis is inherently problematic or cause for concern. Rigorous standards are essential in any identification technique, particularly in one with such diverse and disparate applications as DNA analysis. Indeed, DNA analysis has proven to be an invaluable tool for defendants and persons wishing to prove their innocence. Lawyers Barry Scheck and Peter Neufeld, cited earlier in this chapter as key figures in the DNA wars, have been essential in the use of DNA to prove the innocence of

the wrongly convicted. The two formed the Innocence Project in the Benjamin N. Cardozo School of Law, which had exonerated 234 falsely accused individuals as of March 19, 2009.[54]

Uses of DNA analysis in initiatives such as the Innocence Project highlight the potential for DNA identification to be used toward the fair and equal treatment of individuals. However, what I want to stress here is that the federal control of the technique, via the DNA Identification Act, yields significant power beyond its application in legal and juridical matters. At stake in programs such as CODIS is not simply the control of procedures of analysis by a federal agency but, more importantly, access to and control over genetic information. The continued participation of state and local laboratories in CODIS contributes to the expansion of the National DNA Index, a federally controlled database of genetic identification data.

Conclusion

When DNA analysis entered the courtroom for use in criminal identification, it was promoted as an infallible scientific technique. Its specialized nature prevented it from being questioned by lawyers, judges, or juries, who were forced to rely on the interpretations of "experts." The evidence, the autoradiograph, functioned as a genetic fingerprint. It was taken to testify to the absolute identity of the criminal. As it was developed within the controlled environment of the research laboratory, the autoradiograph entered the courtroom as an immutable and mobile evidentiary document. The unique variables of its construction were rendered invisible in the image, enabling it to move seamlessly and immutably between laboratory and courtroom. Beginning with the *Castro* trial, defense attorneys and scientists started to question the production and interpretation of DNA evidence. The autoradiograph was deconstructed and challenged based on two central features: its specific method of production and the use of population samples in the calculation of probability. What entered the courtroom as an immutable and mobile inscription was made mutable.

The DNA wars, which were waged in professional and public spaces and contexts including journals, government reports, newspaper articles, books, and the courtroom, served as necessary critical forums for the in-

vestigation of a tremendously powerful and far-reaching method of personal identification. These wars addressed the two central problems facing DNA analysis. However, they also pointed to the larger social ramifications of DNA analysis, such as its potential impact on personal privacy and individual rights. In its attempt to address the contentious issues of the DNA wars, the DNA Identification Act established universal procedures for the technique to be used in cases of criminal identification. This was seen as a positive step in alleviating the procedural inequalities of DNA analysis, as the technique was performed by numerous private and public laboratories.

The DNA Identification Act was a central component in the development of federal control over DNA analysis in law enforcement, yielding tremendous discretionary power over the technique to the FBI. An essential precondition for the bureau's authoritative role was the development and regulation of standards for the production of the inscription of DNA, the autoradiograph. However, standardization alone was not enough to cede control over the technique. The specification of the FBI's authority over the technique in law enforcement and the allotment of funds for the dissemination of CODIS were also essential components in the establishment of the bureau's position.

The heightened power and authority facilitated through federal control over DNA analysis and programs such as CODIS and the National DNA Index are far from being mere theoretical concerns. For example, in a 1992 essay, Jeroo S. Kotval, a member of the New York State Legislative Commission on Science and Technology, described that state's confrontation with the FBI. During the DNA wars, the New York State legislature sought to alleviate concerns by requiring that all tests used in state cases be accredited by the state's Department of Health, a notion that would have only strengthened the credibility of the evidence. The FBI opposed this proposition, specifically rejecting the notion that their own tests would have to receive further accreditation by New York State's Department of Health. Kotval notes that, in its opposition, the FBI presented the state with a clear choice:

> If the state were to require the FBI test to be validated and licensed by state authorities before introduction into New York State cases, the FBI would refuse both to do the test for New York State and to allow it access to the nationwide FBI databank.[55]

Kotval's essay highlights the rhetorical nature of the "choice" facing states as well as the ramifications of their decisions. Success stories of CODIS's linking crimes and identifying serial offenders throughout participating states, combined with the severity of cases for which DNA analysis is used (sexual and violent offenses) would assure significant public pressure for states to participate in the program. By early 2009, laboratories in fifty states, the FBI, the U.S. Army, and Puerto Rico were participating in the program.[56] These laboratories and those of private companies such as Orchid Cellmark and Genelex that perform analyses for law enforcement agencies are continually collecting, analyzing, and storing DNA information according to federally controlled protocols.[57] The result is an expanding archive of identification data and, as will be argued in the next chapter, a reconceptualization of criminality and of the body.

DNA analysis remains a key area of interest to law enforcement and will become increasingly prevalent in the twenty-first century as techniques for analysis are refined. The technique is undoubtedly useful to law enforcement agencies in apprehending offenders; however, due to the type of information it affords, DNA analysis also opens numerous possibilities for misuse. Databases of DNA could be accessed according to changing notions of criminality, a practice that threatens to discriminate against individuals based on numerous variables, including race, gender, or sexual orientation. Genetic data could be used to track and identify criminal behavior patterns or to research a biological basis for crime. The potential misuse of this information is further problematized by the interaction of forensic and nonforensic DNA analysis practices facilitated through CODIS. DNA databases are constructed by law enforcement agencies, the military, private biotechnology companies, health and medical institutions, and university laboratories.[58] Information derived from nonforensic investigations, such as that of the Human Genome Project, could be used in conjunction with law enforcement databases to geneticize crime. Therefore, while the DNA wars may have settled and the technique may be procedurally sound, federal control over an identification technology as powerful as DNA must remain a site of key concern.

4

Potential Criminality:
The Body in the Digital Archive

In chapter 2, I argued that the specific collaboration of photography and fingerprint identification at the turn of the nineteenth and twentieth centuries produced a new mode of law enforcement exemplified by a new role of the camera. The camera's ability to capture identification data from the live environment introduced the ability to identify criminals and track crimes independently of the physical presence of the body and free of traditional temporal and material constraints. One effect of this transformation in law enforcement practices was the development of a new archive of identification information. In addition to housing records on known, captured, and incarcerated criminals, this new archive housed latent identification data. Within this developing field of practice, the camera collected aggregates of identification data independently of a clear, immediate need. Instead, data was collected for its potential use in future law enforcement and identification practices.

Although fingerprint identification and photography introduced the potential for law enforcement to collect, store, and use latent identification data, this practice is only now being realized with the advent of digital technologies. The ease of collecting, storing, and sharing images and information made possible through scanners, computers, and digital cameras at the close of the twentieth century and the beginning of the

twenty-first has greatly enhanced the communication, identification, and surveillance capabilities of police. Images of faces, fingerprints, and DNA are now routinely collected and compiled into vast databases, largely free of traditional physical constraints and readily expandable. The continued development of this digital archive gives rise to a space similar to that described by Allan Sekula in his essay "The Body and the Archive." Within this space, the scientific, social, technological, and visual interact in the production of both criminal and normal bodies.

This chapter investigates the contemporary digital archive, distinguishing it from its nineteenth- and twentieth-century ancestors. My concern is not the larger, more abstract inclusive archive described by Sekula but the specific territorialized archives of law enforcement agencies in the United States.[1] I argue that the limitations posed by the physicality of the nineteenth-century archive are largely absent in the new digital space. Thus, contemporary law enforcement agencies increasingly employ digital technologies in the collection of vast amounts of personal identification data. I stress that the construction and use of contemporary information databases in law enforcement practices are dictated and driven by technological capability and prowess and that they pose numerous challenges to the identities of individuals and groups.

Practices of mass data collection and archiving in contemporary law enforcement and criminal identification practices reflect a reconceptualization of criminality and of the body. Combined with mutable conceptions of crime, criminality, and deviance, digital technologies enable law enforcement agencies to bring increasing numbers of bodies under state surveillance through the construction of an increasingly inclusive identification archive. Once archived, the faces, fingerprints, and DNA of these bodies can be identified and reidentified according to the changing parameters and needs of the specific investigation. The body in the digital archive exists as a site of constant surveillance and as something that is always potentially criminal.

Physicality, Inclusivity, and Utility

The archives of law enforcement agencies of the nineteenth and twentieth centuries functioned as spaces for record keeping and for tracking, arresting, and incarcerating recidivists. True to Sekula's description, it was the filing cabinet and not the photograph that defined this archival

mode. For Sekula, the archive provided "a relation of general equivalence between images." This equivalence was guaranteed through "the metrical accuracy of the camera": the camera translated the disparate events of the live world into a system of comparable, static, two-dimensional representations.[2] Similarly, the digital archive provides for "a relation of general equivalence between images"; however, rather than being grounded in the metrical accuracy of the camera, the digital archive is grounded in electronic, binary code. The disparate and diverse representations and inscriptions in contemporary law enforcement and criminal identification practices, the faces, fingerprints, and autoradiographs, are reduced to binary code and are made exchangeable, searchable, and comparable with one another.

The emergence of fingerprint identification at the turn of the nineteenth and twentieth centuries greatly extended the reach of law enforcement by providing police with a highly effective, economical means of identification. Fingerprint records contained identification data in a compact and concise format that was highly amenable to classification and exchange. Similarly, the latency of the fingerprint and the mobility of the camera meant that police could collect identification data independently of the physical presence of the body and without its knowledge. By the opening decades of the twentieth century, equipped with cameras, law enforcement agencies throughout the Western world began to build extensive archives of identification data.

Despite this effort, the large fingerprint archives that developed throughout the twentieth century remained limited by their physicality. Although considerably less cumbersome to produce and to search than Bertillon's identification cards, fingerprint records still occupied distinct physical space and, more importantly, required significant effort to produce, file, and search. The practices of photographing fingerprints necessarily reflected these physical limitations of law enforcement. Although in theory police could photograph a seemingly infinite number of fingerprints, in practice this would render the archive unusable. As the archive grew, searches became increasingly difficult and laborious, and positive matches became increasingly improbable.

The move toward digital technology in law enforcement initiated in the late 1960s and early 1970s offered a solution to the physical limitations of the archive. Reduced to an electronic, binary code, visual and textual identification records occupied significantly smaller space than

their paper predecessors. Similarly, algorithmic searches performed by computer processors achieved results and speeds far greater than anything possible manually. So-called live scan systems, such as that illustrated in Figure 22, enable officers to capture and archive electronic images of an individual's fingerprints, palm prints, and face. Fingerprints can be entered directly into the digital archive from the field using portable, handheld scanners such as that depicted in Figure 23, or if the suspect is not present, prints can be photographed or lifted and brought back to the police station to be scanned and archived using peripheral equipment such as that illustrated in Figure 24. With funding received from the National Institute of Justice, Nanogen of San Diego, California, has developed a portable, handheld DNA scanner.[3] This device fits in the palm of the hand and allows the user to produce a DNA profile directly from a crime scene. Technological innovations such as these give rise to distinctly new practices of data collection and archiving. Whereas the collection and archiving of identification data in the nineteenth and twentieth centuries necessarily reflected the physical limitations associated with the classification, storage, and retrieval of paper records, the digital archive exists largely free of these previous constraints.

I do not want to suggest that the digital archive is lacking all labor or without its own particular constraints. Information databases in law enforcement still require the constant attention of law enforcement personnel. And the rate at which computer technologies have developed has made the upgrade of equipment and programs a constant concern of law enforcement agencies. Indeed, as Richard V. Ericson and Kevin D. Haggerty show in their thorough study of Canadian policing, the adoption of digital technologies in law enforcement has produced numerous unforeseen challenges for police.[4] The authors point to a key paradox of what they call the "computerization of policing": that the introduction of digital technologies to law enforcement, which was to reduce the administrative and records-keeping labor of the police, has in fact increased these demands. That is, although digital technologies can process and search records at speeds impossible with preelectronic systems, these same technologies yield increased amounts of information and also yield new forms of knowledge, both of which require additional police labor. Adding to the complexity is the increased demands placed on police by external institutions. For Ericson and Haggerty, policing in the late twentieth and early twenty-first centuries is based in the

Figure 22. Cogent CLS1 live scan booking station. Live scan systems enable law enforcement personnel to capture images of an individual's face, finger-prints, and palm prints. Courtesy of Cogent, Inc.

Figure 23. Cogent Systems' BlueCheck mobile fingerprint scanner. This hand-held portable device allows the user to record and receive fingerprints in the field and can also capture mug shots. It uses Bluetooth technology to communicate wirelessly with other devices such as a computer, personal digital assistant (PDA), or cell phone. Courtesy of Cogent, Inc.

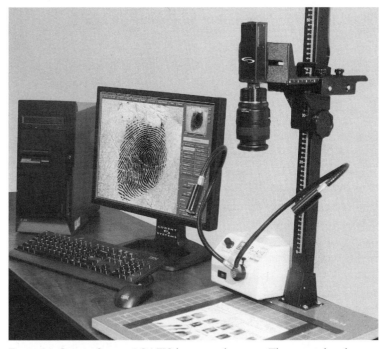

Figure 24. Cogent Systems' CAFIS latent workstation. These peripheral devices allow law enforcement personnel to digitally record, archive, and analyze fingerprints. Courtesy of Cogent, Inc.

assessment and management of risk, a task that unites police with external institutions such as insurance companies and health, education, welfare, and criminal justice agencies. The authors refer to contemporary police as "knowledge workers" and stress the extent to which their work is dictated by the needs of external institutions.

In giving substantial agency to external institutions, Ericson and Haggerty portray police officers as little more than subordinates of insurance agencies. While I would argue that police have greater agency than Ericson and Haggerty suggest, their study is particularly effective' in highlighting the complexity of law enforcement practices in an electronically mediated world. The adoption of digital technologies into policing has given rise not only to new practices of identification but also to heightened communications networks, uniting police with numerous other agencies. In addition, and as exemplified in the practice of DNA analysis addressed in chapter 3, identification is no longer strictly

the purview of police but is instead produced through a network of institutions and agencies and within a competitive, profit-driven industry. Police routinely outsource work to identification companies such as Orchid Cellmark and Genelex, which employ their own idiosyncratic procedures and techniques. Further, the identification equipment used by police and the external institutions with which they cooperate is built by a number of companies, including NEC, Printrak, Cogent Systems, and Lockheed Martin, which compete for lucrative law enforcement contracts. The data produced by one agency or through one technology is not always readily compatible with data produced by a competitor. The diversity of institutions and agencies that participate in the collection and exchange of identification information as well as the different computer programs and technologies used renders the control of data more problematic than with preelectronic practices.

The control of identification data is not a new problem for police and is not unique to the digital archive. Attempts to centralize and standardize the collection, storage, and exchange of identification data have been present since the formation of the modern police force in the nineteenth century. The competition between Bertillonage and fingerprinting at the turn of the twentieth century can be read as a competition between systems of information management as much as a competition between techniques of identification. Nonetheless, the ease and speed with which digital technologies can produce, store, and exchange information has exacerbated the difficulty of centralizing and controlling it. This subsequently calls into question the ability of law enforcement to collect and store identification data with the goal of producing an inclusive identification archive as well as the state's ability to use such data in the surveillance and control of populations. For example, writing on surveillance in the twenty-first century, William Bogard concludes, "Ultimately no police power is capable of controlling the deterritorialization of surveillance."[5] Bogard's comment is indicative of a developing trend in the analysis of surveillance and social control in an electronically mediated world. Borrowing from the work of Gilles Deleuze and Félix Guattari, Bogard understands power, surveillance, and social control not as the products of an all-seeing state apparatus but instead as "assemblages" of information flows.[6] The existence of an all-seeing, centralized state apparatus is viewed as anathema to surveillance in contemporary society, which is described as fragmented, decentralized,

and deterritorialized. For Bogard, and for others writing on surveillance and social control in an information society, the diffusion, fluidity, and sheer quantity of information precludes its centralization and control, thus problematizing the notion of an inclusive identification archive and the role of the state in the surveillance and control of populations.[7]

If the fluidity and quantity of information emerge as challenges to the state in the control and use of identification data, the "nature" of digital technologies also suggests distinct possibilities for resistance to and subversion of police and state power. As Shoshana Zuboff notes, digital technologies are unique in that their application not only automates but also "informates." She writes: "The devices that automate by translating information into action also register data about those automated activities, thus generating new streams of information."[8] As informating devices, the digital technologies used by police could therefore also be used in the surveillance and monitoring of police activity by recording information on the actions of those employing the technology. The extent to which new technologies could be used to "police the police" remains to be seen; nonetheless, it is a possibility enabled through digital media.[9]

As with the use of photographic representation in law enforcement practices, the impacts of digital technologies on policing will ultimately vary according to their specific application and context of use. In this chapter I stress that the physical limitations restricting the collection of identification data during the nineteenth and most of the twentieth centuries are disappearing with the continued development and use of digital technologies. This transformation in the capabilities for data collection highlights a primary feature of the digital archive, and one that clearly distinguishes it from its predecessors: inclusivity. Michael Smith, a member of the National Institute of Justice's National Commission on the Future of DNA Evidence, explains the notion of inclusivity in relation to information databases: "The more inclusive a searchable identification database is, the more useful it is for the excluding or including of individuals based on evidence found at a crime scene." He adds, "the more inclusive, the more useful."[10]

This is the paradox of the digital archive: whereas the utility of the paper archives of the nineteenth and twentieth centuries waned in relation to their growth, the utility of the digital archive increases with each addition to the database. A completely inclusive digital archive,

containing identification data on every member of society, would ensure—at least theoretically—that no crime committed would go unsolved and that no criminal would go unidentified. And while it is true
that a centralized, fully inclusive meta-archive is still far from a technological reality, law enforcement agencies collect and store data with
an eye toward this goal. A primary result of this practice is a reconceptualization of criminality and the body. Constant data collection and
ubiquitous police surveillance, in the form of an inclusive identification
program, positions the body as something that is potentially criminal.
The presumption of innocence is therefore replaced with the presumption of guilt. Criminality exists in every record of the digital archive
and in every body those records represent. It is something that is latent
in all of us and, therefore, awaiting identification.

Law enforcement and criminal identification practices based on a
model of inclusivity pose new challenges to the rights and freedoms of
individuals and groups. In an electronically mediated world, identity is
increasingly shaped through one's representation in digital archives.
Work in the emerging field of surveillance studies emphasizes that an
individual's identity is greatly influenced by his or her representation in
identification archives in the form of "digital personas," "data-images,"
or "data-doubles."[11] The collection and sharing of information by law
enforcement agencies, banks, insurance companies, health and welfare
agencies, educational institutions, and commercial businesses play a
significant role in shaping one's abilities to live, work, and be a mobile
member of society.

In addition to the challenges posed by one's representation as a data-
double, the digital archive also poses new threats to identity because of
a new way in which the criminal is made visible. As has been shown
throughout this book, the act of making the criminal visible has been a
primary component of modern and contemporary police practices. Prior
to the adoption of digital technologies by law enforcement, the criminal was made visible through his or her direct representation. For example, James White's criminal identity was made visible through his
presence in front of the police's camera. Similarly, anthropometry and
fingerprinting made the criminal visible through the direct documentation of specific bodily features. However, with the advent of digital technologies, the criminal is made visible in a new way. Visual representations of identity are produced not just from directly photographing,

measuring, or fingerprinting the body but also from the visualization of data accumulated in identification archives. In contemporary identification practices, mug shots, fingerprints, and autoradiographs all exist as electronic code and are made visible and distinguishable through the application and translation of archived data. In this way, and in contrast to the identities in the paper archives of the nineteenth and twentieth centuries, identity is literally produced through the visualization of data. As such, in addition to its collection, the use, application, or visualization of identification data is of particular concern in addressing contemporary police practices.

Whereas fingerprint identification and photography introduced the potential for law enforcement to collect and use masses of identification data, the adoption of digital technologies a century later has made it a reality. The filing cabinet has been replaced by the computer, producing new capabilities for police as well as new concerns regarding the collection and control of personal identification information. To exemplify, I turn to an examination of two digital archives fundamental to contemporary and future law enforcement, the National Crime Information Center 2000 and the Combined DNA Index System. These databases effectively illustrate the concerted focus in contemporary law enforcement on the accumulation and archiving of identification data.

NCIC 2000 and CODIS

The National Crime Information Center (NCIC) was initiated in 1967 to facilitate communication between law enforcement agencies in the United States. The program originally housed data on wanted persons and on stolen vehicles, guns, license plates, and other articles. A missing-persons database was added in 1975, and an unidentified-persons database was added in 1982.[12] Data is entered into NCIC by local law enforcement agencies. These agencies use standardized data fields and entry codes to promote the uniformity of the information entered. Data fields include various forms of identifying information: license plate numbers, serial numbers or manufacturing numbers in the case of objects, and variables such as height, weight, age, and place of birth in the case of people.[13] A unique identification code given to each participating agency is also entered to indicate the source of the data and to protect against unauthorized access. Entered data is managed through a designated state

agency, called a control terminal agency (CTA), and forwarded into the centralized database of the FBI. Law enforcement agencies at local, state, and federal levels share and access information over a secure telecommunications network.

Use of NCIC is restricted to local, state, federal, and other law enforcement agencies, such as the Royal Canadian Mounted Police. Agencies participating in the program must adhere to security safeguards administered and monitored by the FBI.[14] Searches proceed according to the fields used for data entry. Searches cross-reference all databases so that a search for an individual's name will cross-reference the missing and wanted persons files as well as other relevant databases.[15] Potential matches are ranked through a scoring system based on the number of data fields matching the search parameters.[16] For example, an officer at a local agency in Florida can search the system using the name, height, weight, and age of a suspect. If a suspect is pulled over for a traffic violation, data on the vehicle, such as its make, model, serial number, and license plate, can also be entered. The system returns records matching the search parameters, enabling the officer in Florida to see whether the person apprehended is wanted in relation to other crimes throughout the country or whether the vehicle has been reported lost or stolen. The officer can then use the agency identification code to contact the various agencies responsible for entering the original data and can access the entirety of records on the individual and vehicle in question.

During the 1990s, the FBI received $183 million in funding to upgrade and expand the system. The new program, entitled NCIC 2000, houses seventeen cross-referenceable databases: stolen articles, foreign fugitives, stolen guns, criminal history queries, stolen license plates, deported felons, missing persons, criminal justice agency identifiers, stolen securities, stolen boats, gang and terrorist members, unidentified persons, the U.S. Secret Service Protective File, stolen vehicles, persons subject to protection orders, wanted persons, and the Canadian Police Information Center.[17] This last database is the Canadian equivalent to NCIC 2000 and houses over nine million records.[18]

The upgrade of NCIC coincided with a larger FBI project to reevaluate and restructure its Identification Division. In 1989, the FBI, in cooperation with the NCIC Advisory Policy Board, conducted a study on the division.[19] As noted in chapter 2, the Identification Division

was founded in 1924 to serve as a national site for the storage and ex-change of identification information. A central feature driving the estab-lishment of the division was the need to develop a national fingerprint archive, thereby uniting the disparate fingerprint archives throughout the country. Similarly, the 1989 study of the Identification Division was in response to the need to create better storage and exchange of criminal justice information. The adoption of digital technologies by law enforcement agencies across the United States gave rise to a dis-parate array of digital archives, represented in the numerous automated fingerprint identification system databases referenced in chapter 2.

The result of the 1989 study was the complete reconfiguration and relocation of the Identification Division. Renamed the Criminal Justice Information Services Division in 1992, the new division constructed a new five-hundred-thousand-square-foot complex on 986 acres of land in Clarksburg, West Virginia.[20] The Criminal Justice Information Serv-ices Division remains the largest unit of the FBI. In addition to housing the seventeen databases of NCIC 2000, the division also houses the National Incident-Based Report System and the Integrated Automated Fingerprint Identification System, a program uniting the various AFIS databases in law enforcement agencies throughout the country.[21]

The central feature of the NCIC upgrade was the adoption of digital imaging technologies. The new program enables officers to collect, store, and share digital images and information from a variety of locations. To take full advantage of the system, participating agencies are encouraged to purchase a computer, laser printer, document scanner, single-fingerprint scanner, and digital camera. Agencies are responsible for hardware costs, but the FBI provides software and support free of charge. Using the digital camera, scanner, or single-fingerprint scanner, officers can enter digital images of faces, fingerprints, signatures, and up to ten other iden-tifying images per record. The program suggests that officers collect images of scars, tattoos, and other bodily marks, a fact that draws im-mediate parallels to nineteenth-century criminal anthropology and its focus on the outward "signs" of criminality. These images can be en-tered directly from the field and can be relayed to other officers through laptops and through mobile data terminals (MDTs) attached to the dashboards of police cruisers.[22] In addition, police now routinely use wireless handheld devices to connect to each other and to the informa-tion databases.

NCIC 2000 is searched in the same manner as its predecessor. However, with the advent of digital imaging technologies, officers are no longer restricted to textual descriptors but can enter and access image files from a variety of remote locations. The officer in Florida submitting the information described above can now submit and receive mug shots, fingerprints, and other identifying images for comparison. Using the single-fingerprint scanner, the officer can scan the print of the individual in question for a search against the records of the Integrated Automated Fingerprint Identification System.

NCIC processed two million transactions over the entirety of its inaugural year. By the middle of the 1980s, the program was processing 400,000 transactions per day.[23] Statistics for the year 2000 show that the updated system was processing 2.5 million transactions per day.[24] On March 15, 2002, NCIC 2000 set a new record with 3,295,587 transactions in a single day.[25] Although only officially launched in 1999, NCIC 2000 now links eighty thousand criminal justice agencies throughout the United States, the U.S. Virgin Islands, Puerto Rico, and Canada.[26] The centralized fingerprint database currently houses over 35 million fingerprint records with over 630 million individual fingerprint images, evidence of the depth and size of this developing archive.[27] Fingerprint searches that took four to six months in the 1980s needed only two hours by 2001.[28]

Contemporaneous with the update of NCIC and the transformation of the Identification Division, the FBI began a pilot program called the Combined DNA Index System (CODIS). Like NCIC 2000, the purpose of the DNA index system is to facilitate the exchange of identification data between law enforcement agencies. The program unites local DNA index systems (LDISs) and state DNA index systems (SDISs) with the National DNA Index System (NDIS). As outlined in chapter 3, participating laboratories must meet guidelines for analysis established and monitored by the FBI.

Local agencies collect and forward genetic data through specified state agencies and into the centralized National DNA Index of the FBI laboratory. The specific displacement of bands in the DNA profile is measured with the use of a computer, and the profile is stored as a numeric relation. Searches proceed by matching comparable numeric codes. As with NCIC 2000, a match to the National DNA Index provides additional refer-

ence information, including "[a] laboratory identifier, sample identifier, the associated DNA profile, and details of the search parameters."[29]

Compared to NCIC 2000, the Combined DNA Index System is relatively small and limited in its capabilities. This is largely due to the type of data being stored and the newness of DNA analysis. DNA contains a wealth of personal information, far more than other modes of identification, and therefore presents increased dangers associated with the misuse of data. Thus, DNA databases are not currently interfaced with other systems, as the Integrated Automated Fingerprint Identification System is with the National Crime Information Center 2000. Further, the production of DNA profiles, represented in the autoradiograph, is a time- and labor-intensive process. The initial technique for performing DNA analysis, called restriction fragment length polymorphism (RFLP) analysis, took up to six weeks to produce a DNA profile. By the close of the 1990s, a newer, faster method of analysis called short tandem repeat (STR) analysis had been developed.[30] Although STR analysis could produce results within forty-eight hours, in actual practice, most analyses take between four and five weeks. In a January 15, 2003, press release, Orchid Cellmark announced its new "DNA Express Service," which promised DNA analysis results to law enforcement agencies in five days.[31]

Despite these technological innovations, the production of DNA profiles is still much slower than the production of fingerprinting data. Combine that slowness with the ease with which DNA samples can be collected, and the result is that law enforcement agencies remain plagued by backlogs of unanalyzed samples. In 2000, it was estimated that there were roughly 1.5 million backlogged samples throughout agencies in the United States and that clearing the backlog would need seventy-five million dollars in funding.[32] In 2003 a study funded by the National Institute of Justice found that there were over half a million active criminal cases in which DNA evidence was awaiting either submission or analysis. Five hundred million dollars in federal level grants were awarded between 2000 and 2004 to clear backlogs in the United States, and in 2008, then president George W. Bush announced plans for $1.6 billion in additional funding over six years.[33]

As discussed in chapter 3, in 1990, during the program's trial phase, there were 14 laboratories participating in the Combined DNA Index

System. In 1994, the DNA Identification Act provided the FBI with forty million dollars to expand its program. The majority of this money was used to develop analysis facilities and communications capabilities at the state and local level. As of early 2009, there were over 170 participating laboratories throughout the United States and Puerto Rico. The FBI's National Index houses over 6.5 million DNA profiles from convicted offenders and over 250,000 unidentified or latent profiles from crime scenes.[34]

The adoption of digital technologies by law enforcement and their cooperation with initiatives such as the National Crime Information Center 2000 and the Combined DNA Index System are justified through rhetoric that describes these systems as a necessary response to increasingly mobile criminals. MDTs, laptops, and handheld wireless devices connect officers on foot, on bicycles, and in patrol cars to each other and to the digital archive.[35] Law enforcement journals and government reports and press releases are filled with success stories in which an offender apprehended in one state is linked to crimes in another through these technologies. Such success stories are instrumental in securing funding for law enforcement to continue to develop and implement these technologies and to clear the backlogged DNA samples.

I do not question that the adoption of digital technologies by police has been useful in apprehending serial offenders and in solving and preventing serious crimes. Indeed, the advanced abilities to collect, store, retrieve, and exchange identification data that have been made possible by digital technologies are important and even essential components of policing in a globalized society. Nonetheless, I stress that digital technologies have greatly extended the ability of law enforcement agencies to collect and archive masses of identification data and that such practices are cause for concern. As noted earlier, the use of identification data housed in law enforcement archives and those of the institutions with which they cooperate can play a significant role in shaping one's abilities as a member of society. Despite this concern, the increased technological capabilities of law enforcement have met little opposition. Instead, these technologies and the programs they serve are promoted and, I would argue, publicly accepted as safe, benign, and even necessary in a society perceived as risky or dangerous. Importantly, legislation governing the permissible collection and storage of identification data

and the enforcement of that legislation is either absent or insufficient in relation to the heightened capabilities of police.

NCIC 2000 has received minimal critical attention, primarily because of the type of information it contains. Mug shots, fingerprints, and serial numbers of stolen vehicles, boats, and guns are accepted as relatively banal identification data, which is to say that there is little concern that this information could be used for anything other than identification. Further, I would argue that there is a common cultural belief that the collection and storage of data in NCIC 2000 is restricted to known criminals and therefore does not warrant the concern of the everyday citizen.

Of the limited work addressing the National Crime Information Center, two 1993 studies showed the system to have significant flaws.[36] The studies tested the accuracy of the system and found it to be compromised in two ways: data was entered incorrectly, and entire fields of data were often omitted. The reports concluded that the system was subject to misidentifications that could in turn lead to false arrests. Indeed, a 1985 New York Times article reported that NCIC was producing an average of twelve thousand false database matches per day.[37]

Not only has data been entered incorrectly, producing false identifications, but it has also been subject to misuse. In 1993, the U.S. General Accounting Office issued a report highlighting the misuse of information contained in the National Crime Information Center.[38] The report was a response to a 1991 incident in which twenty individuals with access to the NCIC sold criminal-history information obtained from the system to third parties. The report also found several instances where records had been altered or completely deleted.

The upgrade of NCIC during the 1990s attempted to take account of the problems and potential dangers associated with the system that had been identified through these studies and reports. The upgrade included extensive data-entry checks, including point-of-entry checks for errors and data-validation procedures to assure that information was uniform and that all mandatory data fields had appropriate entries.[39] To protect against unauthorized access to the information, agencies now communicate over local Intranets or through virtual private networks (VPNs). Continued tests of the National Crime Information Center, such as those of 1993, are needed to address procedural issues associated with

the program. More importantly, critical investigation and inquiry from external parties is needed to address the larger social and cultural issues associated with the archiving of personal identification information.

Importantly, regulation governing the collection of mug shots, fingerprints, signatures, and other identification data (excluding DNA, which will be addressed shortly) varies according to the nature of the investigation. A hypothetical case presented during my work with the Metropolitan Toronto Police serves to illustrate the point. A crime occurs at a restaurant and officers are called to the scene. All property within the venue is subject to investigation. Officers lift or photograph finger-prints from every drinking glass in the establishment. This results in hundreds of fingerprints, which are then archived into an automated fingerprint identification system database and linked to the crime through a reference number. An individual committing a traffic violation in Florida, years after the fictional example, can be linked to a past crime through his or her patronage of a Toronto restaurant.

The hypothetical example seems improbable or unlikely. As noted earlier in the chapter, the computerization of policing is not without its problems, and the existence of a completely inclusive, centralized archive is far from a reality. Policing in the late twentieth and early twenty-first centuries is dominated by multiple, disparate, and often competing iden-tification archives.[40] Nonetheless, and despite its improbability, the fictional example does illustrate a key paradox of the digital archive. Digital technologies enable law enforcement agencies to collect and store tremendous sums of identification data. However, this informa-tion is often collected independently of any consideration of its actual, practical use. This, I argue, is indicative of a fundamental disconnect in contemporary law enforcement practices, in which identification data is increasingly collected for its potential use.

There are at least two significant concerns with the collection of iden-tification data based on its potential use. First, practices of mass data collection transform the focus of law enforcement from the individual, physical body to a larger, abstract social body. All bodies, not just crimi-nal bodies, are represented in the archive, thus creating a more inclusive surveillance program. Second, identification data collected and stored in the digital archive can be continually accessed and reinterpreted ac-cording to mutable definitions of crime and criminality and depending on the changing needs or mission of those in control of the data. This

is of particular concern, as law enforcement agencies collect and share information with numerous external bodies.

The problematic nature of data collection in contemporary law enforcement practices is nowhere more clear than with identification by DNA and the construction of DNA databases. In contrast to NCIC 2000, CODIS has received a significant amount of critical attention. More specifically, the construction of the National DNA Index has caused concern from a variety of legal, scientific, and social perspectives. The concern radiates from the fact that DNA contains a wealth of personal information far beyond what is necessary for identification purposes. Work within sociology, cultural studies, and the social study of science points to the dangers of discrimination based on genetic information.[41] For example, medical insurance companies and health care providers could set a different fee schedule for persons exhibiting the BRCA1 gene, which is linked to breast cancer. Similarly, employers could access and use genetic information to discriminate against individuals during the hiring process. In addition to these social and cultural concerns, work from medicine, law, and public policy has addressed the legal and policy issues associated with privacy and confidentiality.[42] Of chief importance in this debate is the protection of privacy and confidentiality and against unreasonable search and seizure as guaranteed in the Fourth Amendment of the U.S. Constitution and in the Canadian Charter of Rights and Freedoms.[43]

The DNA Identification Act addressed these concerns by placing tight restrictions on the collection, storage, and use of genetic information in law enforcement practices. Proponents of the National DNA Index and the Combined DNA Index System rightly note that, under the DNA Identification Act, only persons convicted of certain sexual and violent crimes will have their DNA stored in the national index. Proponents also note that the database contains DNA profiles and not samples. As noted in chapter 3, profiles represent specific noncoding fragments of DNA and do not offer biological information about an individual. In this sense, it is argued, the National DNA Index employs appropriate safeguards to protect against the misuse of genetic identification data.

While the DNA Identification Act does safeguard practices surrounding the inclusion of DNA profiles within the National DNA Index, it does not regulate the collection and storage of DNA at the local and

state levels. Thus, local and state agencies across the country routinely collect and store genetic data from an increasingly diverse group of offenses. Recall that DNA's use in law enforcement was developed to aid in the investigation of specific, serial sexual and violent crimes. Initial laws governing the collection of DNA restricted it to those convicted of such crimes. For example, California enacted the first DNA databanking law but restricted the collection of DNA to adult registered sex offenders. However, by 1994 its data-banking law was among the broadest in the nation. The California law was expanded to allow the collection of DNA from a variety of non-sex-related crimes, including "certain types of assault and battery on custodial officers, transportation personnel, or jurors; contributing to the delinquency of a minor, and inducing disobedience to a court order."[44]

California's expanding law is indicative of a trend throughout the United States. In a 1994 study of state legislation governing DNA collection and data-banking, Jean McEwen and Philip R. Reilly found tremendous discrepancies among state laws and a continued trend toward broadening laws to be more inclusive. They found that several states allowed for the collection of genetic material from an incredibly diverse set of offenses, including "lewd and lascivious conduct," "indecent exposure," "promoting or compelling prostitution," "engaging in or abetting bigamy," "loitering near public toilets," and "possession of child pornography." At least one state allowed for samples to be taken from persons arrested but not convicted.[45] A subsequent study in 2000 by Rebecca Sasser Peterson supports McEwen and Reilly's findings.[46] She notes that Alabama, New Mexico, Virginia, and Wyoming require DNA samples from anyone convicted of a felony; Louisiana requires samples from all individuals arrested on sex offenses, whether convicted or not; and Arizona, Kansas, and Oregon require samples from juveniles arrested in relation to sex crimes.[47] This last case is particularly alarming, as the data is collected and stored for future use when the individual reaches the age of majority. In his study of the Canadian criminal justice system, Neil Gerlach suggests that a similar trend in broadening DNA laws is developing in Canada as well.[48]

To reiterate, my concern is not with the exchange of identification data between law enforcement agencies, nor is it with the misuse of that information by external, third parties, although these remain very significant issues. Instead, my concern rests with the practice of data

collection. The continued collection of data in the digital archive, motivated by its potential use in future law enforcement practices, constructs the body as a site of potential criminality. Chapters 2 and 3 described fingerprints and autoradiographs as highly effective and powerful inscriptions. Importantly, as inscriptions, fingerprints and autoradiographs attest only to the presence of a specific body at a specific time and location. Once archived, these inscriptions remain immutable references to innumerable bodies, throughout innumerable contexts, times, and locations. The individual body's identity as normal or deviant changes with the use of the archive and with the visualization of its data.

DNA analysis was introduced to law enforcement for the express purpose of assisting in the investigation of serial sexual and violent crimes. It was useful in these cases because traditional forms of evidence, such as eyewitnesses, were absent and biological materials were often all that remained. Because DNA contains a wealth of personal information beyond that necessary for the identification process, initial laws placed tight restrictions on its collection and use. However, these laws quickly expanded to allow sample collection for a variety of offenses. As a result, law enforcement agencies have amassed hundreds of thousands of backlogged samples of DNA. As with practices of data collection in NCIC 2000, this attests to a fundamental disconnect in contemporary law enforcement between data collection and its use. Under expanding laws, DNA is collected far faster than it can be analyzed and used. What then are the purpose and rationale behind this data collection? And what is at stake in this process?

A clear effect of this practice of mass data collection is to bring increasing numbers of bodies into the archive, making it more inclusive. An inclusive identification archive is of clear benefit to law enforcement, related state agencies, and the external institutions with which they cooperate. More bodies in the archive means more database hits, more crimes solved, more success stories, and continued funding. However, I stress that the accumulation of DNA samples and other identification data in this effort betrays the rationale for using these technologies in law enforcement and poses clear threats of discrimination.

Archived DNA profiles of persons convicted of indecent exposure pose no clear use for police. Flashers and loiterers are not apprehended through a DNA database search! Importantly, once archived, DNA can be reaccessed and reinterpreted. While it is true that the National DNA

Index stores only profiles and not samples, local and state databases routinely store both the profile and the sample from which it was derived.[49] Profiles entered into local, state, and federal databases are assigned a reference number identifying the agency responsible for entering the data and the specific case. These reference numbers can be used to access the sample from which the profile was produced. The potential danger in this practice is that the information will be accessed and used based on changing definitions of crime and criminality. Genetic research on behavior, sexuality, race, gender, or any other variable can be used to establish new criteria for searching and using the information in the digital archive.

For example, studies appearing in a 1996 issue of the journal *Nature Genetics* suggested a link between a specific gene (the *D4* dopamine receptor gene) and the behavioral trait of novelty seeking.[50] Law enforcement and related state agencies can use this information to search the archive for individuals having this specific gene. The individual brought into the archive on a charge of indecent exposure could be rearrested and incarcerated based on his now presumed genetic predisposition for risky behavior. The search for genetic links for human traits and behavior such as that of the dopamine receptor and the search for the "homosexual" gene suggest a return to Lombrosian criminal anthropology, only the "signs" of pathology are now found in rather than on the body.[51] Such an approach presupposes a simplistic cause-and-effect link between gene and trait and erroneously treats the gene as what Evelyn Fox Keller describes as a "master molecule," ignoring the complex relationships between genes in producing human traits as well as the myriad of environmental factors involved.[52]

Just as the laws governing DNA collection are expanding, so too can the laws governing its use. The DNA Identification Act permits the collection and use of DNA for "law enforcement purposes." As Barry Scheck warns, this term is "disturbingly broad" and could permit the use of genetic information and exchange between a variety of institutions, including immigration, child support, and welfare agencies.[53] In the same way that research on the *D4* dopamine receptor gene can lead to a new notion of criminality and yield new parameters for searching the archives of law enforcement agencies, so too can this information be extended through the social programs and apparatuses described by Scheck. Children carrying the gene could be identified as precrimi-

nal, placing them under constant surveillance and subjecting them to continued discrimination. Similarly, non–U.S. citizens carrying the gene and trying to enter the country could be denied access, and those already residing in the United States could be deported.

Conclusion

The adoption of digital technologies by law enforcement and related state agencies has undoubtedly enhanced the communications, identification, and surveillance capabilities of police. Programs such as NCIC 2000 and CODIS and their respective archives, including the Integrated Automated Fingerprint Identification System and the National DNA Index, enable police to collect, store, and exchange identification data in ways and in numbers that were impossible with preelectronic systems. As a result, digital technologies enable police to bring increasing numbers of bodies under surveillance through their representation in the digital archive. However, and as noted at the beginning of the chapter, the digital archive is not without its own particular challenges and constraints. Chief among these is the challenge of effectively controlling and using the masses of identification data produced within the competitive, profit-driven identification industry. In this way, the digital archive presents a paradox: digital technologies enable the production of an inclusive identification archive within which all members of society are represented; however, they also contribute to the fragmentation of identification practices, problematizing the control of data and the state's role in the surveillance of populations.

While it is true that identification is no longer strictly the purview of police, as it was in the nineteenth century, and that the control of identification data is more problematic now than it was then, I stress that the police and the state still play a primary role in this network of activity. Emphases on the fragmentation, decentralization, and deterritorialization of surveillance or on more mundane practices of "dataveillance" can underestimate and even, as in the quotation from Bogard cited earlier in the chapter, deny the latent power of the state in the surveillance and control of populations. Both NCIC 2000 and CODIS show a concerted effort by the state to collect identification data from an increasing number of bodies, often without any clear rationale for use. As I have argued throughout this chapter, this not only creates a

more inclusive surveillance program, but it also participates in a recon-
ceptualization of criminality and the body. Law enforcement and iden-
tification programs based on a model of inclusivity presuppose the body
as something that is potentially criminal. Further, the accumulation of
identification data in programs including NCIC 2000 and CODIS poses
clear threats to the identities of those represented in the archive. As
with the paper archives of the nineteenth and twentieth centuries, the
digital archive functions in the state-sanctioned surveillance and con-
trol of targeted populations.

To illustrate and to conclude, I want to discuss briefly the current
effort to collect and use identification data under the rubric of a "war
on terror," a topic that is addressed at length in chapter 5. In this war,
then U.S. attorney general John Ashcroft's National Security Entry–
Exit Registration System (NSEERS) digitally captured the fingerprints
and faces of visitors to the United States who originated from countries
deemed a national threat. Law enforcement personnel at border cross-
ings, in airports, and at other ports of entry used live scan systems to
collect this identification data. NSEERS produced "hits" (fingerprint
matches) to fingerprints in the databases of NCIC 2000.[54] Individuals
identified through these hits were acted upon according to a specific,
contemporary conception of criminality. This conception propagates
the notion that there is a connection between race, gender, nationality,
and the propensity to commit criminal acts, in this case defined as ter-
rorist acts, and that connection carries severe and maximum penalties.
An individual born in one of the countries deemed a national threat
who is brought into the archive in relation to a petty crime in 1990 can
be reidentified in 2009 as a potential threat to national security. This
reidentification is made based solely on the individual's place of birth.
Similarly, a visitor to the United States brought into the archive in
2009 under the registration system can be reidentified as criminal in
2020 according to mutable definitions of what constitutes crime and
criminality. In each case, the individual's presence in the digital archive
remains immutable, but his or her identity, rights, and freedoms as an
innocent citizen, petty thief, terrorist, national threat, or otherwise
changes with the nature of the investigation and the assembly and visuali-
zation of data.

The National Security Entry–Exit Registration System illustrates
the problematic nature of the digital archive. Practices of mass data

collection such as that of the registration system and their cooperation with programs such as NCIC 2000 and CODIS are made possible through digital technologies. Discourses driven by fear and notions of national threat mobilize these technologies and legalize practices of data collection that are overtly discriminatory and that are degrading and humiliating to those subjected to collection. The significant and far-reaching social ramifications of these practices are ignored in favor of technological capability and the continued expansion of the archive.

In 2004 Ashcroft's registration system was subsumed under the Department of Homeland Security's U.S. Visitor and Immigrant Status Indicator Technology program (US-VISIT), an initiative that documents each of the country's thirty-five million annual visitors.[55] The mandatory collection of images of faces and fingerprints in this effort is defended as a necessary response to the events of September 11, 2001, and to a terrorist threat promoted as invisible and omnipresent. The purpose and rationale for collecting and storing identification data on such a vast scale must be questioned. Long after the war on terror has come to completion, the registration system will continue to collect data for its archive. What is the purpose of this process of collection? Does the collection of data fulfill a clear need of law enforcement, or is it motivated by paranoia and fear? What are the social, political, and cultural consequences of practices of data collection that are clearly based in racial and religious discrimination?

The enhanced capabilities of law enforcement and state agencies and the unchecked, exponential expansion of the digital archive demand a reinvestigation of the rationale and ethical issues associated with the collection, storage, and use of identification data. Digital technologies do not merely expand the breadth of the archive and increase the speed with which it can be searched. Rather, they announce a restructuring of law enforcement and criminal identification practices. In the nineteenth-century archive, the image captured the criminal, representing his identity within its frame. In the new digital space, the image captures the body independently of any such fixed identity. Criminality is less a function of an actual criminal event or body than it is an attribute that all bodies are prone to. As a result, all bodies, not just those identified as criminal, are sites to be monitored and administered. The body in the digital archive exists as something that is potentially criminal and, therefore, as something warranting continued surveillance.

5

Visible Criminality: Data Collection, Border Security, and Public Display

In the introduction to this book, I posed a series of questions regarding the changing nature of visual representation in law enforcement and criminal identification practices from the nineteenth century to the present. I asked, to what extent are contemporary methods of visual representation merely new manifestations of nineteenth-century practices? What new issues have arisen, and what issues have disappeared? And, perhaps most important, what is at stake in these new methods of representation, as they assist in the construction of identity, with its attendant freedoms and limitations?

To address these questions and to conclude the book, I propose four primary and interrelated conclusions. First, law enforcement and identification practices have become increasingly distanced from traditional spatial and temporal constraints. In contemporary law enforcement practices, identification often takes place independently of the physical presence and knowledge of the body. Second, the scope of data collection in modern and contemporary law enforcement practices has continually expanded, so that the focus of law enforcement is no longer the individual offender but entire populations. The collection and archiving of images in rogues' galleries, anthropometry, fingerprinting, DNA analysis,

and registration programs and identification databases show a clear trend toward inclusivity. Third, contemporary law enforcement and criminal identification practices reflect a reconceptualization of criminality and the body. Criminality is no longer tied to the individual body of the offender but is now something that could be found in all bodies and in the visualization of the data that represents those bodies. Fourth, the large-scale collection and archiving of identification data in contemporary police practices poses distinctly new challenges to the identities and abilities of individuals and groups as the data can be accessed and interpreted according to mutable conceptions of criminality. Once brought into the archive, all bodies can be identified and reidentified according to the changing needs of those in control of the data and the specific parameters for searching and using the archive. This last issue is further problematized by the competitive, profit-driven nature of contemporary identification practices.

I do not want to suggest a teleology of visual representation in police practices from rogues' galleries to information databases in which police and the state accrued greater power and in which identification became increasingly efficient and accurate. Indeed, and as identified in chapter 4, the use of visual representation in contemporary law enforcement and criminal identification practices remains a highly problematic and complex topic. Enhanced technological capabilities enable police to collect and archive a seemingly limitless amount of identification data, suggesting heightened forms of state surveillance and power. However, the increasingly specialized, fragmented, and competitive nature of criminal identification as a field of practice renders the control of identification data more problematic than in earlier police practices. This is exemplified in the contestation surrounding DNA analysis in law enforcement and in the continued outsourcing of identification work by law enforcement agencies to external companies.

To further develop the four conclusions proposed above and to address the questions posed at the beginning of the book, this chapter analyzes two contemporary identification programs: the National Security Entry–Exit Registration System (NSEERS) and the U.S. Visitor and Immigrant Status Indicator Technology Program (US-VISIT). NSEERS and US-VISIT are post–September 11, 2001, initiatives to document persons entering and leaving the United States. The continued prominence and

problematic nature of visual representation in law enforcement and criminal identification practices is nowhere more clear than in these contemporary programs.

Then U.S. attorney general John Ashcroft announced NSEERS on June 5, 2002. The initiative captures and archives biographical data and digital images of the faces and fingerprints of select foreign nationals visiting or residing in the United States on temporary visas. On January 5, 2004, US-VISIT was implemented, under the newly formed Department of Homeland Security, and replaced NSEERS as a registration system.[1] Like NSEERS, US-VISIT collects biographical data and digital images of the faces and fingerprints of registrants. Both of the registration programs developed in response to the events of September 11, 2001. Because the nineteen individuals involved in the September 11 hijackings entered the United States on valid temporary visas, NSEERS and US-VISIT were promoted as programs to prevent future terrorist attacks and to enhance border security through rigorous documenting and monitoring of visitors to the United States.

At their most basic level, NSEERS and US-VISIT are surveillance programs: they are designed to enable law enforcement and related state agencies to record, monitor, and track the movements and activities of individuals. By December 1, 2003, after more than a year of operation, the Department of Homeland Security reported that NSEERS had compiled data on 177,260 individuals.[2] By comparison, in the first three months of its operation, US-VISIT had processed 3,002,872 individuals.[3] The tremendous discrepancy between registrants in NSEERS and US-VISIT points to a key difference between these programs and serves as the point of departure for this chapter. Both programs developed in response to the events of September 11, 2001, and both were promoted as programs to enhance border security. They use similar technology and collect similar data. However, where US-VISIT records nearly all foreign nationals entering and leaving the United States, registration in NSEERS was selectively applied almost exclusively to Arab and Muslim men.

Together, NSEERS and US-VISIT highlight several of the key arguments presented in this book. In its selective focus, NSEERS exemplifies the threat posed by contemporary police practices of discrimination against individuals and groups according to mutable conceptions of crime and criminality. Because the nineteen individuals involved in the Sep-

tember 11, 2001, hijackings were Arab and Muslim men, race, gender, nationality, and religious belief emerged as criminal-like categories and served as the basis for registration in NSEERS. By contrast, the inclusive focus of US-VISIT illustrates the trend in modern and contemporary law enforcement practices toward the accumulation of identification data for its potential use. US-VISIT collects identification data from tens of millions of individuals annually, a practice that not only suggests an inclusive program of state surveillance but also presupposes the body as something that is potentially criminal. In addition to addressing these concerns, the chapter returns to a central theme of the book: making the criminal visible. I contrast the inclusive focus of US-VISIT with the selective program of NSEERS to argue that the latter functioned less to enhance border security than to code, categorize, and display an enemy threat described as invisible and omnipresent. In so doing, NSEERS functioned in the public display of state power.

Background and Implementation

The authority to register individuals in NSEERS and US-VISIT dates to a 1952 section of the Immigration and Nationality Act.[4] The formal application of this provision reached a peak during the 1990s, when the authority to register nonimmigrants was sporadically exercised. In 1991, a final rule published in the *Federal Register*, "the official daily publication for rules, proposed rules and notices of Federal agencies and organizations, as well as executive orders and other presidential documents," called for the registration and fingerprinting of nonimmigrants from Iraq and Kuwait entering the United States.[5] This was in response to Iraq's then recent invasion of Kuwait and the subsequent U.S. involvement in that conflict. Two years later, the attorney general published a notice in the *Federal Register* calling for the fingerprinting and registration of nonimmigrants from Iraq and Sudan. On September 5, 1996, a *Federal Register* notice called for the fingerprinting and registration of nonimmigrants from Iran and Libya. Finally, on July 21, 1998, then attorney general Janet Reno published a document to consolidate and amend all previous registration requirements. Attorney General Reno's notice called for the registration, fingerprinting, and photographing of nonimmigrant aliens from Iran, Libya, Iraq, and Sudan.[6]

In conjunction with, and in response to, the sporadic exercise of registration requirements in the 1990s, Congress mandated in 1996 that the United States develop a comprehensive entry–exit registration system to record nearly all of the country's visitors.[7] This mandate was amended in 2000 through the Immigration and Naturalization Services Data Management Improvement Act (DMIA), which called for greater integration of electronic identification data collected through state departments.[8] Press releases and government reports and documents that reference NSEERS and US-VISIT describe these programs as responses to the 1996 congressional mandate. NSEERS is described as the first phase of the mandate, and US-VISIT as that program's successor. At full implementation, US-VISIT would record nearly all visitors to the country, thereby fulfilling the 1996 mandate.

US-VISIT is typical of contemporary registration programs and operates through four primary levels: pre-entry, entry, data management, and exit. Figures 25–28, initially from an April 5, 2005, Department of Homeland Security internal presentation but updated in March 2007, outline the primary features of the program and point to the centrality of visual representation. During pre-entry (Figure 25), photographs, fingerprints, and biographical information are collected at consular and state offices abroad from persons seeking to enter the United States. All data is archived in US-VISIT databases and searched against a watchlist database of terrorists, wanted criminals, sexual offenders, and immigration violators. During entry (Figure 26), persons entering the United States at any of 317 ports have their photographs, fingerprints, and biographical information taken directly on-site. As with pre-entry, the data is archived into US-VISIT databases and searched against watchlists. The third level of US-VISIT is status or data management (Figure 27) and takes place independently of registrants. Here, collected data is searched and cross-referenced against data from other law enforcement databases, including the FBI's IAFIS. Finally, upon exit (Figure 28), persons leaving the country have their fingerprints and photographs taken at an exit-station identification kiosk, similar to the live scan identification station shown in Figure 22. In this final stage, data is cross-referenced against that collected during pre-entry, entry, and data-management stages.

The scope of the aggregates of identification data collected in US-VISIT is alarming. The potential dangers surrounding the collection,

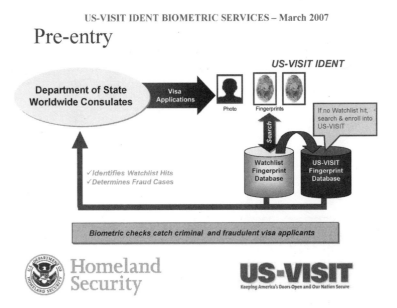

Figure 25. Pre-entry: the first level of US-VISIT, in which photographs, finger-prints, and biographical information are collected at consular and state offices abroad from persons wishing to enter the United States. Courtesy of the U.S. Department of Homeland Security.

deployment, and use of identification data outlined throughout this book must be seen as primary areas of concern in relation to US-VISIT. Fur-ther, the continued collection of data in the program in pursuit of an inclusive identification archive suggests heightened state power and ubiquitous surveillance. As outlined in chapter 4, the purpose, rationale, and consequences of such large-scale data collection efforts must be con-tinually questioned. However, rather than repeating that argument here, I want instead to stress the inclusivity of US-VISIT in order to more fully explicate the unique, selective focus of NSEERS.

The original proposal for the National Security Entry–Exit Registra-tion System was published in the June 13, 2002, *Federal Register*.[9] The proposal was drafted by Larry D. Thompson, then acting attorney gen-eral, and called for written responses and commentary, to be received by July 15. The document, "Registration and Monitoring of Certain Non-immigrants," amended parts 214 ("Nonimmigrant Classes") and 264 ("Registration and Fingerprinting of Aliens in the United States") of

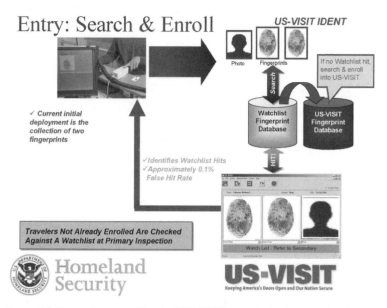

Figure 26. Entry: the second level of US-VISIT, in which photographs, finger-prints, and biographical information are collected from persons entering the country. Courtesy of the U.S. Department of Homeland Security.

the *Code of Federal Regulations*, the codification of rules published in the *Federal Register*.

The selective nature of NSEERS is rooted in two features of the program that distinguish it from other registration systems, including US-VISIT. First, new "special registration" requirements were devel-oped for a new class of nonimmigrants, loosely defined as "certain non-immigrant aliens," who were believed to require closer scrutiny. The 2002 proposal included a vague justification for the "special registration" of these individuals, which simply stated: "The United States frequently acquires information that indicates that a specific alien's or class of aliens' activities within the United States should be more closely monitored."[10] In addition to the general registration requirements of being finger-printed and photographed, those subject to special registration would have to provide more detailed biographical information and would be required to report to Immigration and Naturalization Services (INS) offices upon arrival in the United States, again thirty days after arrival,

Status Management

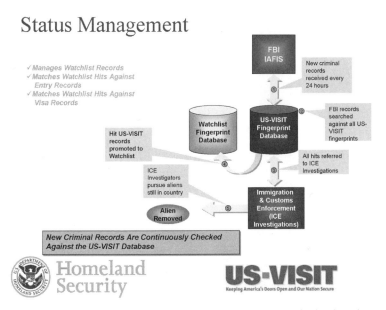

Figure 27. Status management: the third level of US-VISIT, which takes place independently of the physical presence and knowledge of the individual. Archived data is searched and cross-referenced against existing law enforcement databases. Courtesy of the U.S. Department of Homeland Security.

and annually thereafter for reregistration. Further, those subjected to special registration had to report any change of address, school, or employment within ten days of the change and had to report to an INS office at their time of departure from the United States. Special registration was designed as an elaborate surveillance mechanism, to monitor and ultimately control the movements of "certain" individuals while in the United States.

The second distinguishing feature of NSEERS is that it enabled the attorney general to call on "certain nonimmigrant aliens" residing in the United States to report to INS for registration. This is a particularly problematic feature of NSEERS, and one that clearly distinguishes it from other registration programs. Whereas other registration programs, including US-VISIT, document only persons entering or leaving the country, NSEERS allows for the collection of identification data retroactively from persons already residing in the country. Thus, the collection

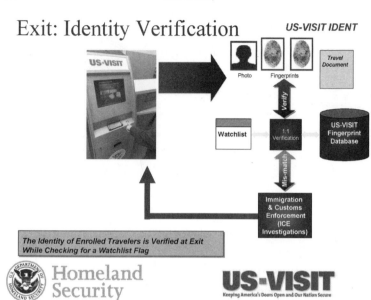

Figure 28. Exit: the fourth level of US-VISIT, in which fingerprints and photographs are collected from persons leaving the United States. Courtesy of the U.S. Department of Homeland Security.

of personal identification data in NSEERS took place under two circumstances: at ports of entry (POE registration) and through "call-in" registration. In the former, individuals entering the country through any of the 317 air, land, or sea ports of entry are registered directly on-site. In the latter, individuals residing in the United States can be called to register at a specified office or location through a notice published in the *Federal Register*.

There are significant penalties for failing to comply with any of the registration requirements. As outlined in the proposed rule, "because failure to complete registration is an unlawful activity, the alien shall thereafter be presumed to be inadmissible to the United States."[11] In addition, failure to register or making a false statement during registration carries a maximum thousand-dollar fine or six months in prison, failure to provide change-of-address or other information carries a maximum two-hundred-dollar fine or imprisonment for thirty days, and failure to comply with any of the registration procedures renders the alien "removable" from the country and "inadmissible" in the future.

The NSEERS proposal was published as final rule in the August 12, 2002, *Federal Register*.[12] Fourteen comments on the proposal were received in the month-long period allowed for by the attorney general. Concerns ranged from the legal basis for such a program and the potential for discrimination and violation of due process rights to the tremendous power afforded to the attorney general. Despite these concerns, the August 12 publication notes: "This final rule adopts the proposed rule without substantial change."[13] In fact, the single set of changes made to the document was clearer indication that the registration system would be paperless, that the data would be collected electronically. In an overtly symbolic move, the new registration system would take effect at select ports of entry a year to the day after the terrorist attacks, on September 11, 2002. The system was operable at all ports of entry on October 1, 2002.

The new provisions of NSEERS gave the attorney general tremendous discretionary power to place "certain nonimmigrant aliens" under increased surveillance and monitoring. Shortly after publication of the final rule in August 2002, Attorney General Ashcroft published a quickly expanding list of nations whose residents would be subject to special registration. This is most clearly exemplified in the four published notices for call-in registration. All four calls focused on men, sixteen years of age or older, who were admitted to the United States on or before September 30, 2002, the date POE registration began. The first call, on November 6, 2002, required citizens and nationals of Iran, Iraq, Libya, Sudan, and Syria to report for registration. The second call, on November 22, 2002, was directed at citizens and nationals of Afghanistan, Algeria, Bahrain, Eritrea, Lebanon, Morocco, North Korea, Oman, Qatar, Somalia, Tunisia, United Arab Emirates, and Yemen. The third call, on December 16, 2002, targeted citizens and nationals of Pakistan and Saudi Arabia. The fourth and final call for registration was published on January 16, 2003, and added nationals and citizens of Bangladesh, Egypt, Indonesia, Jordan, and Kuwait to the list.[14]

By the end of the call-in registration period, twenty-five countries had been identified as warranting special registration and close monitoring. The presentation of the call-in periods in Figure 29 illustrates the extent to which the registration system focused on Arab and Muslim men. Together with POE registration, these call-in registrations produced significant amounts of personal identification data. By September 30, 2003,

Date of Call	Countries Listed
November 6, 2002	Iran Iraq Libya Sudan Syria
November 22, 2002	Afghanistan Algeria Bahrain Eritrea Lebanon Morocco North Korea Oman Qatar Somalia Tunisia United Arab Emirates Yemen
December 16, 2002	Pakistan Saudi Arabia
January 16, 2003	Bangladesh Egypt Indonesia Jordan Kuwait

Figure 29. The four call-in notices for registration in NSEERS.

NSEERS had processed 177,260 individuals, 93,741 of them registered at ports of entry and 83,519 registered through the call-in notices.[15]

Both the proposal and the eventual application of NSEERS drew significant protest from professional and lay audiences. Comments on the June 13 proposal identified concerns and fears that were later taken up in protests throughout the country by concerned residents and by civil and human rights groups, including the American Civil Liberties Union, Amnesty International, and the American–Arab Anti-discrimination Committee.[16] The central area of concern was the selective application of NSEERS and the seemingly unlimited authority of the attorney general to call on bodies for registration.

The amendment to Part 264 of the *Code of Federal Regulations* detailed the three groups of individuals who could be subject to special registration:

1. Nonimmigrant aliens who are nationals or citizens of a country designated by the Attorney General, in consultation with the Secretary of State, by a notice in the *Federal Register*.
2. Nonimmigrant aliens who is [sic] a consular officer or an inspecting officer has reason to believe are nationals or citizens of a country designated by the Attorney General. . . .
3. Nonimmigrant aliens who meet pre-existing criteria, or who is [sic] a consular officer or the inspecting officer has reason to believe meet pre-existing criteria, determined by the Attorney General or the Secretary of State to indicate that such an alien's presence in the United States warrants monitoring in the national security interests.[17]

As these categories show, the task of deciding what individuals or groups should be subject to special registration was the responsibility of the offices of the attorney general and the secretary of state. Vague terminology such as "certain nonimmigrant aliens," "pre-existing criteria," and "intelligence-based criteria" provided the legal basis for the selective application of NSEERS registration. According to the amendment, not only can the attorney general require members of entire nations to register simply by citing the country in the *Federal Register,* but consular officers and inspecting officers throughout the world can impose similar requirements on individuals and groups based on their "belief" that the persons in question warrant registration.

In response to concerns surrounding the seemingly arbitrary criteria for data collection, the final rule of NSEERS included the following statement, which is equally vague if not dismissive: "The criteria by which an alien may be required to make a special registration cannot be made public without defeating the national security and law enforcement effectiveness of the criteria."[18] The selective and discriminatory application of NSEERS at the discretion of the attorney general was cloaked in the rhetoric of "national security." In her analysis of NSEERS, Kathryn Lohmeyer argues that by exploiting this rhetoric, Attorney General Ashcroft was able to supersede the constitutional rights of

registrants to due process and equal protection.[19] She further argues that NSEERS employs the plenary power doctrine, a provision of the U.S. Constitution that gives Congress complete control over immigration policy and allows for differential treatment of citizens and noncitizens. This effectively precludes any judicial or federal review of the program. Lohmeyer rightly concludes that the selective application of special registration is not just discriminatory but is also antithetical to international laws governing the fair and equal treatment of individuals.

Under the guise of "national security," NSEERS was sped into application despite varied concerns and criticism. The program was proposed on June 30, 2002, was adopted as rule on August 12, and was in operation by September 11. NSEERS yielded blanket authority to the attorney general, which was subsequently exercised on "certain" bodies. While the efficacy of NSEERS to protect national security is uncertain, its impact on the identities, rights, and freedoms of those subject to registration is clear. Special registration places severe and unfair limitations on the mobility, freedoms, and abilities of individuals subject to the registration process.[20] Further, identification data collected and stored in NSEERS can be acted on according to changing conceptions of criminality, deviance, or threat, which has the potential to have numerous and lasting impacts on the identities and abilities of registrants.

For example, the identification record of a Pakistani man working in the United States during the year 2000 might attest to his purchasing habits, his travel and employment history, his temporary and permanent addresses, and other biographical information. During the year 2000, this man exists as a nonresident alien: as an individual working in the United States on a valid temporary visa. The third notice of call-in registration, on December 16, 2002, requires this man to report to a local INS office for special registration. Through the process of registering in NSEERS, the man's identity as a valid nonresident alien working in the United States on a temporary visa is reconfigured into that of someone who constitutes a potential threat to national security and who warrants closer scrutiny and continued monitoring. Nothing about this living body has changed, yet his rights and freedoms and his ability to work and function in the United States are now contested and restricted.

The impact on individual identity through NSEERS registration is also affected by the cooperation of NSEERS with other law enforcement

databases. Fingerprint scans taken during the registration process are checked against databases of known criminals and terrorists as well as against a large archive of latent prints collected from "known terrorist locations" throughout the Middle East by the U.S. military. Utilization of this latent archive is cause for particular concern, as what constitutes a "known terrorist location" is unclear. Fingerprint and other data collected through NSEERS is also linked to the archives of US-VISIT. Suppose the Pakistani man from the previous example is questioned in relation to a local, minor offense in which he was simply present. Without his registration in NSEERS, a search through US-VISIT and related databases may not be cause for concern if the retrieved data simply attests to employment history and other biographical information. However, after registration, a search would identify the man as an NSEERS registrant. The man's cooperation with the call-in notice places him within a category of suspicion, which follows him and can have numerous and varied impacts on his identity.

The Homeland Security Act of 2002 officially abolished many of the federal agencies involved in NSEERS, amalgamating them with numerous other agencies under the Department of Homeland Security. Similarly, the efforts of Attorney General Ashcroft to oversee NSEERS were transferred to the secretary of homeland security, Tom Ridge. This transfer of power and the conglomeration of previously disparate federal departments and offices under the unified Department of Homeland Security was paralleled by the announcement of a new registration system, US-VISIT.[21]

US-VISIT accomplishes the same goals as NSEERS but, as already noted, is considerably larger in scope, ultimately collecting identification data from all aliens entering and leaving the country. The reach and mission of the program was extended through the enactment of the Uniting and Strengthening of America by Providing Appropriate Tools Required to Intercept and Obstruct Terrorism Act (USA-PATRIOT Act) in 2001 and the Enhanced Border Security and Visa Entry Reform Act (EBSVERA) in 2002. These acts provided legislation governing the collection of biometric data as well as the technical standards used in biometric identification.[22] Accenture was awarded the multibillion dollar contract to construct and implement US-VISIT. While Accenture will act as overseer to the project, thirty different identification, consulting,

trade, and information-management companies, including AT&T, Dell, Deloitte Consulting, and Sprint Communications were named as participants.[23] The participation of such a large number of external agencies raises numerous concerns regarding control of and access to the identification data produced through the program.

It is important to note that in addition to enabling the collection of fingerprints and photographs from individuals, US-VISIT legislation also allows for the collection of "other biometric identifiers," and the development and use of such technologies is a mandate of US-VISIT. Radio frequency identification (RFID) is already being used to remotely document persons entering and leaving the country.[24] The inclusion of "other biometric identifiers" in the program's legislation is of particular concern, as it foreshadows the collection of other forms of identification data—perhaps even DNA profiles—in future law enforcement initiatives. It is also important to note that although US-VISIT is described as replacing NSEERS, NSEERS legislation remains active, enabling the Department of Homeland Security to call at will for bodies to be registered. US-VISIT was officially launched on January 5, 2004, and was scheduled to be in full operation at all ports of entry by December 31, 2005. While this initial goal was not met, a June 5, 2006, press release notes that full biometric entry procedures were in place at all air and sea ports with international arrivals and at secondary inspection areas of land ports of entry.[25]

In its inclusive approach, US-VISIT may represent an effective and even democratic border security program. This is not to suggest that US-VISIT is benign, but to stress the extent to which registration in NSEERS between 2002 and 2004 specifically targeted certain bodies. The efficacy of NSEERS to enhance border security and prevent future terrorist attacks is difficult, if not impossible, to discern. The Department of Justice, the INS, and now the Department of Homeland Security cite statistics of detentions, arrests, and deportations through NSEERS as proof of the program's success. Of the 177,260 persons registered through September 30, 2003, 2,870 were detained and 143 were identified as "criminals."[26] The majority of offenses were violations of various immigration laws, such as overstaying a visa or presenting fraudulent documents. To suggest that detaining or charging a person with a criminal act for these offenses aided in the prevention of a terrorist attack is speculative at best. What, then, is the purpose of special registration?

As outlined in chapter 2, Simon Cole has shown that the adoption of fingerprinting into law enforcement practices during the early twentieth century worked in concert with broadening criminal laws to bring more bodies under police surveillance.[27] In a similar manner, the tremendous discretionary power of the attorney general under NSEERS increased the number of individuals monitored by law enforcement and immigration departments. However, given the tremendous data collection and archiving capabilities of law enforcement—recall that US-VISIT processed over three million individuals in three months—to suggest that NSEERS simply cast a wider net is inaccurate. More specifically, given that law enforcement and state agencies in the United States had the legal and technological capabilities to address border security by documenting all persons entering and leaving the country, why was a program developed to target Arab and Muslim men?

The selective application of an entry–exit system suggests another function or effect of NSEERS. As it was activated between 2002 and 2004, NSEERS functioned less to enhance border security than to code, categorize, and display certain bodies as potentially threatening and potentially criminal. Criteria for data collection were derived from nineteen individual bodies and expanded to encompass millions of bodies and entire geographic areas. That is, because the nineteen hijackers were adult males from specific Arab and Muslim countries, all adult males from all Arab and Muslim nations were categorically suspicious and therefore warranted increased scrutiny and monitoring. With its emphasis on race, gender, nationality, and religious belief, data collection in NSEERS served a dual purpose: it gave a visual face to a threat described as invisible and omnipresent, and it functioned in the public display of state power.

"With Us or against Us": Public Display in the War on Terror

Throughout this book I have argued that the act of making the criminal visible is fundamental to modern and contemporary law enforcement practices. The criminal is made visible in very literal ways, as in the use of the camera to record the faces and fingerprints of known offenders. In this way, the image is deployed as a representational device. The criminal is also made visible in more abstract ways, as in the use of the image in the production and interpretation of a fingerprint or

autoradiograph or in the visualization of data housed in identification archives. In this more abstract sense, the image functions as an inscription at work in the production of identity.

NSEERS and US-VISIT employ the image as representation and inscription to make the criminal visible in both literal and abstract ways. Literally, mug shots, fingerprints, and other images identifying known offenders are archived into US-VISIT databases as well as into databases serving other programs such as IAFIS and NCIC 2000, with which NSEERS and US-VISIT communicate. And abstractly, the data housed in NSEERS and US-VISIT archives is searched according to specific criteria, and criminality is produced and made visible through the visualization of archived data.

In what follows I want to analyze another way in which the criminal was made visible through NSEERS. Thus far, the chapter has addressed the literal acts of data collection in NSEERS and US-VISIT. To fully understand these programs, it is necessary to position them within their larger context, namely, the war on terror. In so doing, the chapter returns to the abstract visual space of the archive as defined by Sekula and cited at the beginning of this book. Both NSEERS and US-VISIT were developed and implemented under the rubric of a "war on terror," a war that is both highly public and visual. Within this war, the public is co-opted in the supposed maintenance of national security through its participation in surveillance and identification practices. This is perhaps best exemplified in the Department of Homeland Security's color-coded "Citizen Guidance on the Homeland Security Advisory System," which asks citizens to be alert for and to report suspicious activity to law enforcement.

The move to co-opt the public in surveillance and identification practices is not new. Recall that Thomas Byrnes published his 1886 rogues' gallery in the hopes that the public, and more specifically, New Yorkers, would aid police in surveilling "professional criminals." But the co-optation of the public in the war on terror is not just considerably larger in scope; it is also fundamentally different in nature. Byrnes used the representational power of the photograph to make known offenders such as James White and Annie Reilly visible to the public. While it is true that the public is asked to watch for specific individuals in the war on terror, the public is primarily co-opted in the surveillance of an aggre-

gate category, terrorists, primarily described in terms of their potential criminality. The distinction is important: unlike Byrnes's rogues' gallery, which made the criminal visible, NSEERS functioned to make the potentially criminal visible.

The move to co-opt the public in the supposed maintenance of national security was based in a rhetoric that described an enemy who was invisible and omnipresent. Consider the following remarks prepared for Attorney General Ashcroft's public announcement of NSEERS:

> On September 11, the American definition of national security was changed forever. A band of men entered our country under false pretenses in order to plan and execute a murderous act of war....
>
> In this new war, our enemy's platoons infiltrate our borders, quietly blending in with visiting tourists, students, and workers. They move unnoticed through our cities, neighborhoods, and public spaces. They wear no uniforms. Their camouflage is not forest green, but rather it is the color of common street clothing. Their tactics rely on evading recognition at the border and escaping detection within the United States. Their terrorist mission is to defeat America, destroy our values and kill innocent people.[28]

This passage describes an enemy who is seemingly undetectable. He wears the same clothes as we do, occupies the same roles that we do (as a tourist, student, or worker), and walks unnoticed among us. How, then, are we to locate or make this enemy visible? To return to the color-coded threat level, what might count as "suspicious" and warrant reporting?

There is a paradox inherent in Ashcroft's statement, and it underlies the larger visual program of the war on terror: although the enemies may look, act, and live like "we" do, "they" are nonetheless visually distinguishable from "us." Why else would we be asked to keep watch? Throughout the tremendous media activity following September 11, 2001, the suspicious and potentially dangerous body had been coded in a specifically visual way. Race, represented by skin color, became a central means of identification. Newspapers, magazines, television, and Internet sources continually displayed the brown-skinned faces of (almost exclusively male) Arab and Muslim persons as the focus of the war on terror. Racial profiling was employed at ports of entry to literally separate persons believed to pose a threat from the other, presumably law-abiding individuals.

The deployment of NSEERS and the subsequent practices of data collection at ports of entry and through the call-in notices must be understood within the larger visual program of the war on terror. Positioned in this context, NSEERS and its four call-in notices of registration between 2002 and 2004 functioned less to enhance border security than to make visible a potentially criminal body defined according to its race, gender, nationality, and religious belief. Much like Lombroso and Galton and their contemporary phrenologists, physiognomists, and eugenicists who promoted the body as something that offered up signs of its deviance, NSEERS too promoted criminality as something to be discerned through the outward signs of the body. NSEERS shares a common logic with nineteenth-century criminal anthropology and eugenics: if criminality can be seen on the body, it follows that, once made visible, it can be prevented.

In conjunction with visualizing a perceived threat, or making the potentially criminal visible, NSEERS also functioned as a public display of state power. In response to the call-in registration notices, and fearing humiliation, incarceration, and potential deportation, large numbers of people waited until the last possible day to register. The snaking lines of Arab and Muslim men outside registration offices were clear evidence of the categorical suspicion of NSEERS and of the power of the U.S. administration to target, monitor, and ultimately control populations. These scenes were captured by the press and represented in newspapers and news programs across the country and internationally. For example, an image in the January 11, 2003, edition of the *New York Times* displays "men from mostly Arab or Muslim countries" outside an INS office in Detroit in response to the second call-in registration period. An image in the *San Francisco Chronicle* shows immigrants leaving a local INS office following registration. Images in the *Los Angeles Times* and the *Pittsburgh Post-Gazette* show registrants being counseled by lawyers and volunteers. An image in the *Orlando Sentinel* displays an individual being fingerprinted at a Detroit INS office. An image in the *Baltimore Sun* depicts a Pakistani family at the Pakistani embassy listening to a discussion of the registration rules. And a story in the *Buffalo News* contains an image of a Pakistani family waiting in a crowded refugee center trying to cross into Canada before the registration deadline. Perhaps most alarming are images from the January 11, 2003, and March 22, 2003, issues of the *Globe and Mail* and the *New*

York Times, respectively, which show individuals lined up outside a New York City INS office, literally barricaded from the surrounding environment by a fence.[29]

These images are part of the tremendous number of images, moving and still, that have documented, and been deployed in, the war on terror. I am not suggesting that images documenting special registration are powerful in and of themselves, nor that they carry a single, dominant reading. However, as part of a larger visual program, these images participate in the construction of identity and in cultural attitudes toward a nation and its others. Under the rubric of a "war on terror," images documenting special registration function alongside images of the planes crashing into the World Trade Center towers, images of the smoldering walls of the Pentagon, the Abu Ghraib prison torture images, and the now iconic "mission accomplished" images of President George W. Bush aboard the USS *Abraham Lincoln* on May 1, 2003, where he prematurely declared victory in Iraq. As with Sekula's nineteenth-century archive, the honorific and repressive functions of the photograph are welded together in this contemporary visual space: normalcy and deviance, citizen and foreigner, defender of national security and potential threat mutually reinforce one another.

Writing on the Abu Ghraib prison torture images, Susan Sontag argues against the interpretation that these pictures represent aberrations of an otherwise noble, or at least "normal," military campaign. For Sontag, the images are the inevitable result of a "with us or against us" mentality of a nation seeking heightened global economic power.[30] Following Sontag, images documenting special registration in NSEERS can be read as the product of a national mentality; however, I stress that they are more than this: these images are not simply reflections but are constituent parts of the "with us or against us" rhetoric deployed in the war on terror. The deployment and circulation of images documenting special registration contributes to the construction and reinforcement of categorical suspicion based on race, gender, nationality, and religious belief. What we see throughout these events and in the representations of them are Arab and Muslim men put on display, coded, and identified as potential threats to national security. In targeting specific bodies for registration, NSEERS gave a visual face to an abstract potential threat, enabling the public to participate in the state-sanctioned surveillance and control of targeted populations.

As noted earlier, US-VISIT has effectively replaced NSEERS as the primary border security strategy for the United States in the twenty-first century. The implementation of US-VISIT has resulted in a more visible police presence at entry points to the country. In addition to the increased number and armament of law enforcement personnel at border crossings, US-VISIT signage, in-flight videos, and new identification kiosks and equipment, including digital cameras and fingerprint scanners, attest to the increased presence of the state in contemporary life. In this way, US-VISIT also participates in a public display of state power. However, because of its inclusive focus, US-VISIT is made more palatable, for it is rationalized as a necessary response to the increasingly global nature of crime in the twenty-first century. Indeed, US-VISIT has many parallels in nations throughout the world as each tries to enhance the security of its citizens.

The use of images and imaging technologies in pursuit of the construction of an inclusive identification archive as exemplified in US-VISIT represents a dominant trend in modern and contemporary law enforcement practices. By contrast, in targeting specific bodies and in making the potentially criminal visible, NSEERS marks a curious return to the public display of centralized, sovereign power described by Foucault as antithetical to modern societies. This power is targeted at specific persons and is exercised directly on the body. Individuals registered at ports of entry are processed through separate lines and are fingerprinted and photographed while nonregistrants pass by. Those subject to call-in registration stand behind fences in lines snaking out of INS offices. These events constitute an exercise of power that exists precisely to be seen. In a culture that prides itself on its democracy, the successful development and implementation—technologically, legally, and politically—of a program that is overtly discriminatory and that negates basic, fundamental human rights serves as an alarming display of heightened state power. If US-VISIT suggests the democratic potential of law enforcement practices of the future, NSEERS reminds us of the latent power of the state to monitor, regulate, and ultimately control targeted populations.

Conclusion

Throughout this book, I have argued for the centrality of visual representation and inscription in modern and contemporary law enforcement and

identification practices. While not a history of identification, the book has outlined some central changes in the function of images within police practices from the nineteenth century to the present. Photography was initially adopted by law enforcement agencies as a tool to document bodies brought under police custody. In this sense, the image's use was primarily that of static representation: the photograph represented the criminal's identity as such. Alphonse Bertillon's work with the Paris Prefecture of Police mobilized these static representations into a larger communications network; however, the role of the image as representation remained largely unchanged. The specific collaboration of photography and the theory of fingerprint identification at the close of the nineteenth century introduced a new practice in law enforcement, reflected in the new role of the camera. The mobility, ubiquity, and objectivity of the camera, combined with the latency of the fingerprint, enabled law enforcement agencies to collect and archive latent identification data, which expanded the focus of law enforcement from the individual, criminal body to a larger, aggregate social body. Not only did this expansion extend the reach of law enforcement into public life through the monitoring of greater numbers of individuals, but it also announced a reconceptualization of criminality and the body. The collection of identification data based on its potential use presupposes the body as something potentially criminal.

The possibilities associated with the collection and use of aggregates of identification data announced with fingerprinting remained largely theoretical until the adoption of digital technologies into law enforcement in the 1960s and 1970s. Digital technologies have greatly extended the capabilities of police to collect aggregates of identification data independently of the physical presence and knowledge of the body. Images of faces, fingerprints, and DNA are now quickly and easily collected by law enforcement personnel and are archived, exchanged, and accessed in numerous programs, including NCIC 2000, CODIS, and the US-VISIT program. At the same time, identification is no longer strictly the purview of police, as it was in the nineteenth and early twentieth centuries. Instead, identification is produced through a network of institutions and agencies in a competitive, profit-driven arena. This has made the control of identification techniques, and the data they produce, a primary concern for law enforcement and related state agencies in the late twentieth and early twenty-first centuries. The battle

for control over DNA analysis in law enforcement or the centralizing efforts of the USA-PATRIOT Act and programs like US-VISIT are clear examples of the extent to which criminal identification is a contested field of practice, and one in which the state seeks to maintain primary control.

As with the adoption of the camera into police practices in the nineteenth century, law enforcement and related state agencies in the twenty-first century benefit from enhanced technological capabilities to reduce the complexity of the body into manageable two-dimensional representations. Fingerprinting, DNA analysis, and such programs and databases as NCIC 2000, CODIS, NSEERS, and US-VISIT rely on visual representation for the collection, storage, and exchange of personal identification data. However, to address these images as representations of a specific body, criminal, normal, or otherwise, is to lose sight of the central role of the image in the production of identity.

In the introduction, I argued that analyses of law enforcement and identification practices can benefit from work in science studies by treating the image as an inscription rather than as a representation. That is, rather than positioning mug shots, fingerprints, and autoradiographs as representations of criminal bodies, we should understand these images as inscriptions that function in the production of identity. Positioning the image as an inscription not only highlights the complexity of identification practices, revealing the numerous actors at work in the production of identity, but also stresses the extent to which criminality is produced and made visible through representation.

I do not want to propose an inevitable trajectory in law enforcement and identification practices from rogues' galleries to an Orwellian future defined by the all-seeing gaze of the state. The construction of a single, centralized meta-identification archive or a unified, all-seeing surveillant apparatus is far from a practical possibility. Nonetheless, modern and contemporary law enforcement and criminal identification practices show a clear trend toward the accumulation of identification data. As I have emphasized throughout this book, law enforcement and identification practices that are driven by the collection of data pose numerous challenges to bodily identity and raise new questions surrounding the role, reach, and level of law enforcement and related state agencies in public life. The rationale and ethical issues governing the collection,

archiving, interpretation, and exchange of identification data demand continued analysis. Critical work from academic, professional, and lay audiences alike that addresses the use of visual representation in law enforcement and criminal identification practices is not only needed but is fundamental, given the significant and diverse ramifications associated with making the criminal visible.

Acknowledgments

My interest in police photography developed while I was working on my MA in art history at York University. There I had the pleasure of working with Renate Wickens, Shelley Hornstein, and Brian Grosskurth, all of whom provided invaluable insight and support for my work and encouraged me to pursue further research on the topic. The book took shape as my doctoral dissertation in the Visual and Cultural Studies Program at the University of Rochester. I thank the staff, faculty, and graduate students of that program for providing such a rich environment for doctoral work. Specifically, I thank my dissertation committee members in Rochester: Janet Wolff, Robert Foster, and Joan Saab, and my dissertation adviser, Lisa Cartwright. Lisa's continued assistance throughout this project and her clear enthusiasm for academic inquiry were essential to the completion of the manuscript and to my own development as a teacher, researcher, and writer. Thank you also to former Rochesterians Matt Reynolds and Leesa Phaneuf for being such terrific and caring friends.

I am grateful to my colleagues in the Department of Communication Studies at Wilfrid Laurier University for their continued support through the completion of the manuscript and for a book preparation grant from Wilfrid Laurier University that assisted with production costs.

A special thank you to Alicia Sliwinski for her assistance with image permissions. The editorial staff at the University of Minnesota Press has been a pleasure to work with, from the review process through production. Specific thanks go to Richard Morrison for his editorial insight and support, to Adam Brunner for his assistance in bringing the project to completion, and to Kathy Delfosse for editing. I also owe thanks to Andrea Kleinhuber, formerly of the Press, for her initial interest and to the manuscript reviewers for their insightful comments and constructive criticism.

This book would not have been possible without the love and support of my family. My parents, Catherine and Gerry, my brother Patrick, and my brother Andrew and sister-in-law Evelyn Paris have been a constant source of support. My father's sudden death in 2004 hurt us deeply, and I regret that he is not here to share in this accomplishment. The enthusiasm for life that he and my mother shared, as well as their confidence in me, continues to motivate my own work and life. I owe greatest thanks to my wife, Janice Maarhuis; her energy and positive spirit have been a continuous inspiration and have helped me through the frustrations and insecurities associated with writing this book. Our beautiful daughter Naomi brightens each and every day.

Notes

Introduction

1. Thomas Byrnes, *Professional Criminals of America* (New York: Cassell, 1886), between 162 and 163; Committee on DNA Technology in Forensic Science, National Research Council, *DNA Technology in Forensic Science* (Washington, D.C.: National Academies Press, 1992), 39. The fictional crime scene was produced during an apprenticeship held with the Metropolitan Toronto Police's Forensic Identification Services in August 1996.

2. Michel Foucault, *Discipline and Punish: The Birth of the Prison*, trans. Alan Sheridan (New York: Vintage Books, 1979).

3. On the development of a society or culture of surveillance, see Kenneth Laudon, *Dossier Society: Value Choices in the Design of National Information Systems* (New York: Columbia University Press, 1986); David Lyon, *The Electronic Eye: The Rise of Surveillance Society* (Minneapolis: University of Minnesota Press, 1994); Gary Marx, *Undercover: Police Surveillance in America* (Berkeley and Los Angeles: University of California Press, 1988); Gary Marx, "The Surveillance Society: The Threat of 1984-Style Techniques," *Futurist* 19, no. 3 (June 1985): 21–26; William G. Staples, *The Culture of Surveillance: Discipline and Social Control in the United States*, Contemporary Social Issues, ed. George Ritzer (New York: St. Martin's Press, 1997).

4. The number thirty-five million is based on 2004 statistics. While the specific number of persons will vary, the essential point is that US-VISIT will document all persons entering and leaving the country.

5. The term "index" is from the semiotics of Charles Sanders Peirce. See *The Essential Peirce: Selected Philosophical Writings: Volume 2 (1893–1913)*, ed. Nathan Houser and Christian Kloesel (Bloomington: Indiana University Press, 1998), particularly "What Is a Sign?" 4–10.

6. Roland Barthes and Susan Sontag provide the most eloquent accounts of this debate. See Roland Barthes, *Camera Lucida: Reflections on Photography*, trans. Richard Howard (New York: Hill and Wang, 1981), and Susan Sontag, *On Photography* (New York: Doubleday, 1977). Geoffrey Batchen provides a thorough account of the debate surrounding the ontology of the photographic image in his text *Burning with Desire: The Conception of Photography* (Cambridge: MIT Press, 1997). William Mitchell discusses the objectivity and subjectivity of the image in relation to digital imaging technologies in his book *The Reconfigured Eye: Visual Truth in the Post-Photographic Era* (Cambridge: MIT Press, 1992). Jennifer Mnookin's article "The Image of Truth: Photographic Evidence and the Power of Analogy," *Yale Journal of Law and the Humanities* 10, no. 1 (1998): 1–74, provides a thorough account of the debate as it played out in the American courtroom. Alan Trachtenberg's *Classic Essays on Photography* (New Haven, Conn.: Leete's Island Books, 1980) is an extensive collection of early writings on photography, particularly its status as an artistic medium.

7. André Bazin, "The Ontology of the Photographic Image," in Trachtenberg, *Classic Essays on Photography*, 241.

8. Roland Barthes, "Rhetoric of the Image," in *Image, Music, Text*, trans. Stephen Heath (New York: Hill and Wang, 1977); Barthes, *Camera Lucida*. "Having-been-there" appears in the former source and "this-has-been" appears in the latter.

9. A similar claim is made and developed by Mitchell in *The Reconfigured Eye*.

10. Mnookin, "The Image of Truth."

11. Lorraine Daston and Peter Galison, "The Image of Objectivity," *Representations* 40 (Autumn 1992): 81–128.

12. See also Joel Snyder, "Picturing Vision," *Critical Inquiry* 6, no. 3 (Spring 1980): 499–526. Snyder argues that photographic objectivity is the product of a cultural tradition of picture making, one that is inextricably tied to Renaissance theories of vision and the desire of post-Renaissance artists to produce a pictorial equivalent to vision.

13. Allan Sekula, "The Body and the Archive," *October* 39 (Winter 1986): 3–64; John Tagg, *The Burden of Representation: Essays on Photographies and Histories* (Basingstoke, U.K.: Macmillan, 1988). Other articles and books have addressed the topic. See David Green, "On Foucault: Disciplinary Power and Photography," *Camerawork* 32 (1985): 6–9; "Veins of Resemblance: Photography and Eugenics," *Oxford Art Journal* 7, no. 2 (1985): 3–16; and "Classified Subjects," *Ten.8*, no. 14 (1984): 30–37; Tom Gunning, "Tracing the Individual Body: Photography, Detectives, and Early Cinema," in *Cinema and the Invention*

of Modern Life, ed. Leo Charney and Vanessa R. Schwartz (Berkeley and Los Angeles: University of California Press, 1995), 15–45; Suren Lalvani, *Photography, Vision, and the Production of Modern Bodies* (Albany: State University of New York Press, 1996); Sandra Phillips, Mark Haworth-Booth, and Carol Squires, *Police Pictures: The Photograph as Evidence* (San Francisco: Chronicle Books, 1997); Martha Merrill Umphrey, "The Sun Has Been Too Quick for Them: Criminal Portraiture and the Police in the Late Nineteenth Century," *Studies in Law, Politics, and Society* 16 (1997): 139–163.

14. Tagg, *The Burden of Representation,* 3, 118.

15. Sekula, "The Body and the Archive," 16.

16. Ibid., 10.

17. This is similar in concept to Tagg's notion of the "burden" of representation.

18. There is a wealth of material dealing with the social construction of scientific facts. Some of the central texts informing this project are David Bloor, *Knowledge and Social Imagery* (London and Boston: Routledge and Kegan Paul, 1976); H. M. Collins, *Changing Order: Replication and Induction in Scientific Practice* (London and Beverly Hills, Calif.: Sage Publications, 1985); Thomas S. Kuhn, *The Structure of Scientific Revolutions,* 2nd, enlarged ed. (Chicago: University of Chicago Press, 1970); Bruno Latour, *Science in Action: How to Follow Scientists and Engineers through Society* (Cambridge, Mass.: Harvard University Press, 1987); Bruno Latour and Steve Woolgar, *Laboratory Life: The Construction of Scientific Facts,* 2nd ed. (Princeton, N.J.: Princeton University Press, 1979).

19. Latour, *Science in Action,* 21. The metaphor is used outside science studies as well. I use Latour's account of it here, as I find it the clearest explanation.

20. Ibid.

21. This could also be said of much work in the history of photography and is hinted at by Patrick Maynard. He suggests that too often "photographs are considered a puzzling sort of thing, to be addressed in terms of their relationship to other things: notably the relationship of being a photograph *of* other things." Patrick Maynard, *The Engine of Visualization: Thinking Through Photography* (Ithaca, N.Y.: Cornell University Press, 1997), 10.

22. Latour and Woolgar, *Laboratory Life.*

23. Ibid., 48.

24. Ibid., 51.

25. Ibid., 63.

26. Latour, *Science in Action;* "Drawing Things Together," in *Representation in Scientific Practice,* ed. Michael Lynch and Steve Woolgar (Cambridge: MIT Press, 1988): 19–68; and "How to Be Iconophilic in Art, Science, and Religion," in *Picturing Science, Producing Art,* ed. Caroline A. Jones and Peter Galison (New York: Routledge, 1998): 418–440.

27. My use of gendered language here is intentional. As is discussed in chapter 1, while both males and females committed crimes, the discourse surrounding

criminality in the nineteenth century focused on the male body. Female criminality was increasingly defined against the model of male criminality.

28. On the development of expert authority and professional vision, see Simon Cole, "Witnessing Identification: Latent Fingerprinting Evidence and Expert Knowledge," *Social Studies of Science* 28, nos. 5–6 (1998): 687–712; Charles Goodwin, "Professional Vision," *American Anthropologist* 96, no. 3 (1994): 606–633; Sheila Jasanoff, "The Eye of Everyman: Witnessing DNA in the Simpson Trial," *Social Studies of Science* 28, nos. 5–6 (1998): 713–740.

1. Picturing the Criminal

1. Police Pictures: The Photograph as Evidence, exhibition at the San Francisco Museum of Modern Art, October 17, 1997–January 20, 1998, curated by Sandra S. Phillips. Catalogue: Phillips, Haworth-Booth, and Squires, *Police Pictures*.

2. Martha Merrill Umphrey convincingly argues that this image was in fact staged. She notes that the image "less resembles a snapshot than an allegorical painting: it represents not the instantaneous, accidental capture of a private moment by a roving photographer, but the official 'capture' of a criminal" (Umphrey, "The Sun Has Been Too Quick for Them," 144). For my own argument, Byrnes's image represents the use of the camera as a documentary or recording device as well as the cultural belief regarding the image's evidentiary power.

3. Cesare Lombroso, *Crime: Its Causes and Remedies*, trans. Henry P. Horton, Patterson Smith Reprint Series in Criminology, Law Enforcement, and Social Problems (Montclair, N.J.: Patterson Smith, 1968); Cesare Lombroso and William Ferrero, *The Female Offender*, ed. W. Douglas Morrison, The Criminology Series (New York: D. Appleton, 1895); Gina Lombroso-Ferrero, *Criminal Man: According to the Classification of Cesare Lombroso* (New York: G. P. Putnam's Sons, 1911).

4. On the development of criminal anthropology both in Europe and in the United States, see Nicole Hahn Rafter, "Criminal Anthropology in the United States," *Criminology* 30, no. 4 (1992): 525–545. For general discussions on criminology and the work of Lombroso, see Israel L. Barak-Glantz and C. Ronald Huff, eds., *The Mad, the Bad, and the Different: Essays in Honor of Simon Dinitz* (Lanham, Md.: Lexington Books, 1981); Piers Beirne, ed., *The Origins and Growth of Criminology: Essays on Intellectual History, 1760–1945* (Aldershot, U.K.: Dartmouth, 1994); David G. Horn, *Social Bodies: Science, Reproduction, and Italian Modernity*, Princeton Studies in Culture/Power/History (Princeton, N.J.: Princeton University Press, 1994); David G. Horn, "This Norm Which Is Not One: Reading the Female Body in Lombroso's Anthropology," in *Deviant Bodies: Critical Perspectives on Difference in Science and Popular Culture*, ed. Jennifer Terry and Jacqueline Urla (Bloomington: Indiana University Press, 1995), 109–128; C. Ray Jeffery, *Criminology: An Interdisciplinary Approach* (Englewood Cliffs, N.J.: Prentice Hall, 1990).

5. Foucault, *Discipline and Punish*, 201.

6. For a thorough critical summary and interrogation of the Panopticon's use in surveillance studies, see David Lyon, ed., *Theorizing Surveillance: The Panopticon and Beyond* (Devon, U.K.: Willan Publishing, 2006).

7. The seeming totality of power and discipline in Foucault's work has been most thoroughly challenged by feminist scholars. For a summary of this debate, see Jana Sawicki, "Queering Foucault and the Subject of Feminism," *The Cambridge Companion to Foucault*, ed. Gary Gutting, 2nd ed. (Cambridge: Cambridge University Press, 2005), 379–400.

8. Foucault, *Discipline and Punish*, 208.

9. Joseph Rouse provides a self-described "sympathetic" reading of Foucault in this regard, specifically addressing the relationship between power and knowledge. See his "Power/Knowledge," in Gutting, *The Cambridge Companion to Foucault*, 95–122.

10. Tagg, *The Burden of Representation*; Sekula, "The Body and the Archive"; Lalvani, *Photography, Vision, and the Production of Modern Bodies*; Green, "On Foucault" and "Veins of Resemblance"; Sander L. Gilman, *Difference and Pathology: Stereotypes of Sexuality, Race, and Madness* (Ithaca, N.Y.: Cornell University Press, 1985); Sander L. Gilman, Hugh Welch Diamond, and John Conolly, *The Face of Madness: Hugh W. Diamond and the Origin of Psychiatric Photography* (New York: Brunner/Mazel, 1976).

Among this work, David Green's "On Foucault" provides a clear, concise summary of photography's relationship to Foucault's discussion of the modern disciplinary regime.

11. Harris B. Tuttle, "History of Photography in Law Enforcement," *Finger Print and Identification Magazine* 43, no. 4 (1961): 4.

12. Simon Ablon Cole, "Manufacturing Identity: A History of Criminal Identification Techniques from Photography through Fingerprinting" (Ph.D. diss., Cornell University, 1998), 51; Sandra S. Phillips, "Identifying the Criminal," in Phillips, Haworth-Booth, and Squires, *Police Pictures*, 19; Tuttle, "History of Photography in Law Enforcement," 16.

13. H. S. Cooper, "The Evolution of Canadian Police," in *The Police Function in Canada*, ed. William T. McGrath and Michael P. Mitchell (Toronto: Methuen, 1981), 37–52.

14. O. G. Rejlander, "Hints Concerning the Photographing of Criminals," *British Journal Photographic Almanac*, 1872: 116–117; W. B. Woodbury, "Photographing Criminals," *British Journal Photographic Almanac*, 1875: 128.

15. Tagg, *The Burden of Representation*, 56.

16. Tuttle, "History of Photography in Law Enforcement."

17. Ibid., 8.

18. Byrnes, *Professional Criminals of America*, v.

19. Johan Caspar Lavater, *Essays on Physiognomy, Designed to Promote the Knowledge and the Love of Mankind* (London: T. Bensley, 1810).

20. Theodore M. Porter offers a thorough, critical account of Quetelet's

work within its larger social and cultural context. See his *The Rise of Statistical Thinking: 1820–1900* (Princeton, N.J.: Princeton University Press, 1986). Porter does not draw on the work of Foucault, but his discussion of social statistics is complementary to Foucault's major claims about a new disciplinary society.

21. Ibid., 49.

22. Ibid., 48.

23. Adolphe Quetelet, *Sur l'homme et le development de ses faculties, ou Essai de physique sociale* (Paris: Bachelier, 1835).

24. Porter takes up the issue of the difficulty of measuring moral character in *The Rise of Statistical Thinking*, 53.

25. Ibid., 52.

26. Maurice Parmelee, introduction to Lombroso, *Crime*, xxxii.

27. Lombroso-Ferrero, *Criminal Man*.

28. Ibid.

29. Leonard Savitz, introduction to Lombroso-Ferrero, *Criminal Man*, xi.

30. David Horn's recent text on Lombroso provides a thorough account of the transformations in his theories. See his *The Criminal Body: Lombroso and the Anatomy of Deviance* (New York: Routledge, 2003). In the text, Horn also notes that the similarities between the French and Italian schools of criminal anthropology far outweigh their differences.

31. Rafter, "Criminal Anthropology in the United States," 539. A chart detailing Lombroso's scheme matching punishment to criminal type can be found in Lombroso-Ferrero, *Criminal Man*, 210–212.

32. Rafter, "Criminal Anthropology in the United States," 535.

33. A more detailed discussion of these instruments, including illustrations, can be found in the first chapter of part three of Lombroso-Ferrero, *Criminal Man*. While the text details the procedures and rationales for using these instruments, no further reference is available. In most cases, Lombroso noted only surnames and offered no supporting documentation.

34. Horn, *The Criminal Body*, 20.

35. Rafter, "Criminal Anthropology in the United States."

36. Horn, "This Norm Which Is Not One."

37. Summarizing his study of female criminality, Lombroso writes: "The true born criminal exists among women only in the form of the prostitute, who already finds in her lamentable calling a substitute for crime" (*Crime*, 406). On the pathologization of the female body and, in particular, the prostitute, see Gilman, *Difference and Pathology*.

38. Rafter, "Criminal Anthropology in the United States," 539.

39. Lombroso and Ferrero, *The Female Offender*. David Horn has produced a detailed and insightful reading of Lombroso's work on female criminality; see his "This Norm Which Is Not One."

40. Horn, "This Norm Which Is Not One," 117.

41. Lombroso-Ferrero, *Criminal Man*, xxv.

42. Francis Galton, *Inquiries into Human Faculty and Its Development* (London: J. M. Dent and Sons, 1907).

43. Ibid., 1.

44. Francis Galton, *Memories of My Life* (London: Methuen, 1908), 259.

45. Green, "Veins of Resemblance," 11.

46. Galton, *Inquiries into Human Faculty and Its Development*, 7.

47. Sekula, "The Body and the Archive," 42.

48. Havelock Ellis, *The Criminal* (London: Walter Scott, 1890). Nicole Hahn Rafter identifies Ellis's text as a key entry point for Americans to the Italian school of criminal anthropology. She calls Ellis "far and away the most influential" of the scholars responsible for introducing the work of the originators, including Lombroso, to the United States ("Criminal Anthropology in the United States," 530).

49. For a thorough account of Bertillon's work, see Henry T. F. Rhodes, *Alphonse Bertillon, Father of Scientific Detection* (London: Harrap, 1956).

50. Bertillon's methods are detailed in several of his own texts, including *La photographie judiciaire avec un appendice sur la classification et l'identification anthropométriques* (Paris: Gauthier-Villars, 1890), *Identification Anthropométrique: Instructions signalétiques—Album* (Melun, France: Imprimerie Administrative, 1893), and *Alphonse Bertillon's Instructions for Taking Descriptions for the Identification of Criminals, and Others by the Means of Anthropometric Indications* (New York: AMS Press, 1975).

51. Cole, "Manufacturing Identity," 79.

52. Lombroso, *Crime*, 252.

2. Photographing Fingerprints

1. Donald C. Dilworth, ed., *Identification Wanted: Development of the American Criminal Identification System, 1893–1943*, Police History Series (Gaithersburg, Md.: International Association of Chiefs of Police, 1977), 166.

2. Thomas Carey, assistant special agent in charge, Washington Field Office, FBI, "Communication with the Law Enforcement Community," congressional statement, November 13, 2001, http://www.fbi.gov/congress/congress01/carey111301.htm.

3. Federal Bureau of Investigation, "Inauguration of the Integrated Automated Fingerprint Identification System (IAFIS)," press release, August 10, 1999, http://www.fbi.gov/pressrel/pressrel99/iafis.htm.

4. Sekula, "The Body and the Archive," 16.

5. Simon Cole, *Suspect Identities: A History of Criminal Identification and Fingerprinting* (Cambridge, Mass.: Harvard University Press, 2001); Cole, "Manufacturing Identity"; Dilworth, *Identification Wanted;* Donald C. Dilworth, ed., *The Blue and the Brass: American Policing, 1890–1910*, Police History Series (Gaithersburg, Md.: International Association of Chiefs of Police, 1976).

6. The rich and diverse history of fingerprinting as a method of identification has been addressed in significant depth. Sources offering a detailed

historical overview include Harrison C. Allison, *Personal Identification* (Boston: Holbrook Press, 1973); Frederick R. Cherrill, *The Finger Print System at Scotland Yard* (London: Her Majesty's Stationery Office, 1954); Cole, "Manufacturing Identity" and *Suspect Identities;* Dilworth, *Identification;* Chief Inspector J. H. Duncan, *An Introduction to Fingerprints* (London: Butterworth, 1942); Bert Wentworth and Harris Hawthorne Wilder, *Personal Identification: Methods for the Identification of Individuals, Living or Dead* (Chicago: T. G. Cooke, 1932); George Wilton Wilton, *Fingerprints: History, Law, and Romance* (London: William Hodge, 1938).

7. Simon Cole also stresses the importance of another individual, Thomas Taylor, who founded the first division of microscopy at the U.S. Department of Agriculture. Taylor delivered a lecture in 1877 on the use of fingerprints to identify criminals that became the first published work on the subject in the West. See Cole, "Manufacturing Identity," 128.

8. Henry Faulds, "On the Skin-Furrows of the Hand," *Nature* 22 (October 28, 1880): 605.

9. Ibid.

10. W. J. Herschel, "Skin Furrows of the Hand," *Nature* 23 (November 25, 1880): 76.

11. Ibid.

12. In the literature dealing with fingerprinting, there has been continued debate as to who founded the technique. The most recent example is that of Colin Beavan, who pleads that Henry Faulds should be acknowledged as the central figure in the technique's history. See Beavan, *Fingerprints: The Origins of Crime Detection and the Murder Case That Launched Forensic Science* (New York: Hyperion, 2001).

13. Francis Galton, "Personal Identification and Description: 1," *Nature* 38 (June 21, 1888): 173–177; "Personal Identification and Description: 2," *Nature* 38 (June 28, 1888): 201–202; and *Finger Prints* (London: Macmillan, 1892).

14. Cole, "Manufacturing Identity," 230.

15. Most sources agree that the majority of the work attributed to Henry as regards classifying fingerprints was actually produced by Haque.

16. Sir E. R. Henry, *Classification and Uses of Finger Prints,* 7th ed. (London: His Majesty's Stationery Office, 1934).

17. There is a wide array of sources that address the procedures of fingerprint identification. Three particularly clear sources are Charles Edward Chapel, *Fingerprinting: A Manual of Identification* (New York: Coward McCann, 1941); James Holt, *Finger Prints Simplified: A Handbook of the Science of Finger Print Identification* (Chicago: Frederick J. Drake, 1920); and Frederick Kuhne, *The Finger Print Instructor* (New York: Munn, 1916).

18. Holt, *Finger Prints Simplified,* 112.

19. Cole, "Manufacturing Identity," 243.

20. Dilworth, *Identification,* 1.

21. For a detailed account of the development of municipal, provincial,

and federal police in Canada, see William Kelly and Nora Kelly, *Policing in Canada* (Toronto: Macmillan, 1976); McGrath and Mitchell, *The Police Function in Canada*; C. K. Talbot, C. H. S. Jayewardene, and T. J. Juliani, eds., *Canada's Constables: The Historical Development of Policing in Canada* (Ottawa: Crimcare, 1985).

22. Dilworth, *Identification*, 33.

23. See Dilworth, *Identification* and *The Blue and the Brass*.

24. Quoted in Dilworth, *Identification*, 5.

25. Dilworth, *Identification* and *The Blue and the Brass*.

26. Dilworth, *Identification*, 109. The International Association for Identification continues to operate today. Information on this organization and its history is available through the association's Web site, at http://www.theiai.org.

27. On the development of fax technology, see Jonathan Coopersmith, "Facsimile's False Starts," *IEEE Spectrum*, February 1993: 46–49; Daniel M. Costigan, *Electronic Delivery of Documents and Graphics* (New York: Van Nostrand Reinhold, 1978). On transmitting photographs over radio, see Austin C. Lescarboura, "Sending Photographs over Wires," *Scientific American*, November 6, 1920, 474–484.

28. "Finger-Prints via Radio," *Scientific American*, December 1922, 386.

29. Dilworth, *Identification*, 186.

30. Colin Beavan and Simon Cole address the founding cases in Britain and the United States, respectively. See Beavan, *Fingerprints*, and Cole, "Witnessing Identification."

31. The United States, Canada, and the United Kingdom employed variations of the Henry system, Argentina and the rest of Latin America used the Vucetich system, and countries throughout Europe employed individual systems that were largely based on Henry's and Vucetich's. Within each classification system, prints were analyzed according to the basic patterns and ridge details outlined by Henry and his contemporaries, enabling prints to be shared among law enforcement departments.

32. The tremendous advances in computer and database technologies in the 1960s and 1970s greatly extended the depth and power of this system and will be addressed in chapter 4.

33. *The Essential Peirce*, particularly "What Is a Sign?" 4–10.

34. Wilton, *Fingerprints*, 220.

35. Daston and Galison, "The Image of Objectivity"; Peter Galison, "Judgment against Objectivity," in Jones and Galison, *Picturing Science, Producing Art*, 327–359.

36. Quoted in Dilworth, *Identification*, 60.

37. Dilworth, *Identification*, 50. DePue presented his system to the International Association of Chiefs of Police convention in 1902.

38. Simon Cole has addressed the professionalization of fingerprint examination. See his "Witnessing Identification."

39. I do not mean to suggest that this resulted in a total shift in criminal justice practices. Officers in the field still participated in criminal identification; however, in fingerprint identification, their role was as data collectors.

40. Chapel, *Fingerprinting*, 234, 52.

41. For a detailed discussion of single-fingerprint systems, see Chapel, *Fingerprinting*, and Cole, "Manufacturing Identity."

42. On the development of automated fingerprint identification systems, see Bruce J. Brotman and Rhonda K. Pavel, "Identification: A Move toward the Future," *Law Enforcement Bulletin* 60, no. 7 (July 1991): 1–6; Cole, "Digital Digits," chap. 10 in *Suspect Identities*; Bill Reed, "Automated Fingerprint Identification: From Will West to Minnesota Nine-Fingers and Beyond," *Journal of Police Science and Administration* 9, no. 3 (1981): 317–326; Thomas F. Wilson, "Automated Fingerprint Identification Systems," *Law Enforcement Technology*, August–September 1986: 17–46.

43. Reed, "Automated Fingerprint Identification," 320–321.

44. Cole, *Suspect Identities*, 252.

45. Reed, "Automated Fingerprint Identification," 323.

46. Cole, *Suspect Identities*, 253.

47. Three central companies providing AFIS equipment and products are Lockheed Martin (see http://www.lockheedmartin.com/products/ngi/index.html), NEC (see http://www.necsolutions-am.com/idsolutions), and Printrak International (a Motorola company; see http://www.motorola.com). An online source with extensive lists of AFIS products and companies is maintained by Ed German, a member of the U.S. Army Criminal Investigation Laboratory, at http://onin.com/fp/afis/afis.html.

48. As part of the MA degree in art history at York University, Toronto, I established an apprenticeship with the Forensics Identification Services Division of the Metropolitan Toronto Police. The apprenticeship took place during August 1996. Throughout the month, I worked with scenes of crime and identification officers to examine the use of photography within practices of criminal identification. Much of the information on fingerprinting in this chapter comes from this apprenticeship, which included access to various manuals and publications used in the training of officers. Chief among the materials was the Ontario Police College's *Scenes of Crime Manual* and the following articles produced by the Metropolitan Toronto Police Identification Bureau: "History of Fingerprints," "History of Identification by Fingerprints," "Fingerprints as a Means of Identification," "A Capsule Chronological History of Fingerprint Identification," and "Structure of the Skin."

49. In the Metropolitan Toronto Police, scenes of crime officers receive general training on evidence collection, including basic notes on photography. Identification officers receive more specialized training, particularly in reference to the collection and photographing of crime scene materials.

50. It is important to note that the collection of fingerprints is only one part of the larger investigative process. Other forms of potential evidence, such as objects at the scene, are also collected and are photographed.

51. Cole, *Manufacturing Identity*, 35.

52. Ibid., 276.

3. The Control of Inscriptions

1. Paul Rabinow, "Galton's Regret: Of Types and Individuals," in *DNA on Trial: Genetic Identification and Criminal Justice*, ed. Paul R. Billings (Plainview, N.Y.: Cold Springs Harbor Laboratory, 1992), 5–18.

2. Committee on DNA Forensic Science, National Research Council, *The Evaluation of Forensic DNA Evidence* (Washington, D.C.: National Academies Press, 1996), 9.

3. Wilton, *Fingerprints*, 220.

4. K. Amann and K. Knorr Cetina, "The Fixation of (Visual) Evidence," in *Representation in Scientific Practice*, ed. Michael Lynch and Steve Woolgar (Cambridge: MIT Press, 1990), 85–122; Jasanoff, "The Eye of Everyman."

5. There are a tremendous number of descriptions of this process available. Four particularly clear sources are Committee on DNA Technology in Forensic Science, *DNA Technology in Forensic Science*; Committee on DNA Forensic Science, *The Evaluation of Forensic DNA Evidence*; Thomas Curran, *Forensic DNA Analysis: Technology and Application* (Ottawa: Parliamentary Research Branch, Government of Canada, 1997), BP-443E, and also available at http://www.parl.gc.ca/information/library/PRBpubs/bp443-e.htm; Eric Lander, "DNA Fingerprinting: Science, Law, and the Ultimate Identifier," in *The Code of Codes: Scientific and Social Issues in the Human Genome Project*, ed. Daniel J. Kevles and Leroy Hood (Cambridge, Mass.: Harvard University Press, 1992).

6. It is important to note that the specific fragments of DNA represented in the autoradiograph are only a minute portion of the entirety of the human genome. The sources referred to in note 5 discuss the specific fragments of DNA that are used in analysis.

7. A particularly good discussion of the calculation of probability can be found in Committee on DNA Forensic Science, *The Evaluation of Forensic DNA Evidence*.

8. Latour, *Science in Action*; Latour and Woolgar, *Laboratory Life*; Lynch and Woolgar, *Representation in Scientific Practice*, especially Latour's essay "Drawing Things Together"; Michael Lynch, "The Externalized Retina: Selection and Mathematization in the Visual Documentation of Objects in the Life Sciences," *Human Studies* 11 (1988): 201–234. William Ivins makes a similar but more general claim that modern science and technology could not have developed without the "exactly repeatable pictorial statement." See his *Prints and Visual Communication* (Cambridge: MIT Press, 1969), passim.

9. Jay David Aronson argues that judges and lawyers also played a substantial role in the development of DNA analysis as a method of criminal identification. See his "The Introduction, Contestation, and Regulation of Forensic DNA Analysis in the American Legal System (1984–1994)" (Ph.D. diss., University of Minnesota, 2004).

10. For in-depth discussions of DNA analysis covering a diverse array of topics, perspectives, and approaches, see Billings, *DNA on Trial*; Mark A. Rothstein, ed., *Genetic Secrets: Protecting Privacy and Confidentiality in the Genetic Era* (New Haven, Conn.: Yale University Press, 1997); "Contested Identities," special issue, *Social Studies of Science* 28, nos. 5–6 (1998).

11. Michael Lynch and Sheila Jasanoff, "Contested Identities: Science, Law, and Forensic Practice," *Social Studies of Science* 28, nos. 5–6 (1998): 676.

12. Alec Jeffreys, quoted in Earl Ubell, "Whodunit? Quick, Check the Genes!" *Parade Magazine*, March 31, 1991, 12.

13. Aronson, "The Introduction, Contestation, and Regulation of Forensic DNA Analysis in the American Legal System."

14. *State v. Andrews*, 533 So.2d 841 (Fla. App. 5 Dist. 1988).

15. In an interview with Michael Lynch, Alec Jeffreys, who coined the term "DNA fingerprinting," noted that he purposely used the term in an effort to call attention to the technique (Jeffreys, in Aronson, "The Introduction, Contestation, and Regulation of Forensic DNA Analysis in the American Legal System," 56). Similarly, it is interesting to note that contemporary private testing companies often use the term "DNA fingerprinting" in advertisements for their services. This is an obvious yet inaccurate appeal to the authority of fingerprinting.

16. Peter J. Neufeld, "DNA—A Defense Perspective," in *Proceedings for the International Symposium on Human Identification* (Madison, Wisc.: Promega Corporation, 1989), 167–171.

17. Peter Neufeld, quoted in Gina Kolata, "Some Scientists Doubt the Value of 'Genetic Fingerprint' Evidence," *New York Times*, January 29, 1990.

18. *People v. Castro*, 545 N.Y.S.2d 985 (Sup. Ct. 1989).

19. Lynch and Jasanoff, "Contested Identities," 678.

20. *United States v. Yee*, 129 F.R.D. 692 (N.D. Ohio 1990).

21. Katherine Bishop, "A Victory for Genetic Fingerprinting," *New York Times*, November 16, 1990.

22. *Frye v. United States*, 293 F. 1013 (D.C. Cir. 1923).

23. Ibid. The Frye principle is not the only guideline for determining the validity of a scientific technique, although it was the most widely used during early uses of DNA analysis. The Federal Rules of Evidence also offer a "helpfulness" model. A 1993 case, *Daubert v. Merrell Dow Pharmaceuticals Inc.*, 509 U.S. 579 (1993), offered a model parallel to that of the "helpfulness" model. For a discussion of these, see Committee on DNA Technology in Forensic Science, *DNA Technology in Forensic Science*; Jasanoff, "The Eye of Everyman"; Lynch and Jasanoff, "Contested Identities."

24. Don Edwards; Eric Lander; both quoted in Harold M. Schmeck Jr., "DNA Findings Disputed by Scientists," *New York Times*, February 7, 1988.

25. Committee on DNA Technology in Forensic Science, *DNA Technology in Forensic Science*, 102. General information on the ASCLD, including its history, can be found at the society's Web site, http://www.ascld.org.

26. Keith Inman and Norah Rudin, *An Introduction to Forensic DNA Analysis* (New York: CRC Press, 1997), 139. See also the Web site of the American Board of Criminalistics at http://criminalistics.com.

27. Inman and Rudin, *An Introduction to Forensic DNA Analysis*, 98.

28. U.S. Department of Commerce, Office of Technology Assessment, *Genetic Witness: Forensic Uses of DNA Tests* (Washington, D.C.: Office of Technology Assessment, 1990), 10.

29. Committee on DNA Technology in Forensic Science, *DNA Technology in Forensic Science*, 185.

30. Victor A. McKusick, preface to ibid., viii.

31. Committee on DNA Technology in Forensic Science, *DNA Technology in Forensic Science*, 98.

32. Ibid., 97–110.

33. *DNA Identification Act of 1993*, H.R. 829, 103rd Cong., 1st sess., *Congressional Record* 139 (Washington, D.C.: Government Printing Office, 1993). The act appears as an amendment to Title I of the Omnibus Crime Control and Safe Streets Act of 1968.

34. *DNA Identification Act*, 4.

35. Ibid., 2

36. Naftali Bendavid, "Bill Would Expand Use of DNA Testing," *Legal Times*, June 7, 1993.

37. John Hicks; Don Edwards; both quoted in ibid.

38. *Violent Crime Control and Law Enforcement Act of 1994*, H.R. 3355, Public Law 103–322, 108 Stat. 1796 (September 13, 1994).

39. Eric S. Lander and Bruce Budowle, "DNA Fingerprinting Dispute Laid to Rest," *Nature* 371 (October 27, 1994): 735.

40. Saul Halfon provides an interesting and concise account of Eric Lander's unique position within the DNA wars. See his "Collecting, Testing, and Convincing: Forensic DNA Experts in the Courts," *Social Studies of Science* 28, nos. 5–6 (1998): 801–828. Michael Lynch and Sheila Jasanoff, in "Contested Identities," note that the article by Lander and Budowle was also criticized as being an attempt to preempt attacks on DNA evidence in the upcoming O. J. Simpson trial.

41. Lander and Budowle, "DNA Fingerprinting Dispute Laid to Rest," 738.

42. "Correspondence: Forensic DNA Typing Dispute," *Nature* 371 (December 1, 1994): Richard C. Lewontin, 398; Daniel L. Hartl, 398–399.

43. Committee on DNA Forensic Science, *The Evaluation of Forensic DNA Evidence*. Also see Donald A. Berry, "Statistical Issues in DNA Identification," in Billings, *DNA on Trial*, 91–108.

44. Jasanoff, "The Eye of Everyman."

45. Arthur Daemmrich, "The Evidence Does Not Speak for Itself: Expert Witnesses and the Organization of DNA-Typing Companies," *Social Studies of Science* 28, nos. 5–6 (1998): 741–772. For a discussion from the point of view of biotechnology companies, see P. G. Debenham, "DNA Fingerprinting: A

Biotechnology Business," in *DNA Fingerprinting: Approaches and Applications,* ed. Terry Burke (Basel, Switzerland: Birkäuser Verlag, 1991), 342–348. Debenham was an employee for Cellmark Diagnostics at the time he wrote his essay.

46. Jeff Boschwitz, Ph.D., vice president, North American Sales and Marketing, Orchid Cellmark, Inc., interview with the author, March 18, 2009.

47. Daemmrich, "The Evidence Does Not Speak for Itself," 749.

48. From Cellmark's Web site at http://www.cellmark-labs.com/companyprofile.html. For information on Cellmark laboratories, see http://www.orchidcellmark.com.

49. From the forensic page of Genelex, at http://www.genelex.com/forensics/forensicshome.html. For information on Genelex, see http://www.healthanddna.com/index.html.

50. On the development of DNA data banks in law enforcement, see Jean E. McEwen and Phillip R. Reilly, "A Review of State Legislation on DNA Forensic Data Banking," *American Journal of Human Genetics* 54, no. 6 (June 1994): 941–958; Jean E. McEwen, "Forensic DNA Data Banking by State Crime Laboratories," *American Journal of Human Genetics* 56, no. 6 (June 1995): 1487–1492.

51. Private companies can perform analyses faster than the FBI, which remains plagued by a backlog of DNA evidence to analyze. This has caused some agencies to opt for paying for analysis.

52. *DNA Identification Grants Improvement Act of 1995,* H.R. 2418, 104th Cong., sess. 1.

53. Federal Bureau of Investigation, CODIS Statistical Clickable Map, http://www.fbi.gov/hq/lab/codis/clickmap.htm.

54. Detailed information is available from the program's Web site, http://www.innocenceproject.org.

55. Jeroo S. Kotval, "Public Policy for Forensic DNA Analysis: The Model of New York State," in Billings, *DNA on Trial,* 111.

56. Federal Bureau of Investigation, CODIS Statistical Clickable Map.

57. Both Orchid Cellmark and Genelex advertise their accreditation with the FBI's ASCLD-LAB and their ability to perform analyses consistent with FBI and Combined DNA Index System standards.

58. Jean E. McEwen, "DNA Data Banks," in Rothstein, *Genetic Secrets,* 231.

4. Potential Criminality

1. Sekula, "The Body and the Archive," 10.

2. Ibid., 17

3. Gunjan Sinha, "DNA Detectives," *Popular Science,* August 1999, 48–52. More information on the specific equipment can be found at Nanogen's Web site, http://www.nanogen.com.

4. Richard V. Ericson and Kevin D. Haggerty, *Policing the Risk Society* (Toronto: University of Toronto Press, 1997).

5. William Bogard, "Surveillance Assemblages and Lines of Flight," in Lyon, *Theorizing Surveillance*, 101.

6. Gilles Deleuze and Félix Guattari, *A Thousand Plateaus: Capitalism and Schizophrenia*, trans. Brian Massumi (Minnesota: University of Minnesota Press, 1987); Gilles Deleuze, "Postscript on the Societies of Control," *October* 59 (Winter 1992): 3–7. For the use of the assemblage metaphor in describing contemporary surveillance, see Kevin D. Haggerty and Richard V. Ericson, "The Surveillant Assemblage," *British Journal of Sociology* 51, no. 4 (December 2000): 605–622; Bogard, "Surveillance Assemblages and Lines of Flight."

7. Other authors counter Bogard's claim by stressing the extent to which digital technologies have facilitated greater state control. See Katja Franko Aas, "The Body Does Not Lie: Identity, Risk, and Trust in Technoculture," *Crime, Media, Culture* 2, no. 2 (2006): 143–158; Maria Los, "Looking into the Future: Surveillance, Globalization, and the Totalitarian Potential," in Lyon, *Theorizing Surveillance*, 69–94.

8. Shoshana Zuboff, "Dilemmas of Transformation in the Age of the Smart Machine," in *Reading Digital Culture*, ed. David Trend (Oxford: Blackwell, 2001), 129.

9. Ericson and Haggerty show that the informating capabilities of digital technologies were ultimately used by police in an effort to increase efficiency.

10. National Institute of Justice, National Commission on the Future of DNA Evidence, *Proceedings, Legal Issues Working Group Report and Discussion*, September 27, 1999, http://www.ojp.usdoj.gov/nij/topics/forensics/events/ dnamtgtrans7/welcome.html. Also cited in Rebecca Sasser Peterson, "DNA Databases: When Fear Goes Too Far," *American Criminal Law Review* 37, no. 3 (Summer 2000): 1219–1238.

11. Roger Clarke, "The Digital Persona and Its Application to Data Surveillance," *Information Society* 10, no. 2 (June 1994), http://www.anu.edu.au/ people/Roger.Clarke/DV/DigPersona.html; Laudon, *Dossier Society*; David Lyon, "Surveillance as Social Sorting: Computer Codes and Mobile Bodies," in *Surveillance as Social Sorting: Privacy, Risk, and Digital Discrimination* (New York: Routledge, 2003): 13–30. Clarke uses the term "digital persona," Laudon uses "data-image," and Lyon uses "data-double."

12. William D. Haglund, "The National Crime Information Center (NCIC) Missing and Unidentified Persons System Revisited," *Journal of Forensic Sciences* 38, no. 2 (1993): 365–378.

13. See Federation of American Scientists, National Crime Information Center, http://www.fas.org/irp/agency/doj/fbi/is/ncic.htm, for a detailed description of the various data fields as well as a general overview of the National Crime Information Center.

14. Haglund, "The National Crime Information Center (NCIC) Missing and Unidentified Persons System Revisited."

15. Paul L. Woodward, *Criminal Justice "Hot" Files* (Washington, D.C.: U.S. Department of Justice, Bureau of Justice Statistics, 1986), 19.

16. Haglund, "The National Crime Information Center (NCIC) Missing and Unidentified Persons System Revisited."

17. Federal Bureau of Investigation, "National Crime Information Center (NCIC) 2000," press release, July 15, 1999, http://www.fbi.gov/pressrel/pressrel99/ncic2000.htm.

18. Royal Canadian Mounted Police, "Privacy Impact Assessment—Canadian Police Information Centre," http://www.rcmp-grc.gc.ca/pia-efvp/cpic-cipc-eng.htm.

19. Brotman and Pavel, "Identification."

20. Federal Bureau of Investigation, Overview of CJIS, http://www.fbi.gov/hq/cjisd/about.htm.

21. The Integrated Automated Fingerprint Identification System (IAFIS) became operable in July, 1999. See "Technology Update: Unsolved Case Fingerprint Matching," Law Enforcement Bulletin 69, no. 12 (December 2000): 12–13; Federal Bureau of Investigation, "Inauguration of the Integrated Automated Fingerprint Identification System (IAFIS)."

22. Keith J. Cutri, "Laptop Computers: New Technology for Law Enforcement," Law Enforcement Bulletin 65, nos. 2–3 (February–March 1996); Catherine Greenman, "A Well-Equipped Patrol Officer: Gun, Flashlight, Computer," New York Times, January 21, 1999, http://www.nytimes.com/library/tech/99/01/circuits/articles/21howw.html; and "Computers on Patrol Have Got Your Number," New York Times, January 21, 1999, http://www.nytimes.com/library/tech/99/01/circuits/articles/21howw-side.html.

23. Woodward, Criminal Justice "Hot" Files, 19.

24. Stephanie L. Hitt, "NCIC 2000," Law Enforcement Bulletin 69, no. 7 (2000): 12–15.

25. Federal Bureau of Investigation, "An NCIC Milestone," press release, March 23, 2002, http://www.fbi.gov/pressrel/pressrel02/ncic032302.htm.

26. Federal Bureau of Investigation, "Inauguration of the Integrated Automated Fingerprint Identification System (IAFIS)."

27. Raymond Dussault, "Cause and Effect," Government Technology, April 2000, http://www.govtech.net/publications/crimetech/Apr00/CTEfingerprints.phtml.

28. Michael D. Kirkpatrick, "Solving Cold Cases with Digital Fingerprints," Sheriff 53, no. 4 (2001): 14–17.

29. Randall S. Murch and Bruce Budowle, "Are Developments in Forensic Applications of DNA Technology Consistent with Privacy Protections?" in Rothstein, Genetic Secrets, 223.

30. Tod Newcombe, "Slow Spiral: State DNA Lag Databases," Government Technology, April 2000, http://www.govtech.net/publications/crimetech/Apr00/CTENDA.phtml.

31. Orchid Biosciences, "Orchid Cellmark Launches Rapid Forensic DNA Analysis Service," press release, January 15, 2003, http://www.orchid.com/news/view_pr.asp?ID=280.

32. Newcombe, "Slow Spiral."

33. Nicholas P. Lourich, Ph.D.; Travis C. Pratt, Ph.D.; Michael J. Gaffney, J.D.; Charles L. Johnson, M.A.; Christopher H. Asplen, J.D.; Lisa H. Hurst; Timothy M. Schellberg, J.D., *National Forensic DNA Study Report, Final Report* (Pullman: Washington State University, 2003); also available at http://www.ncjrs.gov/App/publications/Abstract.aspx?id=203870. Solomon Moore, "DNA Backlog Stalling Many Criminal Cases," *International Herald Tribune*, October 26, 2008, also available at http://www.iht.com/articles/2008/10/26/america/DNAweb.php.

34. Federal Bureau of Investigation, "CODIS, Participating States," http://www.fbi.gov/hq/lab/codis/clickmap.htm.

35. Federal Bureau of Investigation, "National Crime Information Center (NCIC) 2000"; Brotman and Pavel, "Identification."

36. Gary L. Bell, "Testing the National Crime Information Center Missing/Unidentified Persons Computer Comparison Routine," *Journal of Forensic Sciences* 38, no. 1 (1993): 13–22; Haglund, "The National Crime Information Center (NCIC) Missing and Unidentified Persons System Revisited."

37. David Burnham, "FBI Says 12,000 Faulty Reports on Suspects Are Issued Each Day," *New York Times*, August 25, 1985.

38. Laurie E. Ekstrand, *National Crime Information Center: Legislation Needed to Deter Misuse of Criminal Justice Information* (Washington, D.C.: U.S. General Accounting Office, 1993), 32.

39. Federal Bureau of Investigation, Criminal Justice Information Services Division, National Crime Information Center, http://www.fbi.gov/hq/cjisd/ncic.htm.

40. This is clearly demonstrated in Ericson and Haggerty's study of Canadian policing, *Policing the Risk Society*.

41. Three central texts (each a collection of essays) addressing the social and cultural issues associated with DNA identification are Carl F. Cranor, ed., *Are Genes Us? The Social Consequences of the New Genetics* (New Brunswick, N.J.: Rutgers University Press, 1994); Ruth Hubbard and Elijah Wald, *Exploding the Gene Myth: How Genetic Information Is Produced and Manipulated by Scientists, Physicians, Employers, Insurance Companies, Educators, and Law Enforcers* (Boston: Beacon Press, 1993); and Kevles and Hood, *The Code of Codes*.

42. George J. Annas, "Privacy Rules for DNA Databanks: Protecting Coded 'Future Diaries,'" *Journal of the American Medical Association* 270, no. 19 (1993): 2346–2350; George J. Annas, Leonard H. Glantz, and Patricia A. Roche, "Drafting the Genetic Privacy Act: Science, Policy, and Practical Considerations," *Journal of Law, Medicine, and Ethics* 23, no. 4 (December 1995): 360–366; Andrea De Gorgey, "The Advent of DNA Databanks: Implications for Information Privacy," *American Journal of Law and Medicine* 16, no. 3 (1990): 381–398.

43. The Fourth Amendment reads: "The right of the people to be secure in their persons, houses, papers, and effects, against unreasonable searches and seizures, shall not be violated, and no Warrants shall issue, but upon probable cause, supported by Oath or affirmation, and particularly describing the place to be searched, and the persons and things to be seized."

44. McEwen and Reilly, "A Review of State Legislation on DNA Forensic Data Banking," 945.

45. Ibid., 941–958.

46. Sasser Peterson, "DNA Databases." See also D. H. Kaye, "Bioethical Objections to DNA Databases for Law Enforcement: Questions and Answers," *Seton Hall Law Review* 31, no. 4 (2001): 936–948.

47. Sasser Peterson, "DNA Databases," 1225.

48. Neil Gerlach, *The Genetic Imaginary: DNA in the Canadian Criminal Justice System* (Toronto: University of Toronto Press, 2004).

49. One of the most common reasons given for storing samples is that they may need to be used during a criminal investigation, such as to produce further autoradiographs or to retest the DNA in the face of evidentiary dispute.

50. R. P. Ebstein et al., "Dopamine D4 Receptor (D4R4) Exon III Polymorphism Associated with the Human Personality Trait of Novelty Seeking," *Nature Genetics* 12, no. 1 (January 1996): 78–80; J. Benjamin et al., "Population and Familial Association between the D4 Dopamine Receptor Gene and Measure of Novelty Seeking," *Nature Genetics* 12, no. 1 (January 1996): 81–84.

51. Two research articles that propose a genetic link for male homosexuality are Stella Hu et al., "Linkage between Sexual Orientation and Chromosome Xq28 in Males but Not in Females," *Nature Genetics* 11 (November 1995): 248–256; Dean H. Hamer et al., "A Linkage between DNA Markers on the X Chromosome and Male Sexual Orientation," *Science* 261 (July 16, 1993): 321–327.

52. Evelyn Fox Keller, "Master Molecules," in Cranor, *Are Genes Us?*

53. Barry Scheck, "DNA Data Banking: A Cautionary Tale," *American Journal of Human Genetics* 54, no. 6 (1994): 931–933.

54. Statistics show that the system produced an average of sixty-seven hits a week, and in a preliminary test between January and May 2002, it led to the apprehension of 1,400 people. See U.S. Department of Justice, "National Security Entry–Exit Registration System," 2002, http://www.usdoj.gov/ag/speeches/2002/natlsecentryexittrackingsys.htm.

55. US-VISIT was implemented on January 5, 2004.

5. Visible Criminality

1. Although NSEERS legislation still exists and the program is therefore theoretically active, in practice it was brought to a close with the implementation of US-VISIT. My analysis of NSEERS in this book refers to the highly active period between its implementation in 2002 and that of US-VISIT in 2004.

2. U.S. Department of Homeland Security, "Fact Sheet: Changes to National Security Entry/Exit Registration System (NSEERS)," press release, December 1, 2003, http://www.dhs.gov/xnews/releases/press_release_0305.shtm.

3. U.S. Department of Homeland Security, "US-VISIT Statistics," http://www.dhs.gov/dhspublic/interapp/editorial/editorial_0437.xml.

4. Kris Kobach, counsel to the attorney general, Department of Justice, "National Security Entry–Exit Registration System," Foreign Press Center briefing, January 17, 2003, http://fpc.state.gov/16739pf.htm.

5. [56 FR 1566]. The citation format "[56 FR 1566]" refers to "[Volume 56, *Federal Register,* page 1566]." This format is used throughout government documents and is used in this chapter as well. The *Federal Register* from 1994 to the present can be accessed and searched through the U.S. Government Printing Office's Web site, GPO Access, http://www.gpoaccess.gov/fr/index.html.

6. [58 FR 68157]; [61 FR 46829]; [63 FR 39109].

7. The specific mandate was the Illegal Immigration and Immigrant Responsibility Act of 1996.

8. *Immigration and Naturalization Services Data Management Improvement Act (DMIA),* 114 Stat. 339 (8 *U.S. Code* 1356a).

9. [67 FR 40581].

10. [67 FR 40582].

11. [67 FR 40584].

12. [67 FR 52584].

13. [67 FR 52584].

14. [67 FR 67766]; [67 FR 70526]; [67 FR 77136] (Armenia was mistakenly included in this call, but it was removed from the list two days after the initial publication [67 FR 77642]); [68 FR 2363].

15. U.S. Department of Homeland Security, "Fact Sheet: Changes to National Security Entry/Exit Registration System."

16. Protests occurred in major cities throughout the United States. For example, see Wyatt Buchanan, "Hundreds Protest INS Registration: Men from 13 Countries Sign In," *San Francisco Chronicle,* January 11, 2003; Megan Garvey, Martha Groves, and Henry Weinstein, "Hundreds Are Detained after Visits to INS; Thousands Protest Arrests of Mideast Boys and Men Who Complied with Order to Register," *Los Angeles Times,* December 19, 2002; Chris McGann, "Protestors Accuse INS of 'Very Un-American' Registration; Hundreds Rally in Seattle; Many Fear Tracking Will Be Used to 'Target and Profile,'" *Seattle Post-Intelligencer,* January 14, 2003; C. Kalimah Redd, "Protestors Rally against INS Rules Effort Decried as Racial Profiling," *Boston Globe,* February 21, 2003.

17. [67 FR 52592].

18. [67 FR 52588].

19. Kathryn Lohmeyer, "The Pitfalls of Plenary Power: A Call for Meaningful Review of NSEERS 'Special Registration,'" *Whittier Law Review* 25, no. 1 (2003): 139–179.

20. For a more thorough discussion of these limitations, see Jonathan Finn, "Potential Threats and Potential Criminals: Data Collection in the National Security Entry–Exit Registration System," in *Global Surveillance and Policing: Borders, Security, Identity,* ed. Elia Zureik and Mark B. Salter (Devon, U.K. and Portland, Ore.: Willan Publishing, 2005), 139–156.

21. US-VISIT [69 FR 468].

22. *USA-Patriot Act*, 115 Stat. 353 (8 *U.S. Code* 1379); *EBSVERA*, H.R. 3525, Public Law 107–173, 116 Stat. 553.

23. Nathan Root, "Accenture Faces Daunting Task with US-VISIT Contract," *Inside ID*, June 9, 2004, http://www.insideid.com/credentialing/article .php/3365761.

24. U.S. Department of Homeland Security, "Fact Sheet: US-VISIT," June 5, 2006, http://www.dhs.gov/xnews/releases/pr_1160495895724.shtm.

25. Ibid.

26. U.S. Department of Homeland Security, "Fact Sheet: Changes to National Security Entry/Exit Registration System."

27. Cole, *Suspect Identities* and "Manufacturing Identity."

28. U.S. Department of Justice, "Attorney General Prepared Remarks on the National Security Entry–Exit Registration System," June 6, 2002, http:// www.usdoj.gov/ag/speeches/2002/060502agpreparedremarks.htm.

29. "Facing a Registration Deadline," *New York Times*, January 11, 2003; John M. Hubbell, "Immigrants Register before Final Deadline," *San Francisco Chronicle*, April 26, 2003; Patrick J. Mcdonnell and Jennifer Mena, "Round 2 of INS Sign-Ups Goes Well," *Los Angeles Times*, January 11, 2003; Lillian Thomas, "Register or Risk Deportation," *Pittsburgh Post-Gazette*, March 16, 2003; Kelly Brewington, "Immigrants Sign Up in INS Antiterror Push," *Orlando Sentinel*, January 11, 2003; Scott Shane, "Registration Rules Puzzle, Anger Pakistanis in U.S.," *Baltimore Sun*, January 5, 2003; John F. Bonfatti, "Between Two Worlds; Pakistanis Pack a Refugee Center in Buffalo," *Buffalo News*, March 7, 2003; Simon Houpt, "Thousands with U.S. Visas Race to Meet INS Deadline," *Globe and Mail*, January 11, 2003; Dianne Cardwell, "Pakistani and Saudi Men Find Long Lines for Registration," *New York Times*, March 22, 2003.

30. For Sontag, the Abu Ghraib images reflect contemporary American culture and the "with us or against us" rhetoric of the Bush administration. See her "Regarding the Torture of Others," *New York Times Magazine*, May 23, 2004, 24–29, 42.

Index

Jonathan Finn is associate professor of communication studies at Wilfrid Laurier University in Ontario, Canada. His research interests include visual culture, visual communication, and surveillance studies.